THE ART OF THE ZARAMO

Identity, Tradition, and Social Change in Tanzania

Fadhili Safieli Mshana

MKUKI NA NYOTA
DAR – ES – SALAAM

Published by
Mkuki na Nyota Publishers Ltd
P. O. Box 4246
Dar es Salaam, Tanzania
www.mkukinanyota.com

ISBN 978 9987 75 356 7

Typesetting and Design
Allyn R. Jenkins Typography, Inc.
Athens, Georgia 30606 USA

Visit www.mkukinanyota.com to read more about and to purchase any of Mkuki na Nyota books.

You will also find featured authors interviews and news about other publisher/author events. Sign up for our e-newsletters for updates on new releases and other announcements.

Distributed worldwide outside Africa by African Books Collective.
http://www.africanbookscollective.com/

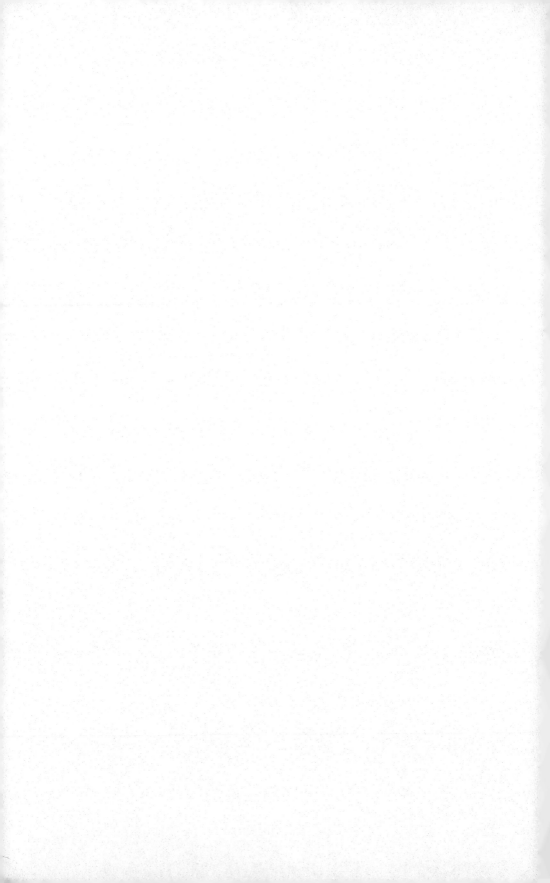

In Memory of my parents,

Safieli Fundi and Happiness Kamba,

For being my first teachers,

And for sending me to school.

Table of Contents

List of Figures

Acknowledgments

This book has been generously supported by several institutions and individuals. I am deeply appreciative of all these, including those who are not listed here. I am most grateful to the University of Dar es Salaam for granting me paid study leave that enabled me to pursue Ph.D. studies in the United States of America, and for funding my initial field research in Uzaramo between December 1996 and January 1997. I am also very grateful to the United States Information Agency for the Fulbright scholarship I received from August 1994 to July 1998 to do doctoral work in the United States. I would also like to acknowledge the Dissertation Year Fellowship that the State University of New York at Binghamton awarded me in the 1998/99 academic year to support my research project. I owe profound debts of gratitude to Georgia College and State University for the Faculty Research Grant that generously supported fieldwork for this book in Tanzania in the summer of 2005.

In Tanzania, I am most grateful to the Zaramo who offered me their time, knowledge, and ideas so critical to this work. Specifically, warmest thanks to Salum Ali Chuma, Salome Mjema, Yusufu Mwalimu Mgumba, Ali Mwinyimkuu Bilali, Selemani Mungi, Mode Kuga, Ramadhani Mwinyimkuu, Omari Abdallah, Mwanamkulu Lamba, Zena Mwinyihija, Cheusi Abdallah, and Sultani Mwinyimkuu, for their collaboration and understanding.

I owe a debt of gratitude to the Tanzania Commission for Science and Technology for granting me a one year research permit for fieldwork (July 5, 2004 to July 5, 2005). I am also indebted to the government officials who allowed me to conduct research in their areas, and to the National Archives in Dar es Salaam, the Dar es Salaam Museum and House of Culture, HANDICO, and the University of Dar es Salaam Library. I am also grateful to former colleagues in the Department of Creative Arts at the University of Dar es Salaam for their support especially, Amandina Lihamba, Elias Jengo, and Frowin Nyoni. Special appreciation is acknowledged, also, to Estomihi and Nainkwa Masaoe, and Roberts and Stella Hillary for their hospitality during field research in Tanzania.

A number of photographs in this work belong to individuals and institutions, and are reproduced here with their permission. I wish to acknowledge all of them for their support. I owe special thanks to Mathayo Ndomondo for taking a number of photographs for this work on my behalf when I was not in a position to do so. My thanks are also due to Verlag Fred Jahn, Marc L. Felix, Marja-Liisa and Lloyd Swantz, William Blackwood,

Tanzania Publishing House, Museum fur Volkerkunde, Munich; Museum fur Volkerkunde, Leipzig; and Art Resource, New York for Museum fur Volkerkunde, Berlin. I could not forget to mention Chris Focht, Emily Gomez, and Patrick Holbrook for their help with the photographs which appear in this book.

At Binghamton University I accumulated debts of gratitude to my dissertation committee, and in particular, I should acknowledge my mentor and dissertation advisor Nkiru Nzegwu, for reading several drafts of my dissertation and for many inspiring discussions, which were of invaluable help. At Georgia College I wish to thank Eustace Palmer in the Department of English and Rhetoric and Roxanne Farrar in the Department of Art for reading drafts of this work and for their insightful suggestions. Finally, I am grateful to my wife Elesia, my sons Ezekiel (Zeke) and Wisdom as well as my daughter Faith and the rest of my family for their support, patience, and understanding.

Permissions

1.1 Courtesy of Marc L. Felix, Brussels.

1.2 Object in author's collection; Photo courtesy of Emily Gomez.

1.3 Courtesy of Mathayo B. Ndomondo.

1.4 Author photo.

2.1 Author photo.

2.2 Author photo.

3.1 Courtesy of Mathayo B. Ndomondo.

3.2 Courtesy of Mathayo B. Ndomondo.

3.3 Author photo.

3.4 Author photo.

3.5 Courtesy of Marc L. Felix, Brussels.

3.6 Courtesy of Marc L. Felix, Brussels.

3.7 Courtesy of Mathayo B. Ndomondo.

3.8 Courtesy of Mathayo B. Ndomondo.

3.9 Courtesy of Mathayo B. Ndomondo.

3.10 Courtesy of Mathayo B. Ndomondo.

4.1 Courtesy of Marja Liisa Swantz.

4.2 Courtesy of Marja Liisa Swantz.

4.3 Museum fur Volkerkunde in Munich.

4.4 Verlag Fred Jahn, Munich.

4.5 Courtesy of Marc L. Felix, Brussels.

4.6 Museum fur Volkerkunde in Munich.

4.7 In public domain: Speke (1863).

4.8 Courtesy of Marc L. Felix, Brussels.

4.9 Art Resource, New York (for Museum fur Volkerkunde, Berlin).

5.1 Art Resource, New York (for Museum fur Volkerkunde, Berlin).

5.2 Art Resource, New York (for Museum fur Volkerkunde, Berlin).

5.3 Verlag Fred Jahn, Munich.

5.4 Author photo.

5.5 Courtesy of Marc Felix, Brussels.

5.6 Courtesy of Lloyd Swantz.

5.7 Author photo.

5.8 Courtesy of Marc L. Felix, Brussels.

6.1 Verlag Fred Jahn, Munich.

6.2 Source: Listowel (1965).

6.3 Source: Listowel (1965).

6.4 Oxford University Press (T) Ltd, Dar es Salaam.

CHAPTER 1
INTRODUCTION

A S I WAS PREPARING THIS MANUSCRIPT, I RECALLED MY INITIAL INTEREST
in investigating the art of the Zaramo then in 1993, when teaching
at the University of Dar es Salaam in Tanzania. The tentative topic was
"The History and Development of Zaramo Sculpture." At the time, the
comparatively wide recognition of Makonde sculpture over Zaramo sculpture
spurred me to choose the latter as the subject of my inquiry. In the first place,
in Tanzania Zaramo sculptors were rated as second to the Makonde on the
basis of skill. Secondly, Makonde sculpture and its creators were well known,
even outside Tanzania. For these two reasons, Makonde sculpture was given
more critical attention than Zaramo sculpture. In view of this, my interest to
embark upon this project grew. It occurred to me that to redress what I took
as an imbalance of treatment pertaining to the two traditions and their artists,
I had to undertake a research project on Zaramo sculpture. This would not
only ascertain the validity of the classification of Zaramo sculptors, but more
importantly, Zaramo sculpture would be brought to central focus.

Over the years, however, my concerns with Zaramo sculpture have changed.
I am no longer satisfied with an investigation that is limited to examining and
writing the history of this sculpture, or one that sees its limited recognition
and its importance only when compared with Makonde sculpture. My
interests have now shifted to the larger, in my view, more interesting questions
presented by the dynamic post-independence Tanzanian social and cultural
politics. To find answers to my questions and to develop an understanding of
how Zaramo figurative sculpture was transformed as it went through

modernization, I was compelled to consider the impact of the following: Zaramo multiple ethnic heritage, social norms and cultural patterns including Swahili interactions, the strategic geographical proximity of the Zaramo to Dar es Salaam (the former capital of Tanzania), influences of Islam and Christian missionaries, colonial history, and finally the socio-economic transformation of post-independence Tanzania. These involve examining the ways that art acts as a vehicle for the formation of individual/group identity; how the two entities negotiate each other in the process of social and cultural change. This book then, is about the Zaramo and their figurative wood carving tradition, and it is written as an attempt to not only understand the origins, development, and centrality of this figural wood carving tradition to the Zaramo, but also, the ways the Zaramo have used select sculptural objects to interpret change and continuity in the midst of modernization and social change. Against the background of the carving's beginnings at Konde in Kisarawe District, Tanzania, which attest to the crucial ties between Zaramo social practices and the carved objects that form an integral part of Zaramo life, the book presents the transformations, and reinvention of Zaramo wood sculpture in line with forces of modernization and social change. The book confirms that art represents history, culture and society.

Art Objects and Cultural Practices

The Zaramo have a long and rich history in creating art and employing it in various cultural contexts. Yet their development and use of art objects has not happened in isolation; to be sure, Zaramo art objects represent the combination of several different cultural, religious, and political influences. Especially important to understanding the Zaramo is their use of sculpture. For my purposes, I will explore the Zaramo and their sculpture within the context of post-independence Tanzania, from 1961-1980, and ultimately I will show how Zaramo art objects—both traditional and modern—have acquired a certain multivalence to them. They have undergone a range of metamorphoses over the historical period in question, but rather than weakening their importance and symbolism, these changes have strengthened the sculpture's significance. The emphasis, however, is not on objects per se, but on reception by clearly defined audiences—looking at people and group's interaction with the objects and how this process resulted in style, use, and attitudes.

To aid in this study, it is necessary to provide a brief history of the United Republic of Tanzania, which was created on April 26, 1964, as a result of the union between the People's Republic of Zanzibar and the Republic of Tanganyika. From 1885 onward the latter was known as German East Africa,

but it was named Tanganyika in 1919. Tanganyika had been a German colony for thirty years, but following the defeat of Germany at the end of World War I, it became a League of Nations Mandate. On the inauguration of the United Nations it became a United Nations Trusteeship and was administered by Britain for 45 years until independence on December 9, 1961. This study is delimited to the 1960s-1980s; an important era of social, political, and cultural developments affecting Tanzanians, their cultures, and arts.

Since Tanzania was emerging from a tumultuous period of colonial rule, the 1960s became an era in which to define national priorities and to determine the country's future course. Thus, in the 1960s and the 1970s Tanzania saw dramatic and diverse developments in the social, economic, political, and cultural fields. In addition to the introduction of radical political changes, such as the institution of a one-party state and the development of a socialist society, strong economic growth gave rise to significant social and economic development. For example, the nation invested in social development in the form of health and education. On the down side, the history of Tanzania in the 1980s was marked by social and economic difficulties resulting from a number of factors. These include the economic crisis affecting almost all countries in Africa South of the Sahara, the collapse of the East African Community in 1977, oil price increase in 1973 and 1979, the cost of the Tanzania-Uganda war on Tanzania, Tanzania's reliance on agriculture as the backbone of the national economy—a sector characterized by erratic policies such as Villagization, poor performance in agriculture in the 1980s resulting in declining exports and food shortage, and the International Monetary Fund's prescriptions—stringent fiscal policies of structural adjustment which plagued a large majority of Tanzanians.

On the cultural front, the 1970s in Tanzania was a period of cultural euphoria, cultural invention and redefinition of identity. To cite an example, a popular urban phenomenon of the 1970s was the creation of a new crop of jazz bands; some of these utilized styles of traditional Tanzanian dances. Dar es Salaam city's bands included Nuta, Urafiki, Sunburst, Super Africa, Afro '70, Safari Trippers, and Bar Keys. Nuta's style was *msondo*, Urafiki were famous for their *mchakamchaka*, while Safari Trippers had *sokomoko*. The growth of popular urban music within Tanzanian culture was expected since, in 1962, the government of President Julius Nyerere showed its will to support the arts in forming the first Ministry of National Culture and in creating the National Arts Council through the National Arts Council Act of 1974. Following the Arusha Declaration, in 1967, in which the Party undertook to build socialism,[1] there were movements to shift the orientation of art and culture to cater to the envisaged socialist revolution in Tanzania. The ruling party, Tanganyika

African National Union (TANU), responded to the concerns by directing attention to culture at the village level to conform to socialist values and practices. Needless to say, the Zaramo, who lived in and around Dar es Salaam and in the Coast Region in the Northeastern part of the country, were among those who experienced these developments. Given these historical developments and changes, certain aspects of figurative wood sculpture of the Zaramo were seriously influenced by these processes as were the arts and cultures of other people of Tanzania. For instance, tourism, which the Tanzanian government considered important for earning foreign exchange, thus boosting the national economy, was an important factor in the development and popularity of the Makonde sculptures. Because of economic reasons, many Zaramo artists produced Makonde sculptures for the tourist art market.

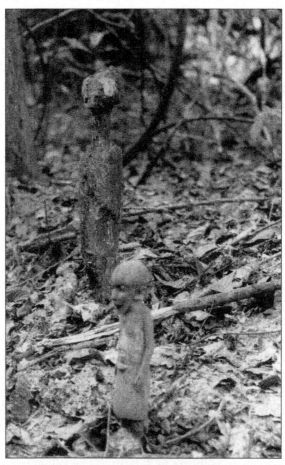

**1.1 A Zaramo grave marker in naturalistic style,
Kisarawe District, 1974**

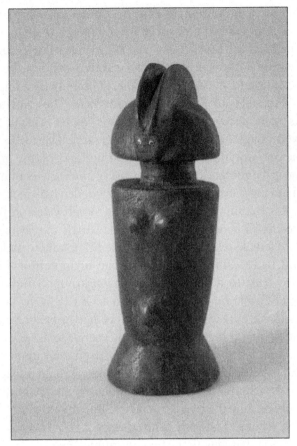

1.2 Zaramo *mwana hiti* trunk figure

However, despite these changes, certain traditional Zaramo arts and cultural forms such as grave markers and *mwali* (initiate) rites adapted slowly to this modernization and change. *Sasa* means "now," the present and *usasa* means of the present, *kisasa* refers to modern, and *fanya kuwa* – a *kisasa* is to modernize; thus, "modernization" here means change in values that reflect the present. Tanzanians say *kwenda na wakati*. But modernization is not from the West only, it is from all over the world. For instance, Tanzanian dress styles have borrowed from the East, and from West and Central Africa. In Tanzania, modernization has positive and negative aspects. The positive aspect includes progression and development whereas the negative is represented by destructive elements like HIV/AIDS which is called *ugonjwa wa kisasa*, a disease of modernity. Thus, for instance, since the *mwali* practice of the

Zaramo is an inherited tradition, its continuation in a modern social context means that it had to reinvent new social meanings to remain relevant.

A visit to the Kisarawe District of Coast Region near Dar es Salaam, which is part of Uzaramo—the country of the Zaramo—shows the richness in culture and tradition of the Zaramo people. On family land one might find several types and styles of Zaramo grave markers. These include wooden sculpted posts (some abstract, others naturalistic [fig.1.1]), plank-like markers with no carved images, crosses, slabs, and ceramic shards. Similarly, at a Zaramo home one would find some Zaramo undergoing the *mwali* rites. A young Zaramo girl undergoes seclusion as part of *mwali* rites of maturity and identity; with her the *mwali*/young girl keeps a wooden figurine called *mwana hiti* (fig.1.2). Restrictions on the custom like ritual seclusion preclude the *mwali* from seeing all people, except for some female members of her natal home and close female relatives. Because this did not allow me to visit with the *mwali* and to see *mwana hiti* in the rite of initiation, I limited my examination to trips to a Zaramo carver's workshop, Salum Ali Chuma. Though I am not a Zaramo and there is no such rite in my family, within cultural purview, there are ways and times of seeing *mwana hiti* and discussing it. But I should point out that my inability to experience the *mwali* during my research has not undermined this work, given that it is an art-historical study and not an anthropological one. By the same token, I could not afford to miss the visits to artist Chuma who Zaramo women regularly commissioned to carve *mwana hiti* because they were crucial for studying *mwana hiti* sculptures. Aside from discussions I had with Zaramo women about the *mwali* rites and *mwana hiti*, Chuma shared with me his communications on Zaramo women. So Chuma's studio on Chang'ombe Road in the Chang'ombe industrial district in Dar es Salaam (fig.1.3) was most conducive to examining stylistic changes.

In addition to grave posts and the *mwana hiti* figure in the Zaramo region, one may notice carved wooden staffs of the Zaramo. For example, staffs such as the *mkomolo* (fig.1.4) may figure at a Zaramo *mwali* ceremony. If witnessing that proves difficult (as it would depend on when Zaramo ceremonies such as puberty initiation, healing, and cleansing rituals are held) a short staff, *kifimbo*, of the type the former President *Mwalimu* (teacher) Nyerere carried around, is readily seen as a part of dressing.

Having noted all these different art objects and cultural practices, the issue before us is: In what ways have these arts and practices (1) contributed to express Zaramo cultural values; (2) undergone change or adaptation; (3) showed relation of stylistic change to accommodate modern Zaramo identity? Considering that the Zaramo have experienced extensive social changes as a

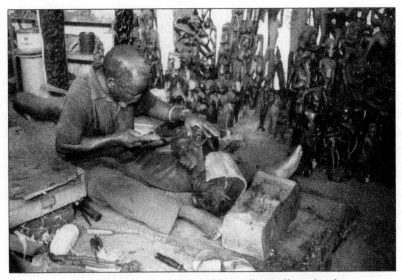

**1.3 Salum Chuma working in his studio on Chang'ombe
Road in Dar es Salaam, 1998**

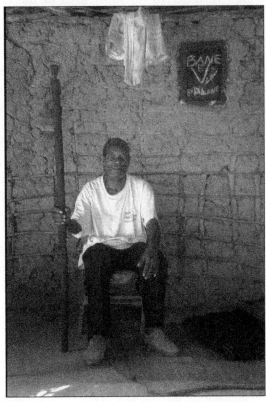

1.4 Ali Bilali "Bane" holding an *mkomolo* staff he made, Maneromango, 2004

result of modern lifestyle, cultural change through education, and religious affiliation, how has their art been affected? Some of the forces of change include Islam, Swahili society and culture, Western cultures, Christianity, colonialism, and post-independence Tanzanian social, political, and cultural developments. The impact of these upon Zaramo cultural production needs to be considered. For instance, how do the Zaramo *mwana hiti* figures compare with those of their neighbors such as Kwere? In the words of Marc Felix,

> I thus conclude that the invention of *mwana hiti* is the Zaramo's main contribution to the history of art in eastern Central Africa.[2]

Needless to say, ascertaining the origins of *mwana hiti* does not deny concerns for style and change and it is not the object of this study.

Aims and Approaches

This book is written in order to fill some gaps in the African data by addressing issues of how three types of figural wood sculpture illustrate some of the social and political effects of modernization on contemporary African art. The work also fills a gap in information concerning Zaramo art as no comprehensive scholarly book presently exists on the subject. Significant scholarly work not devoted to Zaramo art, but nonetheless, rich in information on the Zaramo is the sociological and anthropological studies undertaken by the husband and wife team of Lloyd and Marja-Liisa Swantz in Uzaramo in the 1960s and 1970s. The publications resulting from the couple's research, in particular, L. Swantz's *The Medicine Man among the Zaramo of Dar es Salaam* (1990); M-L. Swantz's *Ritual and Symbol in Transitional Zaramo Society, with Special Reference to Women* (1970) and *Blood, Milk, and Death: Body Symbols and the Power of Regeneration among the Zaramo of Tanzania* (1995) provide us with rich data on the Zaramo, their cultural practices, and social history. A fairly detailed study on art, however, is Marc Felix's *Mwana hiti: Life and Art of the Matrilineal Bantu of Tanzania* (1990). The book focuses on one type of sculpture, *mwana hiti*, produced by the Zaramo and their neighbors such as the Kwere, Doe, Luguru/Kami, and Kutu. The work considers the history, symbolism, and uses of the figurine as well as examining other art objects and the ways other people relate to these art objects. Although Felix's text is a useful reference for understanding some aspects of Zaramo art and culture, it did not specifically study the *mwana hiti* trunk figure, *kifimbo*, or grave posts. In this connection, although these three types of Zaramo sculptural objects have received some anthropological

attention,[3] surprisingly there is no art historically-based analysis that exclusively discusses the influences of modernization on them (such as the influence of Islam, Swahili and Western cultures, Christianity, and Tanzanian socio-political and cultural processes) from 1961 to 1980. The few works that do exist, (except for Felix's detailed study on *mwana hiti*), do not focus on them. These few studies are primarily anthropological, having examined the three objects only as traditional Zaramo sculptures and their link with burgeoning traditional practices.[4] Evidently, given the anthropological method's concern with the ethnographic present, it lacks history and thus, it denies the subject it studies a historical orientation.

Given the part that modernization has played in a variety of changes in Tanzanian societies, cultures, and art traditions, it is important to consider how *mwana hiti* trunk figure, *kifimbo*, and grave posts have fared in the process of historical and political changes. It is especially important to examine the effects of the new socio-cultural values on the initiating values of *mwana hiti* trunk figures, grave markers, and staffs of the Zaramo. The apparent neglect in exploring these Zaramo sculptures and their attendant social formation in order to discover the pattern of their interaction with modernization, does not deny the importance of such a specific, critical assessment. This study differs from others in allowing us to see what the influence of modernization have had on art objects within this realm of social change.

In a general way, this work studies the relationship between art and individual/cultural identity that was affected by social process, tradition, and history. This book does not attempt to be an exhaustive study of how *mwana hiti* trunk figures, grave markers, and staffs express Zaramo identity, nor does it explain the psychological motives of Zaramo artists, their production environments, or the art production process. But it shows the complex relationship between art and a people undergoing a myriad of changes.

To achieve its objective, the study examines changes in form, style, function, and the meaning of *mwana hiti* trunk figures, grave markers, and staffs as the Zaramo responded to a series of public policies and ensuing social changes of the 1961-1980. Societies and art traditions are subject to constant forces that lead to changes in the forms, styles, functions, and meanings of art. Therefore, it becomes historically important to gain a deeper understanding of the ways the arts change, their social implications, and the factors responsible for these changes. A critical assessment of these ways requires an understanding of the cultural context of a work of art; for instance, it is pertinent to know why a *mwana hiti* sculpture and a *kifimbo* were made, so as to understand their form and use, and to gauge social changes and contemporary attitudes to the art. Knowledge of these aspects can explain the significance of particular art

objects in the life of a people at a given historical moment. Similarly, this knowledge reveals the processes that transform objects and alter their relationships with individuals. Accordingly, as the Nigeria-born archaeologist Ekpo Eyo has stated,

> All works of art must speak of social order, must speak of the continuity of society, and must speak of people. They must reflect things around us and they must speak of experiences.[5]

It is in this sense that art is seen as a reflection of society.

When approaching *mwana hiti* trunk figures, grave markers, and staffs, I am not in favor of privileging any of the two most commonly used methods of examining African art: the anthropological approach which considers art and the meanings it embodies within the context of its origins, and the art-historical approach which looks at art away from its context, by itself or comparatively.[6] Rather, I emphasize that while both ways have merits as well as limitations, only a combination of the two can enrich the discussion and our understanding of Zaramo art.

I consider the three chosen art objects individually in different chapters because each was created for a separate purpose in Zaramo society. I raise specific questions about each object, such as: In what ways have the styles of staffs changed when they are used in contexts such as political rallies, ceremonies/festivals, and curing rituals? Or, taking into account the tensions that may exist between tradition and modernity, I explore how the modifications on the *mwali* custom (like the length of the seclusion period, the reduction of the extensive ceremonies associated with the rites, or the use of Kiswahili to translate some of the conceptual ideas in teachings from Kizaramo) have affected the use or forms of *mwana hiti* trunk figures. Finally, the comparison of Zaramo figurative wood grave posts of the second quarter of the twentieth century with those made in the 1980s exhibits a similarity of style that is naturalistic. Is this a continuation of style or are other issues at work? Are these portraits of the dead? What about grave posts topped with generic images that are normally found on the *mwana hiti*? Is this an indication of the gender of the deceased? How do all these innovations and modifications explain modern-living, the impact of Western cultural values, and the Islamic beliefs of the Zaramo? This approach allows us to answer some of the questions specific to a type of sculpture, and raise other pertinent issues that relate to other sculptures. For example, how do the art objects we address continually define and express Zaramo cultural identity given the mélange of cultural elements in Uzaramo? It must be underscored that this approach helps

to explain how the sculptures are carriers of Zaramo cultures in the midst of radical social change.

Problems of Categories and Generalizations

The study of art in Africa and western scholarship is marked by the construction of categories and generalizations, and one needs to be sensitive to their shortcomings[7] lest they undermine the issues we study. As example of broad generalizations in considering Zaramo art, I might mention the 1990 and 1991 studies by Felix and Pelrine respectively. These two studies did not consider the impact of Tanzania's socio-political policies upon the Zaramo art objects under investigation, and lack detailed exegesis on the social utility of some of these objects as reflecting changes in the social contexts in which the objects appear. The implications of not being attentive to what we are examining are wide-ranging. Suffice it to say that lapses of this nature may distort our understanding of the subject we are looking at. The two studies also adhere to the concept of history as unfolding in linear time and follow the linear model for writing such histories. We should not overlook that history can be read and recorded in a variety of ways dependent upon the subject being addressed. Additionally, we should recognize that multiple factors of varying nature such as political, historical, economic, cultural, religious, stylistic, and technological occur at different times and substantively impinge upon cultural products differently. At any rate, my point here is to draw scholarly attention to the magnitude of complications that the two studies looked at and the need to be more focused in order to gain meaningful interpretations of the art under consideration.

The standard Africanist approach to examining African art is not as a living product, but as a moribund sociological artifact. This approach weakens the art's importance and limits its power. It is worth mentioning the connection between subject of interest and research interpretation. In illustration, Felix and Pelrine were at the same time preoccupied with underlying concerns in assessing the impact of change on the art and on Zaramo cultural forms. This may have incidentally intended the studies to encompass today's Zaramo and Tanzanian experience. Whether this was a judicious approach is a difficult question to answer. Clearly, discussing Zaramo art in an unspecified historical frame denies explicit concrete historical and contemporary Zaramo experiences, the process of thematic change, and the effects of both.

Although Felix and Pelrine consider the effects of "tradition" and, by implication, the impact of "modernization" on Zaramo art and culture, however, both their works lack a concrete historical framework of analysis concerning these two categories. For instance, they do not examine the social

and economic impact of the *ujamaa* program on Zaramo art or Tanzanian government policy on culture. *Ujamaa* (familyhood), which Nyerere interpreted as African Socialism, was adopted in Tanzania in 1967 for building a socialist society. Nyerere's policy of *ujamaa* was based on four principles: Socialism as a belief, a rejection of the exploitation of man by man, major means of production and exchange in the nation be controlled and owned by the peasants and workers, and the existence of democracy. Since the social and economic policies of *ujamaa* transformed the Tanzanian society quite extensively, a study of contemporary Zaramo arts that ignores the impact of *ujamaa* upon these arts under-serves them. Since the term "traditional" has often been misconstrued and treated to mean ahistorical and unchanging, its meaning for Felix and Pelrine should be clearly spelled out. These two analyses exhibit the common tendency whereby "tradition" and "modernization" become oversimplified categories. These concepts require reexamination to question assumptions about them, to provide their precise definition, and to establish their parameters and roles in the issues we study. For example, the Zaramo use indigenous art objects such as *mwana hiti* in a modern social context thus, blurring the boundaries of these two categories. A thorough review of these concepts would put all analyses in interpretive frames of modern Tanzanian life and eliminate conflicting epistemological assumptions that have undermined critical consideration, reconstruction, and understanding of African art traditions and their histories. Insights from scholars such as Olabiyi Yai, Nkiru Nzegwu, and Ngugi wa Thiong'o help in broadening the understanding of the two concepts and opening up avenues of fresh inquiry.[8] We would be on better intellectual turf to combat unfortunate stereotyping if we continually review and sharpen our methodological tools of analysis.

The Western world perceived "modernity" as its sole domain. It also perceived it as a designation of a Eurocentric history, but that history can no longer sustain its illegitimate notion of pristinity. Ngugi wa Thiong'o insightfully challenges the assumed center of the world as being in the West.[9] He argues that there is not just one center for viewing the world, but that people of a different culture and environment have their own center. In recognizing that modernity is a societal phenomenon that happens everywhere, varies from nation to nation and that its global presence predates the advent of Europe's colonization of Africa,[10] we become free from the Eurocentric model of historical exegesis that robs Africans of agency. This model denies agency to Africans in the construction of their own histories.

Salah Hassan argues that the origin of the dichotomy concerning notions such as "traditions" and "authentic" is linked with Africa's unique history—

given the continent's tragic episodes of slavery and colonialism.[11] Following Valentin Mudimbe,[12]

Hassan submits that the colonial structure is responsible for a dichotomizing system with many paradigmatic oppositions such as oral versus written and printed, and traditional versus modern. But the understanding that modernity is a societal process that happens everywhere and its global emergence occurred before Europe colonized Africa, poignantly renders Hassan's claim that

> "'modernity' itself is a European construct that was articulated initially and most forcefully at the same time 'traditional' Africa was being colonized"

as baseless.[13] Also, it advocates and reveals "modernity" as a hegemonic Eurocentric device deployed to further European artistic vision and wrongfully categorize African art traditions in order to elide their histories. Furthermore, the recognition enables us to divert our attention from what Nkiru Nzegwu calls the misleading view of "modernity" as progressive and developing towards the West, and of seeing "traditional" as static, unchanging, and the African.[14] Utilizing Nzegwu's scheme, we can understand the vitality of "traditional" African arts and see that they embody historicity; hence, they are anything but ahistorical, static, and unchanging. They too are modern. It is imperative that consideration is given to the concerns of African artists as modern artists. Once that is done, designations labeling traditional creations as "survivals of the past" would have no ground. To be sure, traditional forms of art are still being created in both the urban and rural parts of Africa, as Zaramo wood sculpture, for one, attests.

Recent studies by African scholars present a more dynamic reading of the concept of tradition. One example of the contiguity of tradition and the modern is best seen among the Yoruba. Olabiyi Yai succinctly explains that in Yoruba culture,

> to a large extent the tradition/creativity binary opposition is neutralized. 'Tradition' in Yoruba is *asa*. Innovation is implied in the Yoruba idea of tradition. The verb *sa*, from which the noun *asa* is derived, means to select, choose, discriminate, or discern. *Sa* and *tan* are semantically cognate. Hence *asa* and *itan* are inextricably related. Something cannot qualify as *asa* which has not been the result of deliberate choice (*sa*) based on discernment and awareness of historical practices and processes (*itan*) by individual or collective *ori*.[15]

So, Yoruba artists say, "Our tradition is very modern" because "*asa* is both the 'traditional' and the 'modern.'"[16]

I will not argue for concrete parallels between the Zaramo creative approach and the Yoruba theoretical framework for analyzing Yoruba artistic expression. But Yai's explanation does provide insight for understanding the conception of reality in the Zaramo case and in Tanzanian society—in both, tradition and modern exist side-by-side in the social order. Tanzanians' notion of tradition involves change and contemporaneity. Tanzanians usually perceive the modern or matters related to it as in a passing phase. Time becomes the evaluative device for testing their stand. The Zaramo's continuous use of *mwana hiti* figurines and their taking custody of the *mwana hiti* sculpture for over forty years concretely illustrates this notion of tradition as involving change and contemporaneity. A Zaramo family only commissions a carver to make another *mwana hiti* when one is lost. Some Zaramo hold that since the *mwana hiti* figurine is part of their *mila* (tradition), the figure does not change even though the social context of its practice is changing. In a very concrete way, *mwana hiti* resolves the schism between tradition and contemporaneity by functioning as an instrument for taking custody of the modern. Therefore, modern practices are acculturated and become tradition. And the practice in which *mwana hiti* appears is still relatively strong. This shows that the Zaramo too override the schism between tradition and modernity. In short, traditions are both old and new.

African scholars well equipped with critical art theory informed by a particular art production milieu and that society's history—the artist's culture, politics, aesthetic concerns, techniques of representation and interpretation as well as the role of gender in art, and the complex interrelationship between art and identity, are making significant contribution to the history and study of contemporary African arts. This approach provides a rich text that enables us reach a deeper understanding of the cultures and histories of the peoples producing these arts, and about possible meanings of African arts not least, the relationship between culture, society, and art making. It is in this context that this book has been written, and the work is organized as follows.

Plan of the Book

Chapter 2 offers a detailed account of cultural appropriations that have contributed to shape the Zaramo objects under investigation. And since the Zaramo are Tanzanians, this account of cultural appropriations is essential in gauging the processes of change in Zaramo society and Tanzania society at large as well as the impact of these influences on art. These major influences

are: The German and British colonial histories and cultural influences on Tanzania and Zaramo art; the impact of Christian missionaries on Zaramo social values, Zaramo identity, and art; the influence of Islamic and Swahili culture on the artistic production of the Zaramo; and the effects of the socio-political transformations of the post- independence Tanzanian society on social values, cultural institutions, cultural identity, and art. The chapter maintains that these changes and historical forces have considerably transformed Zaramo society and contributed to shaping Zaramo art and identity.

Chapter 3 discusses the cultural, artistic, and other social influences on the Zaramo artist to shed more light on the objects under investigation and related issues. In this sense, I rewrite the history of Zaramo carving and show the nature of missionary relationship with the Zaramo carvers in style and theme. Furthermore, I expose the effects of tourist taste on style, themes, and color of wood, which explains the ways patronage and the art market have transformed Zaramo figural sculpture.

Chapter 4 concentrates on the role of *mwali* puberty rites for girls in Zaramo culture, and on how these rites express Zaramo identity, and on the significance of *mwana hiti* figurines in the rites. The chapter addresses critical issues of gender construction and gender socialization. It discusses the ways *mwana hiti* acts as a tool for defining Zaramo women and how the *mwali* rite helps place them in society. This also serves to explain the ways *mwana hiti* resolves the modernity/tradition schism and is seen as one sculpture that defines Zaramo cultural identity right in the largest center of modernity in the country. In recognizing the complexity of social life, the chapter argues that although social changes like Islam, Swahili culture, Christianity, the politics of cultural change, education, and progress have had effects on both *mwana hiti* and the *mwali* practice, the traditions that are rooted in Zaramo culture continue.

Even as continuity is noted in the midst of modernity, negative features of modernity on art are also noted. Chapter 5 extensively documents the adverse effects of the modernizing scheme of Villagization on wooden figurative grave posts of the Zaramo since the Zaramo's conception of space and culture changed. The way political change influences art production raises questions on the specificity of the re-use of tradition when politics intervene and contest the enduring nature of traditions. The chapter examines the tenets of *ujamaa* and argues that *ujamaa* was inimical to the flourishing of grave posts. In this connection, stereotypical analyses that blamed Islam have misread the societal and cultural process between 1967-1976.

Chapter 6 considers the transformation of the old into new forms; it offers a relevant account of the changes in social positions and uses of two types of staffs: kome, a prestige walking stick, and two short staffs—Zaramo's *mganga* staff, and one popularly known as *kifimbo* in Kiswahili. The emphasis of the chapter is on staffs as expression of dress codes and authority objects as it engages the transformation of traditional forms into contemporary symbols of new elders. Included in the analysis are social factors like Western norms and values, various dressing patterns, Tanzanian national politics, and other effects of modernity that have affected the contexts where staffs appear. For example, while the *mganga* staff continues to appear in Zaramo curing rituals, *kifimbo* is used in a modified form by political leaders to construct political authority.

Finally, in concluding, I examine the implications of my analysis for studying African art in general, and Tanzanian art in particular, covering the position and significance of *mwana hiti* trunk figures, grave markers, and staffs. By reflecting on the major issues and conclusions found in the preceding chapters, and after ascertaining the findings of the study, I offer broader conclusions concerning the influences of modernization on Zaramo figurative sculpture.

CHAPTER 2

CULTURAL INFLUENCES
ON THE ZARAMO

O F THE NUMEROUS TANZANIAN CULTURAL INFLUENCES ON ZARAMO identity, I dwell only on dominant influences from 1961 to 1980, beginning with the year Tanganyika achieved independence and ending closer to the time when ujamaa policies were abandoned in favor of open market policies.[1] Needless to say, this period of inquiry has social and historical significance. It was an important period of socio-political experimentation to accelerate economic prospects and prosperity. Under the leadership of Mwalimu Nyerere, in 1967 the state undertook a variety of measures and policy reforms geared toward transforming the Tanzanian society. Its goal was to socially, politically, economically, and culturally and artistically transform Tanzania in the aftermath of colonization, a process that radically changed the country. It affected the way many Tanzanians thought about themselves and the different statuses, responsibilities, and positions they occupied in society.

Socio-Political Transformations in Tanzania

At independence, Tanzania was comprised of a complex variety of diverse and divergent groups. Between 1961 and the Arusha Declaration of 1967, we will see the major developments which affected Tanzanians and thus influenced Zaramo identity. The historic achievement of independence was a major political landmark for all Tanzanians. But apparently, independence had meaning to Tanzanians only when a nation was formed and this affected only

a fragment of the population. Most of the population considered themselves members of some group, not as Tanzanians.

The first President of the United Republic of Tanzania, Julius Nyerere, and his lieutenants, faced a formidable challenge of managing diversities and differences in a multicultural country. Tanzanian sociologist Cuthbert Omari identifies major diversities: ethnic diversities, given more than 120 major ethnic groups identified culturally; racial differences, since apart from the indigenous African majority there are White Tanzanians, Asian Tanzanians, Arab Tanzanians, and a few from the Orient; three different religions, Christianity, Islam, and traditional; climatic differences which have led to unequal economic development; and finally, development of two different economic systems, both based primarily on agriculture and animal husbandry.[2]

After independence, Nyerere's overriding concern was the development of the people in the country. As a committed socialist, he saw that this achievement would depend on national unity. Even as Nyerere focused on raising the living standards of Tanzanians—fighting poverty, disease, and illiteracy on the bedrock of a stable economy—building a unified nation was the cardinal political goal. Since the colonial regime thrived on maintaining and fostering "ethnic" differences and the British did not develop a nation state in Tanganyika, Nyerere wanted to unify the country—rid it of the ethnic divisions and tensions created by colonialism. National efforts were expended to restructure political, administrative, and social institutions in line with these ideals. The efforts of this nation state ideals ran head-on into ethnic loyalty and identification. The state's objective was to eradicate ethnic political systems, for instance, the abolition of chieftaincy as a salaried administrative office, and the discouraging of divisive regional and ethnic elements. For example, ethnic loyalty was discouraged and national identification encouraged. The redefinition and assertion of national or Tanzanian identity over other forms of identities—ethnic, racial, religious and so forth—also became apparent. In this process, the *kifimbo* became a transnational symbol since it was used by politicians and army officers. It became emblematic of the movement toward Tanzanian nationalism.

The business of unification entailed making political and social decisions. First, Kiswahili became the national language of Tanzania shortly after independence and was accorded prominence over ethnic languages. In Tanzania, Kiswahili is a *lingua franca* even as it is historically the language of the people known as the Swahili, the "People of the Coast," who live on the coast of Eastern Africa and on the adjacent islands. The strength of Tanganyika African National Union (TANU) under Nyerere's leadership during the

struggle for independence in the 1950s up to 1961 and the ultimate status of TANU as a nationalist party, is partly attributed to an understanding of Kiswahili across the country. Kiswahili carried Nyerere's political message with relative ease to most parts of the country. These developments, therefore, contributed significantly to the adoption of Kiswahili as Tanzania's national language. It was used in government institutions, interethnic communication, and as a medium of instruction at the primary level of education. The net result was that Kiswahili and its culture played a major role not only in socializing Tanzanians and spreading modernization across the country, but in unifying Tanzania. A year after independence, Nyerere formed the first Ministry of National Culture and Youth, which he charged with developing a national culture. The ministry was mandated "to seek out the best of the traditions and customs of all our tribes and make them a part of our national culture."[3] This national culture would replace ethnic cultures in the country. Using political platforms among other media, Tanganyika African National Union (TANU) and its government exhorted Tanzanians to see themselves as Tanzanians instead of belonging to just their ethnic groups.[4] Therefore, the *mwali* rite and *mwana hiti* now became Zaramo/Tanzanian practice because the Zaramo were increasingly now seeing themselves as Tanzanians, not just as Zaramo. The abolishment of chieftaincy in 1963 that had served to maintain social distinction paved the way for a national government under the single party system in 1965. Nyerere saw that having one party identified with the nation was a considerably viable tool for forming a national consciousness and democracy, and national unity would be threatened by the multiparty system which would represent multi-communities. This move, coupled with the construction of a national culture, led to the breakdown of traditional political and cultural forms connected with these institutions. Nevertheless, cultural and art objects survived and mapped new meanings. Due to this disruption, some art forms had their meaning transformed. For example, *kome* staffs of the Zaramo were affected. Their uses changed since the position of headman was no longer in place. Many traditional dances were taken out of their traditional and ethnic cultural contexts and placed on a national level. There they were used by the government to further political objectives, such as entertaining foreign dignitaries at state functions. In this way, art had become de-ethnicized and co-opted by the government.

In addition to all these developments, dramatic changes came with another major political landmark—the Arusha declaration of 1967. The socio-economic structure of the post-1967 period was characterized by a variety of policies contained in the Arusha Declaration. Through this policy document, Tanganyika African National Union (TANU) and later Chama Cha Mapinduzi

(CCM) envisaged the creation of an egalitarian socialist society by eradicating poverty, exploitation, and inequality. Though once again this socialist economic system replaced ethnic socio-economic structures, the general evaluation is that *ujamaa* was a failure partly because Nyerere's *ujamaa* philosophy was based on "belief"—an attitude of mind, and on the traditional African society. For Nyerere,

> 'Ujamaa', then, or 'familyhood', describes our socialism. It is opposed to capitalism, which seeks to build a happy society on the basis of the exploitation of man by man; and it is equally opposed to doctrinaire socialism which seeks to build its happy society on a philosophy of inevitable conflict between man and man.5

Suffice it to say that the process of socialist (Tanzanian one) transformation did not happen alongside the transformation of the whole economy because the *ujamaa* theory is weak. It does not emanate from a concrete analysis of society. In any case, during this period of Tanzania's social and cultural transformation, art symbols that survived and were utilized include the *kifimbo* which Nyerere carried.

The problem of *ujamaa* is seen in the implementation of rural development policies like the Villagization policy, which necessitated resettlement of many villages in rural Tanzania. The Villagization program was implemented under the government policy of Socialism and Rural Development. Considering Nyerere's major concern as political leader—the well-being of Tanzanians, and since a large majority of these people lived in the countryside, rural development was seen as the focal point of development in the country. The intention was to form *ujamaa* villages in large proportions of the rural sector. Villagization brought people living in scattered homes to settle in government-planned villages. Although under the Villages and *Ujamaa* Villages Act of 1975 the resettlement scheme created thousands of new villages, it was coercively imposed upon a large majority of villagers without considering their interests or participation in the planning and implementation stages. To cite an example, M-L. Swantz in her 1995 work points out that in some areas of Kisarawe District it was unnecessary to relocate the people because they "were already living close together" prior to Villagization.[6] It is estimated that by mid-1976 "almost 90 per cent of all Tanzanians were settled in *ujamaa* villages."[7] Because Uzaramo was also part of this massive government campaign aimed at improving the living conditions of the people in the rural areas, social disruptions occurred as the government sought to create permanent villages closer to basic social services such as schools, dispensaries,

and clean water supply. As noted, central to the program was rural development, which would now receive impetus through organized agricultural production since agriculture was the mainstay of the national economy. In addition from effects on the economic production of villagers as some were resettled on drier and infertile land, major concern here is on certain cultural and social effects associated with Villagization. Oral and documented accounts of the program suggest that a number of cultural beliefs and practices entrenched in the lives of Tanzanians were severely eroded as villagers were, in some cases, forcibly moved from their permanent villages to new ones set up by the government. Beliefs centering on funerary rites, sometimes called "cult of ancestors," and the transformation of grave markers are a case in point. Some entirely died out, while others survived with transformed meaning.

Social and Cultural Mix in Uzaramo

Post-independent and cultural developments are not the only influences on Zaramo. The historical, cultural environment of Uzaramo—living patterns and political institutions—have also affected the Zaramo. The geographical area occupied by the Zaramo, which includes Dar es Salaam, the largest city in Tanzania, has historical and social significance to these people, too. In about 1865, Dar es Salaam was founded by the Arab Sultan of Zanzibar, Majid, after buying land with money and cloth from two Zaramo families, the Mwinyigogo and Madenge of present-day Gerezani and Mtoni respectively, who were the original owners.[8] Majid's decision to build a new city at Dar es Salaam as his alternative headquarters to Zanzibar was necessitated by increasing British interference into the affairs of his empire and the greater suitability of Dar es Salaam to serve primarily as a port for the inland slave trade.[9] Thus, the Zaramo not only perceive themselves as the indigenous people of the coastal strip where they live but they even believe they are "the original inhabitants" of Dar es Salaam.[10]

A short background history of the Zaramo is in order here. Oral history, cultural patterns, and linguistic ties indicate that the Zaramo originate further inland in the areas now known as Uluguru and Ukutu in East-Central Tanzania. The Zaramo appear to have been communities which migrated from the Luguru and Kutu probably at the turn of the eighteenth century or at the beginning of the nineteenth century considering that at least by 1857 when Richard Burton passed through the Zaramo area, the Zaramo had already occupied it.[11] Although the early history of the Luguru is colored by uncertainty, oral tradition claims that the Luguru were not a single ethnic

group, but "the product of the migration and assimilation" of families from the Southwest and East, which have been traced far back for about 300 years in their present area of Uluguru in Morogoro Region.[12] It appears that as the segmented Luguru society expanded as need for more land arose, the Luguru moved from the mountains onto the plains, forming the Kutu. Oral tradition relates that this Luguru offshoot (Kutu), moved further East and settled. The Kutu, led by their reputed leader and elephant hunter, Pazi Kilama or Kibamanduka/Kibwemanduka, allied with the Doe to drive out the Kamba from Kenya who were hunting and slave raiding in the coastal areas between Bagamoyo and Dar es Salaam. Pazi Kilama's fight with the Kamba was triggered by a call for help from the Shomvi, who lived in these coastal areas. Previous Shomvi campaigns against the Kamba were unsuccessful. In the wake of the routing, a large majority of the Kamba fled back to Kenya. Some of the inland people who had come to the coast to help the coastal people decided to settle near the coast; formed the people called Zaramo, also Zaramu, *kuzalama* or *kuzama* ("to go down" or "have sunk").[13] *Kuzalama* as referring to the Zaramo means "settlers" in the land they acquired near the coast after moving from their previous homeland further inland. The Zaramo thereafter received a yearly tributary payment called *kanda la Pazi* or *hongo la Pazi* from the coastal people for coming to their aid. The foregoing gives a strong indication that the Zaramo originate from the Luguru by way of the Kutu.[14] As Dar es Salaam grew, many Zaramo went to live there and most did not sever ties with rural Uzaramo. For example, many of the Zaramo urban dwellers have pieces of land in the rural areas, they travel back and forth as occasion warranted. Because of this new residential pattern, in 1938, the Wazaramo Union was founded to foster links between urban and rural Uzaramo. The Union bought two trucks for transportation of passengers and agricultural produce between Dar es Salaam and the villages.[15] The truck business was still strong by the 1980s, suggesting that despite some Zaramo being city dwellers, they still had great concern for the advancement of their rural areas. What is important to this book is that the Zaramo took advantage of the Dar es Salaam urban space and the coast to settle, pursue a variety of jobs, and even to trade, as some early travelers noted in the nineteenth century.

Dar es Salaam became both the colonial and post-independent state capital. The city is now well known for its deep-sea harbor and other aspects of commercial, political, and social life. Because of this, it has led to more cosmopolitan life, featuring cultural and social interactions with Arabia, the Persian Gulf, India, Germany, Britain, Zambia, Zimbabwe, Malawi, Mozambique, Kenya, Uganda, Rwanda, Burundi, and Democratic Republic of the Congo, to name a few. This interaction also includes neighboring people

to the Zaramo—the Luguru and Kutu, from whom, as previously stated, the Zaramo are said to have descended, and the Swahili (who are also related to the Zaramo), Kwere, and other inland people of Tanzania. Colonial rulers sharply defined these groups seemingly with the view to distinguish one group from another to facilitate taxation and rule, but group boundaries and assimilation in this geographical area were far from rigid. In this sense, we should note that the long history of cultural intermingling in Eastern Tanzania makes it highly unlikely that the Zaramo, Luguru, Kutu, and Kwere were discrete units with fine distinctions of art, language, and other elements of cultural identity. For instance, there is evidence of typological and stylistic resemblance pertaining to certain sculptural objects produced by these four groups. This intermingling not only involved the four groups mentioned, but also the Ndengereko, Doe, Sagara, Vidunda, Kaguru, Ngulu, and Zigua. It is noteworthy that the Zaramo readily accepted other groups who moved into Uzaramo through social ties such as marriage, and identified themselves as Zaramo. That is, they accepted Zaramo social and cultural elements. The Swahili are closely related to the Zaramo as evident in the Zaramo adoption of Kiswahili as their main language and their affiliation with Islam. Clearly, the geographical location of Uzaramo facilitated contacts between the Zaramo and other cultures, and has made the Zaramo an advanced, even cosmopolitan group.

Swahili and Islamic Influences

As Uzaramo includes the Swahili culture on the coast, I will look at the social history of the Swahili. And as the Zaramo adopted an Islamic way of life, I will consider the history of Islam with the Zaramo. Concerning Swahili culture, this is not an archaeology of the Swahili, given the extended scholarly debate particularly on who they are. For the purposes of this work they are a group living in Uzaramo, but they have shared important social and cultural interactions with the Zaramo.

There has been no consensus on who the "Swahili" are. A growing body of literature has focused on Swahili origins, history, society, culture, and identity, but surprisingly, the question remains unanswered. I argue that, in part, the issue of who the Swahili are is complex. The name "Swahili," meaning the Swahili people, is an elusive name tag often laden with social and political overtones. For example, Ahmed Salim states that a "Swahili person is one who has inherited or adopted Swahili culture."[16] Since I speak Kiswahili, am I a Swahili person? If we adopt Salim's definition, I am Swahili. Yet Salim also states that Swahili

is not a tribe but a generic or umbrella term covering a wide spectrum of identifiable groups that are not linked by any common descent or lineage—the ukoo.[17]

However, Alamin Mazrui and Ibrahim Shariff make a strong argument for the recognition of the Swahili people as a *kabila*, meaning "tribe"/ethnic group and assert that they are.[18] Now, regarding *ukoo* in Swahili identity, although I have adopted Swahili culture, I belong to another ethnic group and I have an *ukoo*. Thus, regarding descent, I am not connected with the Swahili. In Tanzania a Swahili person has often been perceived socially as a cheat! For example, it is not uncommon to hear the expression, *Mswahili yule!* (He or she is a Swahili, so watch out!). But what is surprising here is that the person in question may not belong to the Swahili group. The Swahili and the Zaramo shift their identity at different times. This fluidity is seen in Uzaramo and in the literature. However, the Zaramo assert their identity in Kizaramo and in their rituals. So once some of these aspects are considered, the elasticity of Swahili consciousness becomes very clear. Regarding scholarship on the Swahili, however, the value of the recent sociological works lies on the rigorous reconstruction of Swahili history centered on a relentless reviewing and critiquing of earlier documents and methods employed in writing this history.[19]

The Swahili are best defined by a shared coastal culture and history rather than by ethnicity. In many respects they lack ethnic affiliations, perceiving themselves as a cultural whole rather than racial separatists. Like the Swahili, the majority of the Zaramo follow Islam of the Shafi'i rite. Now, in the continuing debate of who the Swahili are, one of the markers set for Swahili identity has been Islam, a controversial marker even among the Swahili people. For instance, Mazrui and Shariff cite Ali Mazrui, A. S. Nabhany, and M. Kamal Khan at the opposite ends of the matter. They (Mazrui and Shariff) seem to take a middle position. Whereas for Ali Mazrui, Islam is an accompanying characteristic of a Swahili, Nabhany and Khan hold that it is not necessary to be a Muslim to gain membership in Swahili nationality. Mazrui and Shariff argue that the issue is not Islam as a faith that counts for Swahili identity but "Islam as a grid of cultural practices." Swahili of non-Muslim affiliation follow Swahili-Islamic cultural practices in life, with the exception of worship.[20] Even so, it will be beneficial to see Islamic elements in the religious, social, and cultural consciousness of the Swahili and the Zaramo.

The Zaramo may be said to have "become more fully Islamized only in this century," but because of the distinct and dominant Swahili culture from 1600 to 1800 in East African coastal towns and villages, Western visitors took Islam

to be well established.[21] The visitors' impression that Islam was well established on the Swahili coast or "Swahili corridor," that stretched from the Somali coast to the present-day Mozambique coast, was underpinned by the fact that from the eleventh century onward the "corridor" has been part of the Islamic world. But the entire population of this coast were not all practicing Muslims. The Swahili coast appears to have evolved a culture whose well-springs were mostly local cultural situations and not Islam. In illustration, Thomas Spear in his 1984 paper writes that Kiswahili is a Bantu language in its grammatical structure as well as in the majority of its vocabulary—closely connected to the Pokomo and Mijikenda languages spoken on the Kenya coast, and its literature reflects the African oral form. Furthermore, Swahili stone architecture developed locally and has no stylistic analogs with Arabia or Persia, and

the Islam of the coast bears strong traces of historical African religions in the prominence of beliefs in spirits and spirit possession, ancestor veneration, witchcraft, and sorcery, all of which have been maintained by a local oral tradition of Islam that has coexisted with the more orthodox written legal tradition.[22]

So, it seems that representations of Muslim culture on the Swahili coast were overstated. The representations are far removed from

being primarily a wholesale adoption of Muslim modes of practice and ways of living imagined in their former Arab or 'Shirazi' settings.[23]

Developments in the nineteenth century created conditions that invigorated the spread of Islam in East Africa. Particularly significant were the establishment of the Busaidy Sultanate of Zanzibar in 1832 coupled with the penetration of colonial influence,[24] the German's use of Muslims in the colonial government's service, and the spread of Kiswahili as a *lingua franca*. In the pre-colonial period, however, Islam did not extend widely in the interior of the country, but this changed during the colonial period. The Germans adopted Kiswahili as the language of communication in the colonial administration and in schools. Also employed in this government service were *akidas* from the coast and people literate in Arabic. Adopting an Islamic way of life or becoming a Muslim in the rural areas was a way of entering the elite. For Muslims were seen as people with new ideas and were sometimes associated with coastal civilization. For instance, in 1967 and 1968, the Zaramo and Kwere informed M-L. Swantz that they understood the Germans' plan to

make Islam the recognized religion of the coast after the Germans adopted Islamic law as the popular law for the area.[25] As M-L. Swantz also reveals, the Germans positioned themselves to "exploit Islam as a religion well suited to the African way of life" in East Africa because, compared to the culture of the indigenous people, Islam seemed to offer a "more civilized culture." However, in the twentieth century following the British administration of Tanganyika (1919-1961), and in the post-independence period, Islam lost ground and Muslims did not increase or consolidate their numbers as they had during the German era. This was primarily due to the expansion of European-type education during the British Mandate and the marginalization of traditional Islamic education. This turn of events led to the appeal of Western civilization and influences for most Tanzanians, as exemplified in the dissemination of new values through modern education. Given this background history, it would therefore be incorrect to generalize that Islam had a long history with Zaramo society.

The Sunni Islam introduced on the Swahili coast, and the manner in which the Zaramo and the Swahili received it highlight its flexible, adaptive, and assimilative character. For the Zaramo, the Sunni tenets show their flexibility in dealing with change and modernizing elements and also the accommodative strength of Zaramo traditions in the face of very different religious and cultural norms and conventions. Writing in 1970, Lloyd Swantz highlights the adaptive strength of the Zaramo and their culture. He submits that, "The majority of the Zaramo are practicing Muslims who at the same time follow traditional Zaramo beliefs and practices."[26] M-L. Swantz notes that although the Zaramo quickly and widely followed Islam, its accommodative stance has brought disruptive forces into Zaramo society like beliefs in powerful *majini* (spirits) and changes in the status of women and the legal system. But even with these Islamic changes, the overall picture shows that Islam neither totally undermined the cohesiveness of the kinship-based society nor swept away Zaramo traditional ways. Perhaps this was because the "symbolism of Islam fit into the dynamic and organic nature of the Zaramo society," which may have, in the process, led Islam to protect rather than destroy these traditional practices.[27]

In a discussion of the relationship between Islam and Kwere sculpture, John Wembah-Rashid argues that

> for a large part of the east coast of Tanzania, Islam did not come with missionary militarism and a concise doctrine, rather as a way of life, part of the Arab culture which infiltrated with Arab commercialism. The Kwere and their neighbors accommodated

some of the Islamic and Arab culture within their own without losing much from either. Most Arabs, Moslems included, wear talismans and believe in their power even today.[28]

In this way, we can see the Zaramo ability to absorb Islamic ways while maintaining their own traditions and identity.

We might generally see the evolution of Swahili culture in this way: local cultures along the East African coast incorporated Arab and Islamic elements to form a unique culture, and vice versa. Obviously Islam shaped the religious and commercial life of the Swahili communities, but as Rene Bravmann has seen, the African component within Swahili life has always been prominent. For example, the African element found its expression in the Kiswahili language and in the form and style of Swahili stone architecture that "developed out of local mud and wattle traditions."[29] And Swahili beliefs incorporated African notions on ancestors, spirit possession, and witchcraft and coexist everywhere with Islam. Moreover, as Middleton noted in 1992,

> All Swahili, including those who are devout Muslims and learned
> in the Koran, accept the powers of many localized spirits that can
> be contacted by specialists.

For this reason, he asserts that it is misleading to make a distinction between "core" and "peripheral" elements when referring to more orthodox and less orthodox elements of Islam, respectively.[30] So, a dialectical relationship exists between Swahili and local East African cultures, and the local influenced the Arab element.

In a context characterized by such social and cultural overlap, we can see why the Zaramo have drawn from Swahili culture and Islam. This cultural pattern explains why at times the Zaramo claim Muslim and Swahili identity. The Zaramo conferring Swahili identity on themselves could most likely be explained by the Zaramo's utilization of Kiswahili as their main language and their use of Swahili dress, houses, and customs. Indeed, a large number of the Zaramo are Muslim. Considering that the Zaramo make these choices, this fluidity or plurality of their consciousness has social meaning.

The Zaramo may also be identified as coastal people simply because they live on the coast. With respect to social and cultural boundaries, by the 1980s those of the Zaramo were said to be open and the Zaramo could not close them. For Swahili society, Middleton states that these borders are not clearly defined, given the ambiguity inherent in Swahili identity, complex origins, and history.

2.1 Cheusi Abdallah wearing *kanga*, Bunju, Dar es Salaam, 2005

The Zaramo consciousness becomes fluid primarily because of shifting perceptions about them and the socio-cultural situations they face. To cite an example, Salome Mjema (a Zaramo woman) does not think that there is a clear-cut boundary; if one exists at all, it is between Zaramo and Swahili culture because the Zaramo have adopted some things which have nothing to do with being a Zaramo but are typical of being a Swahili:

These include, for instance, the kind of dressing especially for women such as wearing of *kanga, ushungi, buibui, heena*. Men also don *vikoi, msuli, kanzu*. Many people associate this way of dressing

with religion such as Islam, but in reality even Christians dress in the same manner. My own grandmother used to go to the church service on Sundays wearing her best clothes but covering herself with a *buibui*.[31]

Kanga (fig.2.1) are cotton factory-made printed fabrics with borders on the four sides. These cloths are worn in pairs by women in East Africa, but mostly by women of the coast. *Ushungi* is a way of veiled dressing, in which a garment is draped and tucked to cover the upper part of a woman including the head. It may wholly or partially cover the face, depending upon the wearer. Women on the East African coast wear it over other garments. *Baibui* (*buibui*) is a long, black cloth that women wear. It covers the body from the head to the feet. *Heena* is a cosmetic used by women especially on the East African coast. It is applied to the feet (may include the soles) and on hands. *Vikoi* (sing., *kikoi*), *msuli*, also *shuka* as well as *kitambi* are loincloths worn by men of the coast, Swahili men and Muslim men. These men also don *kanzu* (a long gown) over trousers and shirt. A woman's dress is sometimes called *kanzu*. Clearly identity is both relative and dynamic, acquiring differing forms as a result of differing groups' interests as well as differing time, social, political, and economic conditions.[32] The location of Uzaramo, coastal culture, and Swahili society have contributed to Zaramo culture. Complicating this mix are the influences of colonial history, colonial culture, and Christian missionaries.

Colonial Process and Christian Missionaries

The colonial process had a strong bearing on the physical, material, human, and spiritual dimensions of Tanzanian identity. In comparing the colonial influence on the Zaramo with the rest of the country, Pelrine writes that,

> In spite of the Zaramo's proximity to the center of colonial power (Dar es Salaam), the colonial administrations of the Germans and later the British do not seem to have had an extraordinary effect on the Zaramo beyond that which it exerted on Tanganyika as a whole.[33]

Although Pelrine does not elaborate, she implies a limited colonial effect over the entire period of colonial rule. But there were two different colonial systems that differed in ruling the country. For example, the Germans used Muslim elites to serve their interests, but later the British did not recognize Muslim schools. Such colonial maneuvers show how the colonial process affected the

Zaramo and other Tanzanian people. It becomes increasingly clear that the advent of colonization and the introduction of Western culture to Tanzania began with the Germans in 1885 and was followed by the British in 1919 until independence in 1961. Based on the choices Tanzanians made, these contacts have contributed to changes in Tanzanian life ever since. This is not to say that today all Tanzanians attribute every cultural change to Westernization and colonialism. But it equally cannot be denied that the "new" Western cultures and the colonial process impacted on Tanzanians.

In the colonization process, colonial rulers contributed in fashioning not only the cultural identity of their colonial subjects— "the mental universe of the colonized,"[34]—but the economic field as well. In fact, although the political aspect of colonial rule was clearly evident, the paramount objectives were economic. This might be seen in the restructuring of historical societies of Tanzania by the colonial economy to establish a social organization of production conducive to capitalism. The results were the incorporation of Tanzania into the world capitalist economy and the opening of Tanzania to foreign trade. Other factors were the introduction of cash crop production of mainly sisal, cotton, coffee, and tea. An example of colonial resistance in colonial control over the colonized and in the colonial administrators' introduction of cash crop production is first, the war of resistance the coastal people, led by Bushiri bin Salim and Bwana Heri of Uzigua, waged against the Germans. Second is the collective resistance against colonial rule through the Maji Maji conflict against the Germans, which the Germans suppressed in 1907. In both these conflicts won by the Germans, the Zaramo took part. Before the Maji Maji war, Kibasila, a Zaramo headman appointed by the Germans, was imprisoned for his refusal to make the Zaramo grow cotton. Though Kibasila was later released and took part in the Maji Maji conflict, in the end, the Germans hung him. Other factors, in addition to the introduction of cash crop production, were taxation, improved transportation systems, monetization, increased urbanization, Christianity, and the expansion of Western education. These factors affected economic and social production patterns, including apprenticeship systems used for acquiring traditional values, and productive and artistic skills. These patterns eventually gave way to other forms of production relations generated by colonial presence and modernization.

Colonialism and Christian missionaries principally succeeded in making some educated Tanzanians look down on their traditional cultures and artistic heritage and endeavored to transform the Tanzanian society from traditional to modern society. The introduction of Western culture included European-type education, European marriage patterns, and nucleate family structures

that differed from the African extended family, Western forms of government such as parliaments and presidencies, the English language, European theater—especially English, cinema, and music, as well as European dress and accoutrements. But at the same time, indigenous and Muslim marriage practices, and indigenous languages were not outlawed. Colonial values, then, served to render Western ways superior to traditional African ways.

The details and effects of the changes European missionaries brought to bear on the Zaramo and their sculpture are discussed further below (Chapter 3). It is worth noting, however, that early missionary work and influence among the Zaramo began in 1868 at Bagamoyo through the Holy Ghost Fathers and was extended by the Evangelical Mission Society for German East Africa (or Berlin III) in 1897 in Dar es Salaam. Missions were established in 1892 (Kisarawe) and 1895 (Maneromango). At Maneromango, the mission buildings which were constructed by the missionaries are still standing. In addition, a wooden carving representing an early, local Christian convert at the mission in 1895 stands in the mission grounds today (fig.2.2). This figure shows a man wearing a loincloth carrying a book, perhaps a bible, in his hand. From the plaque we learn that the sculpture shows how an early Christian looked when going to church. The carving and its plaque can be interpreted as not only celebrating the success the Maneromango Mission had in its evangelizing efforts among the Zaramo, but it also acts as an important historical monument for the mission and Christianity in Uzaramo. In 1888, the Benedictines of the St. Ottilien, Germany, began work at Pugu, twelve miles West of Dar es Salaam and at Kurasini in Dar es Salaam. In 1893, the Anglican Church began work at Mtoni and Kichwele in Dar es Salaam. At any rate, the history of Christian missions in Uzaramo shows the uphill task the missions encountered in their attempts to convert the Zaramo to Christianity. None of the missions in Uzaramo registered any considerable success in converts because of the Zaramo's affiliation with Islam. Different churches though, opened settlements for ex-slaves, schools, hospitals, dispensaries, vocational training centers, farming projects and animal husbandry, which were some of the channels for acculturation in Uzaramo. For example, both the Roman Catholic Church and the Anglican Church opened large secondary schools in Uzaramo; St. Francis College, Pugu (now Pugu Secondary School), and St. Andrew's College (Minaki Secondary School) built at Minaki in 1925, respectively. And, in 1897, the Evangelical Mission Society set up training centers for men and women. Men acquired skills in carpentry and woodwork while women were taught home-craft. Arguably, a turning point made for the Zaramo rests on a much broader view of the world as the net result of the contacts, training and education offered by the missionaries. But clearly

2.2 A carving of a Christian going to church in 1895 at Maneromango Mission, 2004

through these divisions the missionaries were trying to channel Zaramo society in a different way and limiting it. The goal was to produce a different society.

The social changes and historical forces I have sketched in this chapter have considerably transformed Zaramo society and contributed to shaping Zaramo identity. They have affected the production patterns, social uses, and cultural significance of Zaramo sculpture. Yet as this book will demonstrate, certain Zaramo cultural traditions like *mwana hiti* trunk figures, grave markers, and staffs have reinvented for new social and cultural purposes such as resistance to conversion efforts.

CHAPTER 3
CARVING A SOCIAL MESSAGE
Zaramo Artists in the Post 1960 Period

F ROM 1961 TO 1980, ZARAMO WOOD SCULPTURE WENT THROUGH MYRIAD changes affecting the art's form, style, and social uses. Yet largely unexamined are the factors impinging upon Zaramo carvers' creativity over this historical period that in turn, affect the carvings produced and the social message conveyed. In this chapter, I examine responses of Zaramo sculptors to socio-cultural forces within the contexts of their art making during the post 1960 era. As part of this study I will examine a variety of facets, such as how the relationship between Zaramo sculptural tradition and Zaramo social history has been influenced by modern forces like tourism, nationalism, economic development, and urbanization. To show the effects of social and historical changes it is necessary to review the aesthetic and formal principles of Zaramo sculptures and the role of sculpture in Zaramo society. The relations and distinctions between tourist art and traditional art will show how patronage and market forces shape art traditions. And finally, the national government's contribution to the development of Zaramo sculpture serves to gauge its commitment to Tanzanian arts.

My focus in this chapter, therefore, is on patronage in Zaramo wood sculpture and I aim to show the social, political, economic, cultural, and artistic considerations and influences on the Zaramo artists. Clearly Zaramo artists experienced the effects of modernization through the transformation

of Zaramo traditions, changing nationalist political structures, and cultural environment of Tanzanian society. All these developments created situations that stimulated Zaramo sculptors to produce art registering change. By exploring the types of patronage involved, relationships between Zaramo carvers and patrons, and the transformations of Zaramo wood sculpture under the aegis of patronage, my main emphasis is to show the missionary influence on style and theme, and the impact of tourism on style, themes, and color of wood in this art. Also, given that there are books writing Zaramo carving out of history, my other concern is to write the Zaramo back into history. Since I rewrite the history of Zaramo carving, I must go further back in time than the 1961-1980 period. To achieve this, I will investigate the Maneromango school run by German Lutheran missionaries to ascertain notable influences of the school and other developments concerning Zaramo artists. Though the Maneromango school is important in transformations of Zaramo figurative sculpture, it is not because most of Zaramo carvers today passed through the school; apparently they did not. Rather, at Maneromango, a large majority of Zaramo carvers from Kisarawe District developed and refined their carving style. Equally important is the far-reaching influence of the school upon Zaramo carvers today—in the 2000s. Thus, this investigation will clarify and rectify the history of Zaramo carving and provide a better ground on which to show the transformations which had taken place in *mwana hiti* figures, grave markers, and staffs.[1]

Zaramo Arts

Historically, Zaramo individuals with special skills worked part-time in healing/divining, basketry, ironworking, pottery making, and woodcarving to make ritual paraphernalia, musical instruments, household items, farming tools, and other objects. Compared to woodworkers and those involved with basketry, practicing potters and blacksmiths are few in number though their products are still used. In contrast, household objects such as baskets, mats, mortars and pestles, stools, and *mbuzi* or coconut graters (wooden folding stools with serrated metal knife blades) are widely used and readily seen in Zaramo society, attesting to their popularity.

Regarding the healing/divining profession, L. Swantz's study of the *waganga* (African traditional healers) of Dar es Salaam in the 1970s shows that the largest number of them were Zaramo.[2]

The relatively early visual evidence of Zaramo aesthetic taste and artistic craftsmanship is offered by Richard Burton. As I will discuss in Chapter 4, Burton observed in 1857 that the Zaramo wore ornaments such as bead

necklaces, white disks, girdles, brass or zinc wrist rings, and a peculiar decoration—*mgoweko*—a tight collar or cravat of colored beads with cross-bars of different colors.[3] Since then, the Zaramo have produced various objects across a variety of media. For instance,

> In the pre-German days, apart from beads and cloth sold or traded to the Zaramo by the Arabs, the Zaramo produced all their household, hunting, and agricultural implements.[4]

As late as 1941 according to Reckling, the Zaramo hardly used other agricultural implements than those made by their smiths. They preferred their homemade tools because of durability and usability to the relatively cheaper British and Japanese goods on the Tanzania market.

Since colonial relations with Germany and Britain had drawn Tanzanians into capitalism, they significantly altered the organization of production at the family-community levels. For instance, the colonial administration utilized mechanisms such as the introduction of imports which penetrated rural markets, monetization, and taxation. These strategies discouraged craft producers such as smiths, who abandoned their professions and sought wage-labor and cash-crop cultivation.[5] Thus, colonial administrators and local artisans did not have consistent, harmonious relations since the former often interfered with the latter's production of crafts. Also, colonial administrators wanted all villagers to grow cash crops demanded in Europe, and because the colonies were seen as markets for European products, the administrators frequently banned smiths from production to give priority to imported European tools. The ban was also triggered by the colonial authorities' fears that smiths might make guns, which they did. In 1978, the Tanzania *Daily News* reported that

> the German and later the British colonial authorities forbade the blacksmiths' trade in many regions of the country. If smiths defied the ban, they were imprisoned and their tools were confiscated.[6]

Although craft producers were recalled in periods of economic recession, such restrictions ultimately led to the decline of many crafts. Because of dramatic changes that emanated from the new social order, by 1965, according to L. Swantz, the Zaramo had turned away from the once popular tools made by their smiths and instead used imported ones.

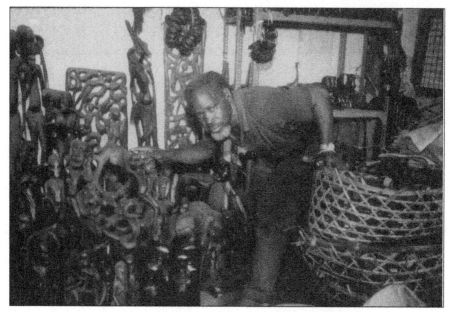

3.1 Chuma surrounded by carvings, Dar es Salaam, 1998

Zaramo Carving

The Zaramo are best known for their wood carving skills and artistry though in Tanzania they were generally rated second to the Makonde. Zaramo carvers work part-time in wood carving, but for some who carve for the tourist art market such as Salum Ali Chuma and Sultani Mwinyimkuu "Hamangu" (fig. 3.1, 3.2) and who live in Dar es Salaam, carving is their main occupation.[7]

Although Zaramo carvers who live outside of Dar es Salaam produce tourist carvings, for the most part they make traditional objects. When commissioned, those based in the city make traditional items as well.

Zaramo carving tradition has been developing for a long period, and study shows a crucial link between Zaramo social practices and the carved items that form an integral part of Zaramo life. The social, cultural, and political life of the culture offers fertile ground for the use of carved objects. Traditional dances, rites of maturity and identity, religious rituals, political organizations and family practices have continued. These are the major forces behind the production of sculpture. Salum Chuma locates Zaramo carving roots at Konde in Kisarawe District. At Konde, the Zaramo produced objects used in Zaramo ceremonial life such as embellished fly-whisk handles and *mwana hiti* ritual figures.

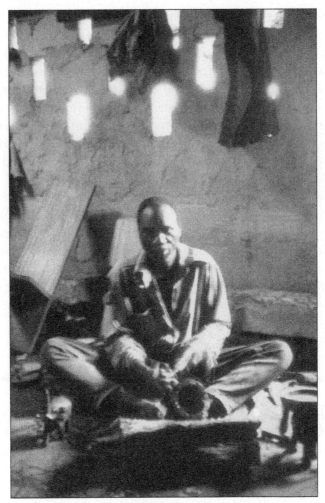

**3.2 Sultani Mwinyimkuu working at his Mwenge
studio, 1998**

Interestingly, oral history connects the Zaramo carving history to the
Mpilimo clan of Konde. And Kolahili, a famous Zaramo carver, belonged to
this family. Apparently, this talented carver acquired these skills from his father,
and he was commissioned to make objects for his community including those
used by chiefs and headmen. Zaramo carver Saidi Abdallah states that during
the German era (1885-1914), these Zaramo leaders commissioned Kolahili to
make objects connected with their political and social life.[8] Kolahili carved
handles of fly-whisks and spears as well as figurative images of headmen which
were placed on their graves. In light of this information, the British artist and

curio dealer Robert Dick-Read in his 1964 work distorts a part of the history of Zaramo carving when he asserts that the Zaramo carving tradition had no traditional base and began after World War I.[9] On the contrary, Zaramo carving had its roots in traditional Zaramo society. This representation must have come about because Dick-Read either discounted traditional Zaramo sculpture or did not know of its existence. Like the work of many European artists and chroniclers of the period, his dismissive attitude had the theoretical effect of impeding historical reconstruction, and obscured the contribution of Zaramo artists to both the carving tradition of the area and the other cultures with whom they interacted.

In Zaramo society, wood carving was traditionally done by men and this practice continues today. As happened in many parts of Africa, one learned the carving skills from male members of the family such as a father, grandfather, uncle, or brother, as in the case of Kolahili. Another example is sculptor Issa Selemani Bahari, who studied under both his father and elder brother, whereas Shabani Sefu learned his carving from his father.[10] One can also learn to carve from a non-relative as did Sultani Mwinyimkuu, who was taught by Yusufu Lusu at Boga in Kisarawe District.

Salum Chuma learned the carving skills from his family and outside of it. Chuma was born in 1942 in Chang'ombe village, also in Kisarawe District. In 1956, at the age of fourteen, Chuma began to sculpt under the guidance of his grandfather Salum Chuma. Chuma's grandfather who made traditional household items, taught him to carve after school. Chuma left his grandfather's apprenticeship when his father sent him to study with Selemani Nassoro Dendego, a carver based at Boga where his mother was married. He states that Saidi Abdallah, who at one time worked among Chuma's carving circle, learned to carve under Mwalimu Nassoro Dendego, the younger brother of Chuma's teacher. Carving, then, has been handed down along the male line for generations, investing it with a long, well-developed history.

Typically Zaramo carvers produced furnishings like elaborately carved beds, various forms of *vigoda/viti* (stools) like the three-legged stool called *kigoda cha mnghungo* (in Kizaramo), or ancestral/ritual stool—*kiti cha asili* (in Kiswahili). These items remain in use today. On the symbolic significance of the traditional three-legged stool, M-L. Swantz points out that "in the traditional rites this kind of low stool always signified authority or power, either political, social or religious."[11] Furthermore, Zaramo carvers crafted and ornamented household objects such as *mbuzi*/coconut graters (fig.3.3), mortars and pestles, ladles and bowls. They also created a variety of musical instruments such as many types of wooden drums with single or double heads (some of them three-legged), fiddles (fig.3.4), trough zithers, side-blown

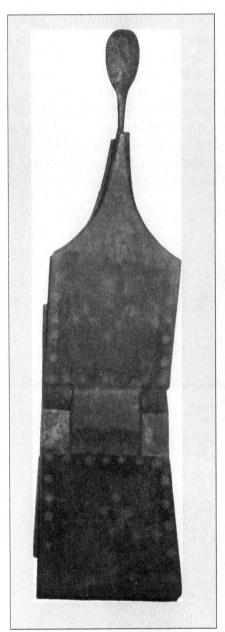

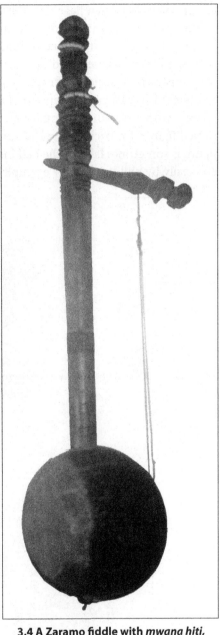

**3.3 A *mbuzi*/coconut grater,
Museum and House of Culture,
Dar es Salaam, 2004**

**3.4 A Zaramo fiddle with *mwana hiti*,
Museum and House of Culture, 2004**

trumpets, and wooden flageolets called *siwa* or *zomiri*. Drums and flageolets feature prominently in various Zaramo ceremonies including ritual. Other items include elaborately carved doors, side posts, arches, fly-whisks, *tumba* (gourds) with beadwork, and carved stoppers/dippers. Some of these objects, like dippers and musical instruments, incorporate carved human figures.

The traditional Zaramo repertoire includes figurative carvings and objects topped with three-dimensional figures. An example of wood sculpture is carved figures for tricking the bad spirit called *kinyamkera*. It is said that the figure is sometimes laid on the bed instead of the child as this spirit is feared especially by children. Other examples are *mwana hiti* trunk figures used in

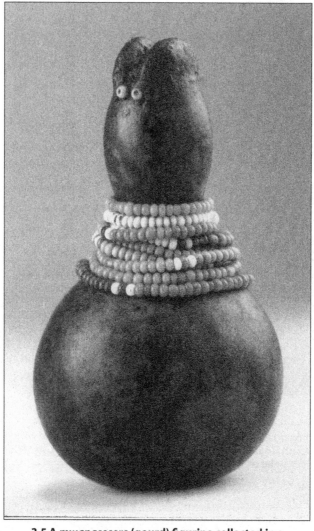

3.5 A *mwanasesere* (gourd) figurine collected in a Kwere village in 1988

puberty rites, masks, and *mwanasesere* (fig.3.5). *Mwanasesere* is actually made of a *kibuyu* (gourd) not wood, and *mwanasesere* can be used in the same way as *mwana hiti*. Carvings topped with three-dimensional figures include grave markers/figures which appear in several styles. Others are embellished staffs which served a variety of purposes, but especially as tools and status symbols. For example, walking sticks for headmen, called *kome,* or those used by *waganga* in healing ceremonies double as both functional items and status symbols. Posts were carved for functions such as hanging ritual paraphernalia during healing and initiation ceremonies. Felix mentions tall thick wooden posts which "were erected in houses used for meetings of 'secret' societies or initiations, to impart a sacred character to the building."[12]

Though a myriad of social changes have affected the forms, uses, and meanings of objects like *mwana hiti* trunk figures, staffs, and grave markers, they still continue to be utilized because they are significant in Zaramo culture. These three types of sculptures not only help to define and perpetuate Zaramo culture in the midst of modernization, but they bring out the centrality of wood carving in Zaramo society. Clearly Zaramo carving is a principal means for producing some of the art objects needed for socialization among the Zaramo, such as using *mwana hiti* in pedagogy.

Maneromango Carvers and Missionary Patronage

Today Zaramo carvers make objects whose themes rhyme with those found in arts and crafts produced for the tourist art market. Such items include salad bowls, treasure chests, ashtrays, letter-openers, candle holders, combs, napkin rings, wooden bracelets, figurative carvings showing wildlife, human figures such as Maasai masks, heads, young Maasai warriors, and the popular "Makonde carvings." Other carved and widely used objects include wooden grave markers, staffs, *mwana hiti* figurines, drums, musical instruments, ladles, mortars and pestles, *mbuzi,* and stools. Given that Zaramo carvers were making items for use in their communities, what accounts for the increased production of figurative sculptures used outside of their cultural forms? What explains the carvings for the art market? How did this shift affect art production for community use? Equally interesting to discover is how outside influence affected both the creativity of Zaramo carvers and their creations.

Attempts to explain formal, stylistic, thematic, and functional changes in Zaramo figurative wood sculpture have ranged from the purely economic to popular demand. For example, Chuma singles out economic factors and claims that these have killed originality among Zaramo carvers. Driven by money, the carvers have become stuck in overly repetitious production of

subjects with no thematic variation. The net result is shoddy work. On a relatively close note, Pelrine observes that

> for the most part, tourist carvers do not place a high value on creativity; they simply want to carve whatever they know they will be able to sell and really do not care about the subject.[13]

But one should consider that in striving to meet art market demands, carvers who carve for a living may give this aspect much attention and override aspiration for craftsmanship. The focus on economics has largely overshadowed the influence of the Maneromango school upon Zaramo artists.

Maneromango is a small center in Uzaramo, fifty miles Southwest of Dar es Salaam city. In 1926, German missionaries set up a carpentry and crafts school at a Lutheran mission there. Though Pelrine and Castelli do mention the involvement of the German missionaries with Zaramo carvers at Maneromango, what they say is limited and consequently does not fully explain the carving relationship between the two parties nor the ways the missionaries shaped Zaramo wood sculpture.

Before World War I, German missionaries opened carpentry training centers for training indigenous artisans in Dar es Salaam and Kisarawe. The Dar es Salaam school was reopened at Maneromango in 1926 when the German missionaries returned following the end of World War I. In his 1942 paper the Maneromango Lutheran missionary, Reckling, mentions that some of the craftsmen trained at these schools managed to found their own businesses. They also opened workshops for training other craftsmen in Tanganyika. This training of craftsmen, including the development of artistic talents, and the furniture and carvings produced and sold, led Reckling to note that from 1926 (when the Maneromango school opened) through to 1942, it made remarkable progress. In 1965, L. Swantz wrote that the school has been closed since the start of World War II. The Maneromango school taught its trainees to make doors, windows, and furniture, and especially notable was the production of wickerchairs, which had a country-wide market. An interesting aspect for this book, something oral and documented material maintains, is that while the Maneromango school offered general carpentry and furniture making, Reckling also introduced a special type of program in blackwood (*Dalbergia melanoxylon*) or *mpingo* carving.

Following the logic of Eurocentrism, Pelrine represents the carving relationship between the Zaramo artists and the missionaries at Maneromango as one in which the artists "were first taught by the missionaries to do carving work in a relatively realistic style" that is still manifest in today's production.[14]

Pelrine's claim, one devoid of proof, suggests that the artists were not doing that prior to the missionary initiative. This view is patently false since Zaramo carvers were carving themes in the realistic mode well before the missionaries opened the Maneromango school. For example, the realistic work that Kolahili made in his community during the German era and beyond so impressed the missionaries at Maneromango that they collected his creations and took him to the school to teach carving. Moreover, we have evidence of figural wood sculptures in realistic style attributed to the Zaramo (fig.3.6) depicting a *mwali* and *kungwi* (initiate and teacher/initiator). This wooden figure was collected in Kisarawe at the end of the nineteenth century. It was created *before* Reckling set up the carving program at the Maneromango school.

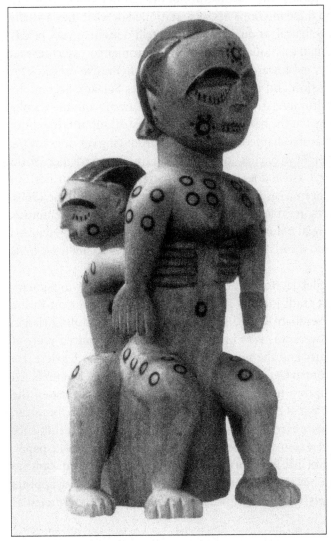

3.6 A Zaramo carving of an initiator and initiate collected in Kisarawe at the end of the nineteenth century

Castelli's paper focuses on traditional carving of East-Central Tanzania and not specifically on Zaramo carving. Even so, he unsuccessfully explains changes that Zaramo figurative sculpture registered since he does not provide enough data and a coherent argument that has historical specificity. Castelli failed to explore a variety of factors to explain the changes he was concerned with—the physical appearance of Zaramo sculptures, or the sculptural form. Instead, Castelli's project pursued the carving relationship between Zaramo carvers and Christian missionaries as well as between the Zaramo and Kamba of Kenya. This would imply that indigenous Zaramo carvers created carvings whose morphology was different because they were destined for the art market. In his explanation, Castelli first mentions the presence of Catholic missionaries in the Zaramo area since the turn of the century. But he does not say where in Uzaramo these missionaries were stationed or what they actually did regarding Zaramo figural wood sculpture. Castelli does note very briefly the efforts of the German missionaries based at Maneromango, asserting that their strategy was directed towards the production of figurative carvings for the market at the mission and in areas close to Dar es Salaam. Second, he points out that the cultural relationship between the Zaramo and the Kamba involved wood carving. On the basis of oral history, Castelli submits that both the Zaramo and the Kamba charged each other for producing carvings for the British colonial market. Both parties confirmed that this occurred after World War I began. However, Castelli does not explore these two factors further, but confirms that in the Zaramo case the external market flowered until the 1960s. Castelli misses his mark in explaining changes to Zaramo figurative sculpture, but he does assert correctly, along with the Tanzanian artist Nassoro Nyumba that traditional Zaramo society was opposed to the changes taking place in its carving tradition.

In a somewhat parallel development, Wembah-Rashid debunks missionary influence on local art traditions in Tanzania. In his 1970 paper on Kwere fertility sculptures, Wembah-Rashid states that the influence of Christian missionaries on the Kwere was very little despite over one hundred years of establishing Christianity and the number of missions set up in Ukwere. He argues that because Roman Catholicism (the Church among the Kwere) failed to penetrate these Zaramo neighbors, it did not discourage the use of the *mwana hiti* figurines. For the Zaramo sculptors at Maneromango, however, the Lutheran missionaries exerted considerable stylistic and thematic influence on them when they created their wood sculpture. But in his 1942 paper, Reckling is oblivious of his influence even though he introduced Zaramo carvers to producing objects for the art market. In contrast, Reckling appears to take some credit and he expresses pride in view of what he interpreted as

learned craftsmanship compared to old, traditional craftsmanship. Zaramo arts and crafts were part of what he saw as European civilization in Zaramo society. He points to the successful training of artisans by German missionaries in Uzaramo. In what appears to be an alliance between the missionary project and colonialism, Reckling states that the training of artisans was given first priority in establishing a mission. And once the missionaries had trained these artisans, they turned them over to German planters or craftsmen to provide labor, and were absorbed in the capitalist economy. But just as Catholic missionaries failed to affect the beliefs and social values of the Kwere, the Lutheran missionaries had little to do with the development of Zaramo sculpture.

Reckling's move to set up a carving section in the Maneromango school was erroneously taken as the origins of Zaramo carving by European chroniclers. A further exploration of the argument Dick-Read advances reveal inconsistencies, namely that the Zaramo carving tradition had no traditional foundation and that it started after World War I. He claims that

> originally, after the first world war, a few boys were taught to carve by a German missionary whose hobby was woodcarving. The industry, such as it is, has developed entirely from those small beginnings.[15]

Some Zaramo do not agree with the view put forth in Dick-Read's work. They dispute that the missionaries taught the Zaramo to carve. They affirm that the missionaries offered training in carpentry, but that the Zaramo were carving before the arrival of the missionaries. But Dick-Read, misleadingly credits the Maneromango carpentry and crafts school as the beginning of the Zaramo carving tradition when in fact the tradition had been established for generations among Zaramo men. In rebutting his claim, my concern is not to trace an unbroken line of the artistic origin of the Zaramo—an investigation that is beyond the scope of this work. Rather, I wish to state that Zaramo carving did not begin at the Maneromango school; it had its basis in traditional society. Thus, I wish to note the *stylistic* transformations of the Zaramo sculptural tradition through non-Zaramo contacts. These artistic and cultural contacts underline how Zaramo carving enriched other carving traditions even as it was transformed in the process.

Walter Elkan asserts that Reckling introduced carving in the school to keep alive and foster the carving tradition of Kolahili.[16] Reckling tells about a select group of indigenous Zaramo carvers from Konde in the Western part of the mission whom, after seeing their work, he chose them to work at the school

when he began to serve at Maneromango. Nyumba also points out that it was the work of Kolahili which encouraged the missionaries to open a carving section in the school. He goes on to reveal that Kolahili's products were eye-catching to most Europeans, and that Kolahili had the ability to create any piece he desired. Similarly, Zaramo elders Omari Abdallah and Yusufu Mwalimu Mgumba (retired carver), and Zaramo carver Ali Mwinyimkuu Bilali had high regard for the carving skills of Kolahili such as the making of *mwana hiti*.[17] Mgumba states that in addition to Kolahili, the missionaries took in another Zaramo carver, Kristofoo to teach at the mission school. And their students included Selemani Manoti and Juma Samatta. Still, it is not clear how benevolent Reckling's action was. Reckling does note that the missionaries admired the work of Kolahili and had commissioned him on several occasions. Though impressed by the carving of Kolahili, it appears that the missionaries had ulterior motives. They took him to the school to teach Zaramo students who already had a background in carving. What the German Lutheran missionaries at Maneromango did was not something new— insofar as it relates to the interaction of European missionaries with African art traditions. European missionaries in Africa had begun to go in that direction quite early.

Marshall Mount[18] offers an interesting examination of "Mission-inspired art" in sub-Saharan Africa, though he does not include the Maneromango school. He traces the earliest missionary initiative to the Christian liturgical objects devised by Africans living at the mouth of the Congo River at the end of the fifteenth century. Mount suggests there is no substantial evidence to support a proliferation of this art in Africa until in the twentieth century, when a number of Catholic and Protestant missions opened art schools and workshops, or commissioned traditional artists to make objects. The examples he provides include the art workshop at Cyrene Mission (established in 1936) of the Protestant Church near Bulawayo in Zimbabwe, the Catholic Church's workshops at Oye Ekiti (opened in 1947), Ondo, and Ijebu-Igbo in Nigeria. Mount writes on the aim of the art created in Africa under the guidance of missions:

> The primary aim of most of this art is to promulgate the concepts of Christianity, that is, for the education of mission parishioners. To further this end, the works usually embellish the walls, altars, and portals of mission churches. They are also at times sold to Europeans, thereby providing additional, much needed revenue for the missions. A corollary result, obviously, is the training of craftsmen and artists; some of them have, in the course of time,

successfully established themselves in workshops independent of the mission and consequently are free to sell to whomever they choose.[19]

Mount's statement sheds light on the deep involvement of missionaries with African art to further their interests. The portion of this statement concerning the production of objects for church use, to raise income for the mission and train craftsmen, applies to the Maneromango school.

Although Reckling notes that a variety of talents emerged among the students at the Maneromango school, it is clear that these carvers had found a new patron. Instead of carving for their society, Kolahili and his students now carved for the church and others on a commercial basis as orders were placed. The real question remains: to what extent did this interaction add to or modify their carving style and themselves? Regarding the relationship between the missionaries and the Maneromango carvers, Reckling states that he encouraged the carvers to work as their imagination directed them—that he did not influence their style. Yet Reckling would make corrections on proportions and lines which he felt were not in order. On a similar note, Father Kevin Carroll, one of the missionaries who ran art workshops in Nigeria, has this to say on their relationship with carvers at Oye- Ekiti:

> We are often asked, 'How do you get carvers to do what you want?' They are told in general what is required. . . . When the work is finished or in progress obvious mistakes, like a forearm bent in the middle or a thumb on the wrong side of a hand are criticised.[20]

Incidentally, Father Carroll was not happy with the carving style of "the bead-like shape of the mouth" at Oye-Ekiti and noted that a suggestion for "another more pleasing way of carving a mouth" was to be made.[21] The Oye-Ekiti and Maneromango examples vividly illustrate missionary influences to shape local styles.

As Reckling has put it, the Maneromango carvers developed a creativity that was recognized all over Tanganyika and compared favorably with Indian imports as well as works created in Dar es Salaam. Here Reckling saw the recognition of the Zaramo carvers' creativity in terms of the popularity of their work in the art market. In this connection, Reckling also encouraged the Zaramo carvers to create carvings of animals, particularly giraffes, elephants, and lions to cater for the demand for curios. The strong connection that Zaramo carving has with Reckling and the Maneromango school, to carve for the art market, is evident today. Zaramo carvers tend to specialize in certain

types of sculptures for the tourist art market, but this does not necessarily reflect mastery. Most make sculptures depicting wild animals with no variation on this theme, indicating the carver's limitations. Even in rural Zaramo, one can be directed to a carver known for making a type of animal sculpture one is looking for. In his 1965 work, L. Swantz points out that Reckling invited a few Makonde carvers from Southern Tanzania perhaps to inspire the Zaramo. And given the Makonde wood carving reputation both in Mozambique and Tanzania, and the fact that they carved for the art market, it appears that these were strategies to manipulate and influence the Maneromango carvers towards applying their production to the art market. This may explain why the Zaramo began to carve for sale outside of their society, including the tourist art market from the 1930s on. Though the Maneromango school and the missionaries reshaped traditional styles, this also gave Zaramo art recognition and increasing demand.

Beyond the Confines of Maneromango

From the time the Maneromango school opened in 1926 to the 1980s, notable developments—both positive and negative—affected the art created there. Negative developments include manipulation by the missionaries who dictated styles and themes, such as making animal sculptures and stereotypical human figures in daily pursuits. The school's focus on art for sale might have led a large majority of Zaramo sculptors to shift from making objects for their communities to commercial production of Zaramo figurative carving. Stylistic transformations in the school, such as a carving of a human face, may have easily crossed over to other sculptural objects for cultural forms like grave posts. The artists may have revisited themes, or copied over subjects that sell easily, leading to mass production and hampering creativity. Similarly, experimentation was blocked when clientele began to dictate types of wood used in sculpture, such as the popular preference for *mpingo*. All these changes arose out of the Maneromango school's commercial concerns and ultimately impeded Zaramo creativity.

On the positive side, the Maneromango school helped to expose the crafts made at the Maneromango center, thus boosting the Zaramo economy. Also, the school helped in the expansion of Zaramo carving. We have seen that the missionaries' influence occurred principally on theme and style. This issue crystallizes when we consider the actions of the missionaries and the reaction of the sculptors. Focusing on the response of Zaramo sculptors and the course their sculpture has taken within the dynamics of inter-cultural exchange, Yusufu Mgumba observes that Zaramo families joined the carving occupation

because they made money; it was a profitable undertaking. The carvers continued to work on their farms, but carving became an occupation for making money on the side. To attest to the Zaramo families' connection in the carving occupation, Mgumba gives the example of the Kristofoo family and his own. Established carvers, Kristofoo, Mungi Chugo, and Kondo Mirambo belonged to the same family. Chugo was like an overseer among Zaramo carvers in that he assigned pupils to carvers he considered capable of teaching others. Chugo taught Mgumba to carve in the early 1950s. And Mgumba and Bilali are family and they used to carve together. Mgumba used to make sculptures such Maasai figures, wizened old men or *masikini* (poor) figures, and women in daily pursuits like a woman carrying a water pot on her head. Bilali creates Maasai with shield sculptures and has carved *mwana hiti*, and staffs such as *mkomolo*. Continuing with the theme of the Maneromango sculptors' response and the direction their sculpture has taken, in 1965 L. Swantz wrote that enough Zaramo had learned the art to turn it into a thriving business and that fathers were passing down the art to their sons and relatives. Furthermore, Indian curio dealers from Dar es Salaam and Nairobi visited Maneromango to collect vast quantities of Zaramo carvings which were then sold to tourists or exported to many countries. In this context the Zaramo were drawn to create sculptures for the art market purely for economic reasons.

In his study of Makonde sculpture in Tanzania, Wembah-Rashid reports that when the artists created objects for local consumption, like household utensils or masks for initiation ceremonies, their products were geared to meet the demands of a small, often personalized market.[22] To cite an example, masks used in initiation for boys were made on request by members of the male initiation society. These ritual objects were created and preserved in hidden places away from the uninitiated members of the community. In commissioning for sculptural pieces, a customer could place orders for items or acquire ready made ones created by the artist. Thus, regarding the production of Makonde objects to cater for the needs of a small, often personalized market as Wembah-Rashid has it, the situation not only controlled the quality and volume of the items, but there was local influence of style since the artists knew the taste of their clientele. Presumably new symbols were created in this way. Following colonization and missionary patronage, increased international demand triggered chain reactions, directing artists to make objects to satisfy the middleman's requirements as marketing was now commercialized. The artist's logical response to economics was mass production and commercialization.[23] Although this business of making sculptures for the art market has boosted the economy of the Zaramo, neither

the artistry of the carvers nor the art has fared any better as sculptures of the 1960s through to the 1980s exhibited much stylization and mass production.[24]

Once the Zaramo began to carve for others their influence spread beyond their borders to the Kamba of Kenya by way of a renowned Kamba carver, Mutisya Munge. During World War I, Munge served in the Carrier Corps in a part of the German East Africa later called Tanganyika. Munge collected Zaramo models and upon returning to Kenya took up carving as a full-time occupation. Following Munge's efforts, a booming trade in carvings developed close to the border with Tanganyika at Wamunyu in Kenya. Elkan, writing in 1958 on the involvement of the Kamba in the trade of wood carvings, notes the Zaramo "genesis" and development of Kamba carving. Surprisingly, in her 1975 survey of art in East Africa, Judith Miller does not.[25] Although she discusses notable ethnic groups in the region who make art and crafts, the Zaramo are not among those listed. Miller goes to great lengths to shower praise on the Kamba—celebrating them as enterprising and creative—but she ignores the very people who contributed to the development of Kamba carving in the first place. Apart from the fact that the basis of Kamba carving rests on the Zaramo carving tradition, Miller should have mentioned the Zaramo because of their prominent place in the history and development of sculpture in Tanzania alongside the Makonde. Whatever reasons Miller had for this apparent neglect of the Zaramo, she joins forces with people like Dick-Read, who elide the carving history of the Zaramo.

In 1942 Reckling was disappointed with the on-going World War II because it paralyzed the work of the school and markets for the sculptures could not be found. But the market situation changed rapidly from the 1950s onwards. First the Kamba of Kenya, then Indian and African dealers entered the scene at Maneromango to purchase blackwood carvings created by Zaramo carvers and sold some in Dar es Salaam while others were exported. The Kamba involvement with the carvings trade certainly contributed to the expansion of Zaramo carving. Elkan points out that after 1945, the demand for carvings rose primarily because of growth in prosperity, especially in America. This prosperity led to an increase in tourist travel and in overseas domestic expenditure on luxuries. More tourists visited East Africa or traveled through the region and bought curios, resulting in the transformation of the two carving traditions. Interestingly, the Americans who patronized "Kamba" carvings "preferred the darker woods to the light ones which were becoming increasingly the hallmark of Kamba carving." But as the supply of dark wood in Wamunyu deteriorated, the need for other alternative sources arose:

The search for dark wood, and particularly for ebony, led to two parallel developments—a migration of carvers to areas where ebony was available and, more important, the expansion of the Zaramu carving industry in the vicinity of Dar es Salaam as the direct result of Kamba encouragement. Kamba dealers regularly travel to Tanganyika to buy black carvings which are distinct not in colour but also in type….[T]hese black carvings are sold in the streets at Dar es Salaam—not by Zaramu but by Kamba. The Zaramu come into Dar es Salaam to sell to non-African firms, but the bulk of their carving is sold to Kamba dealers, who buy from them either at their homes or in the market-place at Maneromanga (sic)—the Wamunyu of Zaramu country.[26]

Nyumba notes that as the Kamba were interested in buying the finished product from other carvers, they heard of Zaramo artists and began dealing with them. He mentions a Kamba named Martin who visited Maneromango in 1954 and not only admired Zaramo work, but observed abundant blackwood in the area. Soon, Martin was joined at Maneromango by large numbers of Kamba traders. The Kamba bought Zaramo carvings at low prices and shipped the sculptures by trucks to Dar es Salaam for export. The Kamba are said to have prospered through the trade in Zaramo carvings, which were of wild animals such as elephants, lions, reptiles, and birds.

From the early 1960s up to about 1980, more traders converged at Maneromango, not only Kamba but African and Indian. This situation stimulated further thematic and stylistic development. The themes of the sculptures included human figures like Maasai figures, masks, and heads, a woman carrying a water-pot on her head and peasant elder-figures which are still produced today by the Zaramo (fig.3.7). As stereotypical representations from Tanzania, Maasai sculptures and wizened old men or *masikini* (poor) were perhaps popular among tourists and curio dealers. The visual popularity of Zaramo sculptures in turn led to two other significant developments. First, in 1965, as L. Swantz has put it, the Zaramo formed their blackwood carvers cooperative society. Second, a wave of skilled Zaramo artists made a move to the urban centers such as Dar es Salaam to carve. This rural-urban shift was designed to counter the exploitative dealings of middlemen like the Kamba. The move enabled the Zaramo to sell directly to the dealers or customers. But the move to the urban centers did not curtail the Kamba practice in dealing with Zaramo art. In 1997 Chuma related an incident about Kamba curio dealers who deceptively labeled Zaramo carvings they were selling as made in

3.7 A Maasai head created by Chuma, 1998

Kenya. It would seem that the Zaramo needed more sophisticated marketing strategies to thwart such shady business dealings that the Kamba used.

Mohamed Peera's Patronage

Indian curio dealer patronage exerted considerable influence on theme and style because they determined what sculptural pieces they wanted in response to curio market demands. Zaramo artists such as Saidi Abdallah, Sultani Mwinyimkuu, Ramadhani Saidi, Shabani Sefu, Issa Bahari, and Salum Chuma, who gravitated toward Dar es Salaam to carve, worked mainly for Indian curio dealers. The highly skilled artists were hired by Mohamed Peera to work at his carving yard at Chang'ombe in the industrial area of the city. It is reported that Peera only hired the best carvers. Peera also operated a curio store, "Peera's Curio Shop" on Acacia, later named Independence Avenue (now Samora Avenue) in the tourist and commercial district of Dar es Salaam. Like the missionaries at Maneromango, Peera fits well in the division of adviser-participant-consumer paradigm outlined by Dele Jegede. In this division, Jegede had people like Father Kevin Carroll involved not only in the creation

process, but in influencing the results of the undertakings and in disseminating the products, some of which the patrons themselves appropriated.[27]

Peera was so enterprising in his curio business that in 1970 he was considered "the most successful of the dealers."[28] In 1975 Miller wrote that for many years Peera owned the largest outlet store for Makonde sculptures in the capital. It is noteworthy that by 1953 Peera was running a carving workshop and provided carvers working for him with tools, wood, and a steady market for their art products.[29] His flourishing curio business also dealt with the exportation of carvings to department stores abroad.

In order to understand the patronage situation in which Zaramo sculptors worked it is necessary to examine the general patronage arrangements and the activities at Peera's carving yard. In her 1970 field research in Dar es Salaam, Kasfir identified two types of carver-dealer arrangements being practiced. The first one involved a workshop setting where carvers produced art exclusively for the dealer who not only owned the place, but also who supplied them with wood and bought their products by piecework. In the second type, the dealer made weekly rounds to the carvers' yards and bought what he fancied. In the process, the acquired pieces would be sold in the dealers' stores in Dar es Salaam, or exported to other curio dealers abroad, or to department stores. In the second arrangement, carvers could also take their work to the dealer once they had a relationship and had agreed to meet his preferences. Thus, what the dealer preferred had impact on style, innovation and change. Aside from the two types and indigenous patronage, Kasfir also observed that tourists purchased pieces from dealers, but Tanzanian elites and resident foreigners would buy directly from carvers to circumvent high prices charged by dealers. These "retail buyers," as Kasfir calls them, may not have interfered in the creation process in the same manner as Peera's artist-patron interaction, which *did* influence art styles.

Peera's association with a group of esteemed Zaramo and Makonde carvers from the 1950s to the early 1970s is recorded. Though Kasfir's 1980 work focuses on Makonde carvers, at least she lightly treats Zaramo carvers in contrast to the 1975 work by Miller who completely ignored the latter in her discussion of artists working for Peera. Miller did not mention Chuma who was working for Peera since 1963. It is fruitful to highlight Chuma since he occupied a central position in Zaramo visual arts, and had extensive interactions with patrons. In addition, Chuma was the leading Zaramo sculptor and represented Tanzania abroad in a number of art exhibitions. Moreover, he had interacted with other Zaramo artists from 1960s to 1980s period in Uzaramo. We will also learn about experiences of his carving circle.

Chuma learned carving in the traditional manner, under his grandfather and Selemani Nassoro Dendego. In 1960, Chuma joined other groups of carvers, such as the Makonde who carved in several styles. In describing his creative process, Chuma maintains that aside from the need to earn a living through carving, he left his home district because he wanted to expand artistically. Having mastered carving within the limits of the local tradition, he felt that the move to Peera's workshop presented new challenges and avenues for broadening his art. Chuma first worked at Peera's workshop at Simba Plastics in Chang'ombe, Dar es Salaam. Because of his expanding curio business, Peera opened a large warehouse in the Chang'ombe area. In 1970 Chuma and the other carvers working for Peera moved to the warehouse yard to work there. This building later housed the Handicrafts Marketing Corporation (HANDICO), which was under a state parastatal called Small Scale Industries Development Corporation (SIDO). Chuma later joined HANDICO and in 1998 he was still based at the premises. In July 2004 when I went to the HANDICO premises looking for Chuma, I found workers renovating the place. When I asked about Chuma's whereabouts, I was told that he still worked there. I did not know anything about the renovation until after I had spoken to Chuma a few days later.

For decades Chuma was self-employed and had only engaged in the carving occupation. As a master-craftsman, he taught carving in classes organized by HANDICO. He told me during my last interview with him on July 10, 2004, at his home at Kigogo in Dar es Salaam city that Prof. Elias Jengo of the Department of Creative Arts, University of Dar es Salaam, regularly sent his art students to Chuma's studio to learn the history of art, his creative approaches, and the like, and Chuma readily shared what he knew with the students. Chuma informed me that he has established an art company called Mikono Gallery, located at the HANDICO premises. "Mikono" literally means "hands" in Kiswahili, and one can easily see the relationship between hands and artistic activities such as carving. The renovation of the HANDICO premises mentioned above was designed to provide space for the gallery. Mikono Gallery will have working space for Chuma and other artists. Since Chuma does not own the premises, proceeds from his company will cover the rent for the space at HANDICO. Chuma worked for patrons, which included tourists as well as for Zaramo women who would commission him to create *mwana hiti*. Even as Chuma worked in a cosmopolitan city, like most Africans, he maintained ties with his traditions.

Although Kasfir states that in 1970 about 35 of the best Makonde and 10 Zaramo carvers were working for Peera on a regular basis,[30] some well-known Makonde sculptors did not work in Peera's yard. A good example is Kashimiri

Matayo. And though Robert Yakobo Sangwani, the originator of the *ujamaa* carving style, sold his work to Peera, he worked at Boko outside of the city. Nevertheless, Peera's carving school had prominent carvers. Chuma cites members of his carving circle as including the following Makonde carvers: Atesi Mulungu, Andriki Alimela, Stefano Yakobo, Samaki Likankoa (who introduced the *shetani* or spirits style), Thomas Valentino, Christiano Madanguo, John Fundi, and Karinto Lidimba. Dastan Nyedi and Chanuo Atalambwele Maundu were also among the group of Makonde carvers. According to Chuma, the Zaramo carvers included Ramadhani Saidi, and Saidi Abdallah. In this list, Sultani Mwinyimkuu includes Ayubu Uwesu, Buge Madunda, and Juma Mikembe.

Chuma singles out Peera as the one person who most profoundly helped him develop his art. Peera let the carvers in his yard create on the basis of their skills and imagination. Peera would tell the artists the type of sculpture he wanted, such as a *binadamu* (literally child of Adam) piece. He considered only what would sell, never interfering with the artist's creativity. The main popular figurative styles from the late 1950s were *binadamu* and *shetani*, so as Kasfir notes, typically a carver chose to make "either one or the other, but not both." Carvings depicting wild animals were also popular. For example, Chuma had high regard for Saidi Abdallah who excelled in creating elephant carvings. Mwinyimkuu states that though he joined Peera to carve elephants, he also made hippos, Maasai heads, and drummers. Chuma explored a variety of styles to enrich his carving skills and creativity. He asserts that since 1960 he could create any art object he could think of (fig. 3.8, 3.9), and even in the 2000s he could carve anything he desired. When I spoke with Chuma in 2004, he told me that some of his European clients did not believe that he was carving from his mind. They thought that a carver like him was copying the subject from books. So these European clients came to his studio everyday to watch him carve. Typically, the subject of his carving would come to him after he had seen the wood but he preferred to carve the face of a human figure in the morning when he is fresh. Even when creating standard types of sculptures, Chuma injected personal elements such as facial features of relatives—which he thought gave his work distinct characteristics to facilitate recognition. In a sense, that constitutes his carving signature. Chuma stresses originality and is against the practice of being driven by money to the point that the artist copies the same types of sculptures over and over.

In Chuma's view, his individual creativity and his quest to innovate resulted in his representing the nation abroad. He visited several European countries to run carving workshops and exhibit his creations. He visited Germany in 1974, spending eighteen months, again in 1982 for four months, and

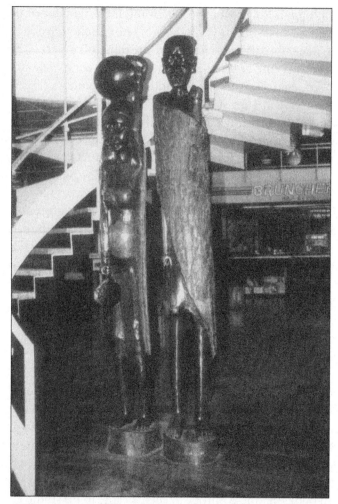

3.8 Two large sculptures of a Maasai couple carved by Chuma in the 1960s, the Kilimanjaro Hotel in Dar es Salaam, 1998

Yugoslavia in 1979 for four months. In 1993, he visited Sweden for eight months and England for another three months. In 2000, Chuma exhibited his work twice in Nairobi, Kenya. Apart from the exposure to other cultures and art traditions, one may speculate that Chuma's overseas travels influenced his carving style. Chuma observed that he has no equal among Zaramo carvers. Even some Makonde in Chuma's carving circle acknowledged that Chuma was a better sculptor compared to them. Although Chuma emphasizes that Peera did not suggest any stylistic innovations among the group, this dealer's support was important to this select group of carvers and to the development of contemporary wood carving in Tanzania.

3.9 Detail of intricately carved door at the Simba Grill of Kilimanjaro Hotel by Chuma, 1998

Peera was not a sculpture teacher, but he was well-versed enough to tell a good piece from a bad one. Within the adviser-participant-consumer scheme, Peera often made references to the work of the prolific carvers, emphasizing originality and criticizing copied work. At the end of the working day Peera had a practice of asking his carvers to assemble and show what he chose as the best carving of the day—a move designed to motivate them. Because the carvers were paid for what they turned out, the creator of the best sculpture was paid twice the agreed price. Peera would announce the price change at the gathering and at the time Makonde artists were winning the lion's share of these bonuses. In this way, Peera both sought and inspired the carvers' best in creativity. And even if the scheme was not intentionally geared to influence trends, styles, and innovations, it certainly did. For example, the *shetani* was developed in Peera's workshop. When comparing the work of a Zaramo carver working in the traditional context alone or with family members/students with the work of Peera's artists, one finds limitation on the work of the former. In this regard, the traditional artist is limited with respect to the competitive spirit noted among the artists working for Peera given that patronage, incentives, demand, and the market situation are markedly different. Similarly, at the Maneromango school this competition was limited. In this respect, it is

not difficult to see that the art products produced by these three categories of artists: traditional Zaramo carvers, Maneromango school's carvers, and those working for Peera, were also very different in terms of quality and innovation. Thus, it is worthwhile to note that unlike at the Maneromango school where originality was discouraged and mass production art was encouraged, at Peera's workshop this dealer reinserted originality and individuality into creating sculpture. Peera reinvested Zaramo art and culture with the pride of originality.

Since Peera supplied the artists with wood and paid them for the pieces he chose (Chuma said they were paid labor-charge), the carver was then allowed to sell rejected pieces to anybody. Now, considering the price of wood along with Peera's successful business and dealing connections, it was indeed the carver's privilege to be linked to him. Chuma must have won Peera's confidence for he was assured that what he created would be bought. Encouragement of the sort must have been telling to Chuma, especially in light of the intense competition among the sculptors to create good sculptures that would sell. Equally significant, this practice enhanced the status of the artist among the circle. Clearly Peera's inspiration and good advice played an important role in Chuma's artistic development, but we should not lose sight of the rich dialogue among the carvers in shaping individual creations. These extended, fertile interactions gave rise to innovations among the carvers. Thus, the works produced differed though what Peera ordered was simply *binadamu* as an example. We may say that success and exchange hinged largely on the industry and the will of the artist to make use of positive elements to enrich his products. But what Chuma was exposed to at the artists' workshop, coupled with his overseas travels, enabled him to push the boundaries of his work and locate it in "a space of his own." Even so, patronage and developments in a workshop such as Peera's aside, the role of the artist in society has not changed in that artists still strive to create work tailored to meet the specifications of their clientele or that would sell, even if the work is made in accordance with the artists' imagination. Doing so contributes to the artists' economic well-being and enhances their status in the community.

Consonant with these processes, the literature on East African art usually referred to the popular carving genres such as *binadamu, ujamaa,* and *shetani* as "Makonde sculpture," perhaps reflecting the view of the people associated with these genres. It is hardly surprising given the notable development in the creation of "Makonde" carvings that other ethnic groups have begun to produce these carvings after they realized that the carvings sell easily. Now, the popularity of "Makonde" carvings on the art market is an acknowledged fact. This popularity is a result of the skills, creativity, and imagination of

Makonde sculptors. Also significant in this respect are the economic, political, social, and religious factors affecting the different styles and themes which the artists utilize in their creations. For example, Makonde artists produce *shetani* carvings based on their beliefs about nature spirits, but this process of selective retrieval does not end there. More than this, the artists also respond to situations confronting them such as economic and social needs by retranslating and reinventing these spirit manifestations for a modern audience. Regarding the production of "Makonde" carvings by other ethnic groups after they found out that the sculptures sell easily, it is worthwhile to note that across the border from Tanzania, Kamba carvers have coined a name for their type of "Makonde" carvings. Bennetta Jules-Rosette, in her 1984 work reveals that these carvers call the pieces "Kisanza," quite aware that what they produce originally came from the Makonde.

"Makonde" carving in Tanzania has now attained a national character in view of this ethnic composition. For instance, Chuma has for years created "Makonde" sculptures and was mistakenly included in *Masterpieces of the Makonde*, a book on Makonde art featuring Makonde sculptors. Many Zaramo artists are known for making "Makonde" sculptures for the tourist art market. However, Chuma had said that his work now cannot be identified as "Makonde" or Zaramo. On the whole, since the carvings are "Makonde" in style, while those who produce the pieces are not limited to the Makonde, the multi-creators' ethnicity necessitates a reconsideration of the name of the sculptures as "Makonde."

Patronage of State Agencies

As dealers like Peera recorded successes in their businesses, it did not take long for the Tanzanian government to show its controlling interest in the business, particularly when viewed in the social, political, and economic environment of nationalization in the 1970s. No sooner had Peera opened the warehouse at Chang'ombe than the government showed its hand. The 1970 government's move to nationalize the marketing of wood carvings within and outside of Tanzania had a notable impact on the curio business of Peera and the patronage situation under which Zaramo carvers operated. The nationalization of key sectors of the Tanzania economy began in 1967 following the promulgation of the Arusha Declaration. So, the government's decision on the carvings trade was in line with *ujamaa* policies since the goal was that Tanzania become an economically self-reliant nation—which is yet to be realized. Kasfir has rightly argued that the nationalization was designed to put the carvings trade in the hands of indigenous Tanzanians, minimizing the exploitation of artists by middlemen such as Peera.

Similarly, the government's creation of the National Arts of Tanzania (N.A.T.) in 1970 helped to control the exportation of wood carvings from the country and promote local arts and crafts. Miller contends that in addition to reflecting and concretizing *ujamaa* principles and the policy of self-reliance, the primary aim of N.A.T. was "to prevent the exploitation of Tanzanian artists and to see that artists receive a fair percentage of sales prices."[31] N.A.T. had three major objectives: to make, purchase, and export all kinds of local handicrafts and carvings, paintings, and African curios; organize exhibitions and art galleries, and promote the making and exportation of the products either through the government, semi-government or other independent agencies; and to sell all the products in wholesale only to dealers in East Africa for the intention of re-sale in East Africa.[32] These objectives aimed to preserve Tanzanian control over indigenous art.

According to Miller, in 1970 N.A.T. opened the first art gallery in Dar es Salaam to display and sell work created by N.A.T. artists at the Chang'ombe carving yard. Eighty percent of the carvings were exported, N.A.T. retained a 25 percent commission from the selling price, and the rest went to the artists. Also, Miller notes that besides providing carvers with working space, tools, and materials, N.A.T. encouraged carvers to acquire shares in the company through local cooperatives. From 1970 to 1973, N.A.T. organized exhibitions in Japan (Expo '70), Kenya in 1971, at the Commonwealth Institute in London, and the Smithsonian Institution in Washington, D.C. in 1973. The N.A.T. faced problems with inefficiency in management and organization, smuggling and illegal exportation of wood carvings, and an unpromising business outlook owing to the global economic market. In 1976, N.A.T. was reorganized and a subsidiary of SIDO called Handicrafts Marketing Corporation (THMCO), later known as HANDICO was established. Because HANDICO was essentially a marketing organization, it was not effective in art promotion. It dealt with sales promotion of handicrafts in Tanzania by organizing exhibitions, and wholesaling crafts to tourist shops, other retailers, and exporters.

When the Tanzanian government nationalized Peera's business, it appointed him the first manager of the National Arts of Tanzania. Though Peera became manager, he was not satisfied with the new arrangements of the enterprise. The artist-patron arrangement was more or less the same, but now the profit that Peera generated went to the government. Similarly, some artists were not happy with the nationalization of the business either. Consequently, some left N.A.T. to found their own workshops instead of working for the government. These carvers sold their products to N.A.T. or to tourists. But other carvers left Peera's patronage before the nationalization. For instance, in 1969 Sultani

Mwinyimkuu moved from Peera's yard and later joined other carvers in a carving cooperative called "Uzaramo Uchongaji Sanaa." The cooperative which is based along the Sam Nujoma Road at Mwenge in the city serves as a carving "village" mainly visited by tourists. At "Uzaramo Uchongaji Sanaa" Mwinyimkuu and his colleagues built their own property to serve as a workshop (fig.3.10) and the building has space for displaying their work.

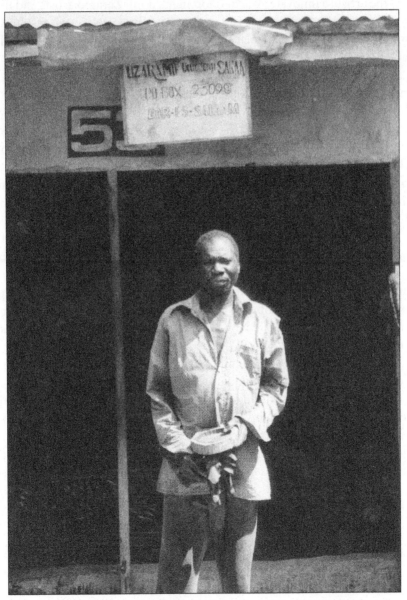

3.10 "Uzaramo Uchongaji Sanaa" studio on Sam Nujoma Road at Mwenge, Dar es Salaam, 1998

Whereas traditional patronage sanctions socially relevant arts and even tolerates change, non-indigenous patronage such as Peera's is markedly different.[33] As much of Zaramo wood sculpture was increasingly created for economic reasons to cater to a foreign clientele outside of Zaramo society, the non-indigenous patronage that sustained the art has not warranted stability or change so long as the art was easily sold. These two forms of patronage allow the artist to innovate. The developments upon Zaramo artists and their art in conjunction with other forces operating in society, have resulted in changing traditional forms, such as the mwana hiti discussed in the following chapter.

In summary, each of the major points in the chapter show Zaramo art as carving a social message, reflecting social, historical, and economic change. In this respect, we have seen the origins of Zaramo sculpture at Konde and how the art was closely connected to the social and cultural forms of the Zaramo. Additionally, the ways Zaramo sculpture shifted in function, styles, themes, and meanings as it largely served demands outside of Zaramo society. This art changed because of economics, the Maneromango school, and dealer influence. For instance, economic needs, missionary and Peera's patronage led Zaramo artists to increasingly produce figurative sculptures for use outside of their communities. We have noted positive developments in the transformations of Zaramo sculpture, and how outside influence affected both the creativity of Zaramo artists and their artistic manifestations.

In the section, "Zaramo Carving" we see that Zaramo carving is a principal vehicle for producing art objects central to defining and fostering Zaramo identity and culture. In the section, "Maneromango Carvers and Missionary Patronage" the social message here is: the school and the missionaries reshaped traditional methods and genres, but it also gave Zaramo art the recognition it deserved, in turn increasing demand. In "Mohamed Peera's Patronage" the social message revolves around his reinserting originality and individuality into creating sculpture. He invested Zaramo art and culture with the pride and originality that was discouraged at the Maneromango school where mass production art was encouraged. These points assist us in understanding the activities of the Zaramo artists, the formal, stylistic, and aesthetic elements of their art products, and the social role of Zaramo art in the process of historical and social change.

CHAPTER 4
MWANA HITI TRUNK FIGURE
A Tool for Defining Womanhood

THIS CHAPTER WILL FOCUS ON *mwana hiti* TRUNK FIGURE TO EXAMINE its artistic and aesthetic qualities as well as its role in gender construction and gender socialization among the Zaramo. Here we will consider questions of aesthetic appreciation and symbolic roles of *mwana hiti*, particularly the ways family members interact with it, and how this object becomes a tool for defining women in Zaramo society. In this way, we will use *mwana hiti* as an example of the social role of Zaramo art.

Historically, the Zaramo understand that life-cycle rites connected with birth, puberty, marriage, and death are crucial to an individual and necessary to perform. However, here we will focus on puberty rites for girls which predominantly use *mwana hiti*.[1]

Maturity rites for Zaramo women include the *mwali* practice. The custom still occupies a central position in Zaramo society even though the Zaramo have been exposed to foreign influence because of the location of Uzaramo. *Mwana hiti* figurines form a distinct type of wood sculpture in the Zaramo sculptural corpus, and are an integral part of these rites of maturity and identity. In the *mwali* rites a young Zaramo girl is given a *mwana hiti* figurine to prepare her for her future adult role in society as a woman and mother. Zaramo boys undergo a rite called *jando*, an influence of Islam and Swahili society. *Jando* includes circumcision and teachings about adulthood. It is a Zaramo men's rite that runs parallel to the *mwali* custom. The Zaramo's continued adherence to the *mwali* practice and the *mwana hiti* sculpture up

to the 2000s indicates that they still use the symbols and values which help shape their own vision of the world and give meaning to their lives. Thus, it is necessary to examine the historical and contemporary significance of *mwana hiti* trunk figure to the Zaramo. This will enable us to grasp the forces active in preserving and modifying *mwana hiti*, Zaramo traditional values, and Zaramo culture, all within the context of social changes and modernity.

What is *Mwana hiti*?

The term *mwana hiti* consists of one Kiswahili/Kizaramo word—"*mwana*"—and one Kizaramo word—"*hiti/nhiti*." The variant term of *mwana hiti* is *mwana nya kiti*—the Kiswahili version of the Kizaramo term *mwana nya nhiti*.[2] "*Mwana*"means child in both Kiswahili and Kizaramo, referring to a state of dependency. "*Nya kiti*"and "*nya nhiti*" can refer to "of wood" or "of chair." The Kiswahili word for something to sit on such as "chair" is "*kiti*." "Child of wood," which is a Zaramo translation and a descriptive designation, fits *mwana hiti* as Salome Mjema asserts: "Mwana is a baby, a baby made of wood. Kiti is wood." Some Zaramo though call this trunk figure *mwana mkongo*. *Mkongo* is the name of the tree often used to make the wooden figurine. In this sense, statements like "*Mwana nyakiti* could be interpreted to mean a child of the one with the chair"[3] (perhaps signifying the Zaramo headman), or the implied meaning of *mwana hiti* as "daughter of the ancestor,"[4] need further substantiation. Among other factors, variations in language in the Zaramo area have contributed to the multiple versions and meanings of the image which range among

> child made out of wood, wooden daughter, child from the tree, daughter of the sacred tree (*mkole*), child of the initiation stool, daughter of the initiation chair, child of the throne, daughter of the chief's stool, child of the clan, daughter of the lineage, or any combination of these.[5]

Although the term is indeed debatable, it is plausible to settle for "child of wood" considering that this sculpture representing a child, is carved from wood.

In Chapter 3 we discussed that a variety of carved Zaramo objects incorporate three-dimensional human representations. Some of these are carvings of *mwana hiti*. Thus, the Zaramo utilized the image of *mwana hiti* in a broad range of objects such as prestigious walking sticks of chiefs/headmen, healing staffs used by *waganga*, posts erected in initiation areas/enclosures,

stools, musical instruments, fly-whisks, grave posts, and trunk figures used in the *mwali* rites. But as already noted, our concern here is on the *mwana hiti* trunk figure that the *mwali* is offered during her ritual seclusion.

When a Zaramo girl reaches puberty, she is called *mwali* and she is secluded (*kualikwa*) indoors at the onset of her first menstruation. And because a Zaramo father cannot take part in his daughter's puberty rites, his sister, the paternal aunt called *shangazi*, represents him. It is the responsibility of the *shangazi* to ensure that the *mwali's* teachings and ceremonies are conducted in an appropriate manner. Among the family taboo articles that the *shangazi* gives the initiate is a wooden figurine, *mwana hiti*, or a calabash version of *mwana hiti* called *mwanasesere*. The gourd has many seeds and was believed to enhance female fertility. The choice of a wooden or gourd *mwana hiti* depends on the tradition of the family or clan, but the *mwali* must take care of the figurine like a child: keep it clean and oil it. As Mjema explains,

> They say it is your baby. So you should make sure that you have it
> with you because it protects the power of reproduction.[6]

(fig.4.1). The *mwali* may wear the figurine around her neck (as she does at her coming-out ceremony), carry it on her back with a wrapper (the way a baby is carried), tie it to the foot of her bed, or place it under her bed. Again, this depends on the tradition of the *mwali* family.

4.1 A Zaramo *mwali* holding her *mwana hiti* wooden figurine during ritual seclusion

In form, the *mwana hiti* trunk figure usually measures five inches. Of the two examples that I saw in 1997 at the Museum and House of Culture in Dar es Salaam, one was very small. All *mwana hiti*, however, primarily appear in the same sculptural form: they represent a highly stylized female torso with an equally stylized head (figs.1.2, 4.2). *Mwana hiti* may be seen to depict a woman than a baby. In fact, the Zaramo (woman) with whom I spoke, Mode Kuga, opined that the figurine represented the *mwali*, perhaps because of its

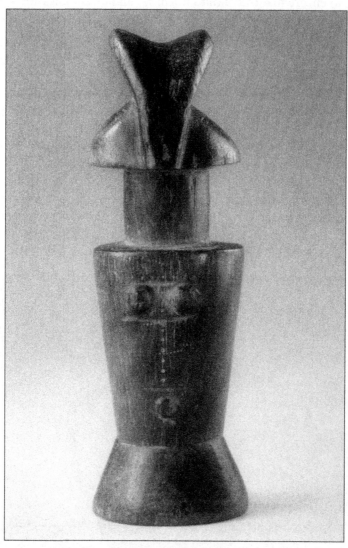

4.2 A *mwana hiti* trunk figure of the Zaramo

form and decorations.[7] Carved from a single piece of wood, the figure is cylindrical, portraying a female body with no legs, arms, or genitals (figs.1.2, 4.2-4.6). Breasts, a navel, and waist are depicted (figs.1.2, 4.2-4.6). A sagittal crested head is sometimes fitted with hair or fiber as shown in figure 4.3 and 4.6. Facial features were merely suggested (probably as figs.1.2, 4.5 shows) or often absent (figs.4.2, 4.3, 4.4, 4.5, 4.6). Bulbous protuberances that flank the crested head as clearly represented in all of the six examples may represent ears.

Decorations can include metal discs on the hair (perhaps in figs.4.3, 4.6), metal chains (fig. 4.6), and strings of small white beads around the neck and waist (figs.4.3, 4.4, 4.6). Interestingly, though figure 4.6 depicts the main features of a *mwana hiti* figure with abundant jewelry, the seemingly peculiar base of the figurine suggests that perhaps it was part of a musical instrument.

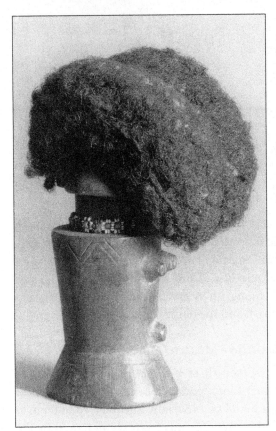

4.3 A Zaramo *mwana hiti*

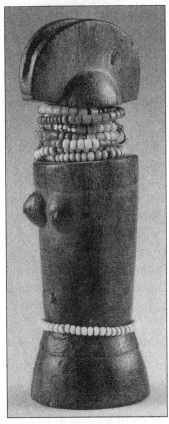

4.4 A *mwana hiti* figurine of the Zaramo

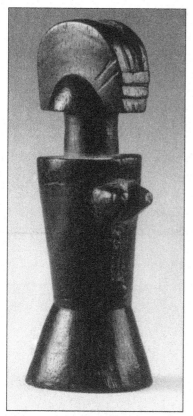

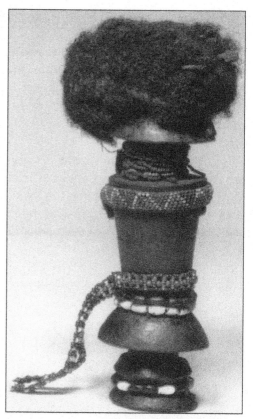

4.5 A *mwana hiti* trunk figure of the Zaramo/Kutu

4.6 Zaramo *mwana hiti* which was probably a part of a musical instrument showing long hair, abundant jewelry, and a peculiar base

However, this sculpture may have stood on a very small stool. The calabash version (fig.3.5) may also have hair attached but the face is not indicated. Beads, incision, and other decorations might appear as well. The *mwanasesere* example at the Museum and House of Culture in Dar es Salaam, collected between 1944 and 1947, depicts among other carved decorative motifs a heart-shaped face, a bird, a wheel, a heart, and the name of the carver.[8]

Mwana hiti and the *Mwali* Practice in a Modern Context

In 1961, J. R. Harding misrepresented three *mwana hiti* objects acquired between 1944 and 1947 for the then King George V Memorial Museum (now the Museum and House of Culture) in Dar es Salaam. She referred to them as "relics of a custom (the '*mwali* custom') that was formerly practised by the Zaramo." This statement misguidedly posits both *mwana hiti* and the *mwali*

practice as if in the past. In other words, she describes them as part of a dead culture while in fact they were not. Even in 1961, when Harding was writing, the *mwali* custom was very much a living custom. The tradition was and still is burgeoning in the largest center of modernity in the country—the former nation's capital Dar es Salaam. Contrary to Harding's position, some five years later (1966) in her study of women's life-cycle rites, M-L. Swantz acknowledged that it was not easy to explain why the Zaramo loyally continued to follow their *mwali* custom whereas the other groups she studied did not follow theirs. She writes that,

> In recent times the Zaramo have been in closer contact with the Muslim Swahili who also practice this type of seclusion, and this might have given the custom certain new religious meaning, but on the other hand, the Christians also have adhered to it up to this time.[9]

Given the importance of the *mwali* practice to the Zaramo, it appears that religious affiliation (such as Islam and Christianity) has not barred the Zaramo from practicing this custom. This religious and cultural traditions have been accommodated in traditional Zaramo culture without threatening the custom. For instance, since there was a flexible interaction between Islam and indigenous cultures on the East African coast such as Zaramo, Kwere, and Swahili, and given that "the practice of confining girls at puberty is not uncommon among the Arabs,"[10] this interaction may have positively enhanced the *mwana hiti* figurine and the *mwali* rite among the Zaramo. With regard to Christianity, Mjema informed me that though Christian missionaries in Uzaramo strongly discouraged their Zaramo converts from following traditional Zaramo rites, they did not completely succeed in this endeavor because they had no consistent philosophy in this regard. She offers the example of her grandfather who was a Lutheran, but was excluded from the Lutheran Church because he wanted his daughter to participate in the *mwali* rite. Following the dismissal of Mjema's grandfather from the Lutheran Church, he joined the Anglican Church where apparently he experienced no conflict and remained a member until his death in 1987. In this connection, all his sons and daughters went through the Zaramo coming-of-age rites. In cases where the missionaries failed to break Zaramo adherence to traditional rites, the missionaries opted to reform the custom as illustrated by missionary Anna von Waldow's strategy at the Maneromango mission. Using a boarding school to seclude young Zaramo girls instead of their natal homes, Waldow followed the rite's frame-work while introducing changes like Christian

teachings and the use of Zaramo women as instructors.[11] Though Waldow's endeavors were credited with success, there were conflicts of interests among fellow missionaries. This incident concerning Waldow's strategy underscores the relevance of *mwana hiti* and the *mwali* practice to the Zaramo and shows Zaramo determination to keep certain traditions alive in the face of modernity.

Even though *mwana hiti* and the *mwali* practice have survived, these traditions have certainly been affected by change. These changes have affected the ways Tanzanian girls were being prepared to take up adulthood. To cite an example, Alice Nkhoma-Wamunza narrates the life history of a Tanzanian woman belonging to the Nyasa ethnic group, Anna X, who also talks about her experiences at puberty:

> Among other things my aunt explained to me was that what I had seen was a sign that I had now become a woman. She taught me how to behave and respect older people and she also emphasized body cleanliness and personal hygiene on my part. She told me about what I could and what I could not do. . . . I realized this must have been my first lesson in sex education. But at that age it was not easy to understand such deep matters. . . . Things are different today, for, there is a lot of information in written form which one can read on her own. In the past, most people were still conservative and you could not find such information in newspapers or hear them on the radio so openly. . . .The introduction of formal education meant that a girl could not be kept in the house for a long time as it would interfere with her schooling. So while staying with my aunt I was only taught the basics and a few facts of life which I did not even understand; and I went to school as usual.[12]

This quote illustrates the changes to the tradition of preparing Tanzanian girls for adulthood.

In the Zaramo *mwali* custom the confinement and restrictions during the ritual of seclusion vary. Today the seclusion period has been shortened. In the past, it used to last several years since the coming-out ceremony and the marriage of the *mwali* would take place at the same time. In recent years the seclusion may take a few months or weeks, which reflects the changes taking place today among and around the Zaramo. Apart from the length of time that the ritual takes, consideration has been given to aspects such as value of time, occupations, and the rites' running costs. For girls who attend school, the seclusion takes a few days: Omari Abdallah's granddaughter was secluded

for seven days while in Class V. Permission to attend the rites was sought from her primary school teacher. I noted this trend when working as a teacher in Uzaramo in the late 1970s and early 1980s. Zaramo girls would go through the puberty rites during the school holidays as was the case with Mjema in 1973:

> At that time I didn't know what they were planning, when they would take me out, when they were doing things up. Of course they were influenced somewhat by the school holidays. Actually, I came out on a Sunday and on the next Monday I started school. So it had to be a very short time and they had to do everything at that time.[13]

This shows how the *mwali* seclusion rite has been affected by social change in Zaramo society.

Wembah-Rashid, in his 1970 paper discusses these changes in the rite among the Kwere, changes that similarly apply to the Zaramo, and rightly interprets the modification of the seclusion of girls at puberty who must attend school as an "exercise of modernity into traditionalism." The parents are pressured by social change because their daughters are expected to go to school. Additionally, adhering to tradition by secluding the girls as part of the coming-of-age ceremonies adds more pressure. Wembah-Rashid goes on to note that colonial governments as well as post-independence Tanzanian governments took severe measures in the form of heavy fines and imprisonment against fathers who observed the rite at the expense of their daughters' education. Clearly these colonial and post-independence government measures were aimed at breaking the hold of this culture. Having realized the importance of this rite to society, post-independence governments have offered room to accommodate the rite without forfeiting school education.

Traditional restrictions governing seclusion prevent the Zaramo *mwali* from meeting men, especially her father. Zaramo women informed me that the *mwali* was not allowed to meet her father because of her dress. While in seclusion the *mwali* wore a piece of cloth around her waist, which covered the lower part of her body, leaving the upper part uncovered. She may see female members like grandmothers and sisters in the household and close relatives such as aunts and cousin-sisters. Her female guardians and an older female instructor, a *kungwi*, keep her company along with the *mwana hiti*. The *mwali's* mother is not allowed to serve as her daughter's *kungwi*, however. Today it is not uncommon to see the *mwali* in the backyard of her home, even with male

relatives. For example, in the late 1970s while in the company of a *mwali* Zaramo suitor, I happened to have a very brief opportunity of seeing a Zaramo *mwali* in seclusion. Perhaps this particular visit was allowed as a courtesy to the *mwali's* suitor, but also, I happened to be the *mwali's* former teacher.

The women's roles that historically the *mwali* rite underscored and reinforced are encapsuled in the position of women in the life of the community. Women's roles included involvement with economic production at the family and community levels, housekeeping, bearing and caring for their children, and socialization in society at large. Ideally, the seclusion aims to fatten and lighten the *mwali* to increase her fertility, to protect her from sexual contacts, and instruct her to be respectful to family members. She learns household chores such as cooking and cleaning, sexual matters, and how to associate with her husband. Girls in the past may also be taught crafts like pottery and basketry. Given modern education and contemporary life, the focus of instruction now is on learning matters of Zaramo women and how to be a good wife. During the last rites before her coming-out, the *mwali's* instructions stress moral and sexual behavior and responsibilities of a wife—appropriate behavior toward relatives, her potential spouse, co-wives and children. The *mwali's* attention is also drawn to the Zaramo ideal qualities of a woman which stress hard work, generosity, and discretion.

The *mwana hiti* and Kizaramo are still the languages of instruction in these coming-of-age ceremonies. However, the Kizaramo language is declining in use. It has been observed (and my own research supports it) that Kizaramo is gradually being replaced by Kiswahili and its latent Muslim values and gender categories. Today when Kizaramo is used in ritual, it often presents some problems of misunderstanding which necessitates a Kiswahili translation, especially in cases where the message must be precise.[14] By late nineteenth century, Kizaramo was spoken even in Zaramo villages close to Dar es Salaam and European explorers observed that most Zaramo used Kiswahili as well. Today, some Zaramo families living in the city periodically send their children to their rural kin to learn Kizaramo. These Zaramo are anxious lest the younger Zaramo generation is cut-off from Zaramo traditions. Also, they seem to recognize that not only is language crucial in the formation of identity, it offers a vehicle through which important social values are shared among its members. In this way, language expresses a given culture.

The Zaramo's adherence to the *mwana hiti* figurine to mark the passage to puberty affirms the resilience of these cultural traditions. Similarly steadfast to tradition are the men who carve and decorate the figurines. Although according to Chuma not everyone in Uzaramo carves *mwana hiti*, he considers himself prolific at making it. Zaramo women seek reputed carvers even if it

means traveling long distances to commission them. For example, because of Chuma's carving reputation these women would travel from as far as Kisarawe to secure Chuma's services in the city.

The business of commissioning *mwana hiti* offers incredible insight into artist and client interaction. By examining such an exchange between Chuma and Zaramo women we discover which facets are important. Chuma was only commissioned when a Zaramo family wanted to initiate a *mwali* and only if that family does not have a *mwana hiti*. Zaramo women asked Chuma to carve only one *mwana hiti*, and not several figures. It would take Chuma about two to three days to carve one figurine. The Zaramo women who commissioned Chuma are adults who certainly know the difference between a "good" and "bad" *mwana hiti*. The fact that they sought out Chuma means that they were looking for skill, precision, correct forms, and embellishment. In any case, Chuma states that as a Zaramo, he knows the tradition and (probably because of his skill) has never been criticized for creating a bad *mwana hiti* piece. This shows that Zaramo women who sought Chuma's prolific carving skills were assured that he would create a good *mwana hiti*. In a sense, after the women have made a choice between a wooden and a gourd *mwana hiti*, seemingly they would not tell Chuma how the form should be produced; they would leave the design choices to him. Usually Chuma would purchase the wood while the women provide the items for decorating the sculpture, for example, strings of beads. Although these clients may ask Chuma to embellish the *mwana hiti* after he had carved it, in most cases he would not do so. The women would then decorate the figurine in readiness for the rites.

According to Zaramo traditions, Chuma must conduct a transaction dialogue to ascertain the family of the women and why they want *mwana hiti*? This is another reason why the women sought out his sculptural skill—he could tailor work he produced to be relevant to the family. The figurine is not made just for anybody, given its crucial role in Zaramo cultural traditions. Also, Chuma had to negotiate both the dues for his services and the method of payment. The transaction to ascertain cultural propriety may go as follows:

> *Nomuuzani mwenu zile hano lukolo gani?*
> I am asking you, what is your clan?
> *Mlala kwa?*
> Where are you from?
>
> *Tulala wilaya ya Kisarawe twiza kwa Mzaramo mwiyetu*
> We come from Kisarawe District to visit a fellow Zaramo
>
> *Muwinza choni?*
> What are you after?

Tuinza utusongolele mwana nya nhiti
We have come to ask you to carve us *mwana hiti*

Haya mwana nya nhiti ino mumlonda kwa sanghano gani?
What do you need *mwana hiti* for?

Tumlonda tuna mwali nng'anda twenda tumvine lusona.
Kama twenda kumvina lusona, mwana nya nhiti wetu wa umwaka
kaga. Kwa hiyo, tuiza kwa mwiyetu hano twakukula utusongolele

We need it for we have a *mwali* we want to initiate. Even as we
want to initiate her, our old *mwana hiti* is lost. Therefore, we have
come here to our fellow to request that you carve for us.[15]

When Chuma is satisfied with the explanation given by these women, and
when both parties have agreed on a charge for the work, Chuma would ask
the women to assure him that when the figurine is completed they will return
to his studio to collect it. Understandably, Chuma had to get this assurance
from his women clients since the *mwana hiti* figurine is not carved for sale.
His clientele may pay a part of the price and settle the remaining sum when
mwana hiti is ready for collection.

Mwana hiti role opens up ideas about consolidating family identity. *Mwana
hiti* is not owned by an individual, but by a family whose daughter uses it
before passing it to the next generation. When the *mwali* gets married, she
takes *mwana hiti* to her husband's house and puts it on the bed. Since the
figurine belongs to the *mwali's* clan and not the husband's, eventually the
object is returned and kept in *mwali's* natal family to be used by another *mwali*.
Thus, the *mwali* and her spouse are not *mwana hiti's* custodians, but rather
her clan is. The next time around, the *shangazi* will once again give the figurine
to a girl in the clan who has become *mwali*. So, the *mwana hiti* participates in
constructing Zaramo female identity by symbolizing her values, traditions,
and matrilineal heritage. The figurine could be retained in the *mwali's* natal
family for up to forty or fifty years, perpetuating both this tradition among
the Zaramo and the long line of female identity history. For instance, Mjema
believes that her *mwana hiti* was probably created in the 1940s. This means
that her family followed tradition since it handed the figurine down the female
line to Mjema. And as tradition dictates, Mjema should have returned the
figure to her natal home for a younger sister's use when she too becomes
mwali. In any case, she must have good reasons for keeping her *mwana hiti*.
Some art historians have speculated that older figurines "were better than
newer ones because they were more likely to be effective."[16] This view is

misguided. For the Zaramo certainly do not think because they have formal procedure for creating *mwana hiti* replacements means they do not value the old *mwana hitis*. Though acts like Mjema's may break the object's transfer, we should consider the more plausible explanation that Mjema offers. She maintains that *mwana hiti* signifies continuation, reproduction, and fertility. The central issue of the *mwana hiti* object is maintenance of the tradition, not so much the age of the object used to define and perpetuate that culture. This may partly explain the use of *mwana hiti* in other Zaramo ritual and household objects.

The use of *mwana hiti* assists in socializing the *mwali* during her ritual seclusion. It is necessary, though, to provide a brief, general reading of gender socialization in Tanzania. I should point out that in this general overview of socialization, some of its elements are culturally specific, varying from one ethnic culture to another within the broad ethnic and cultural diversity of the Tanzanians. Tanzanian women's scholars Fenella Mukangara and Bertha Koda, in their 1997 work, state rather generally that in the socialization process in Tanzania, social norms, beliefs, and traditions are passed on from one generation to the next at all times and in all places, but mostly at the family level where the mother has the greatest share. But this statement is not specific to any particular ethnic group in Tanzania. We saw among the Zaramo that in the *mwali* practice the mother is restricted by tradition not to serve as her daughter's *kungwi*. Even so, this is not to say that outside these puberty rites the Zaramo mother cannot participate in the socialization of her children. Mukangara and Koda go on to observe that the means utilized in the process of socialization in Tanzania stress "gender differences and the superiority of boys and men, as well as the inferiority of girls and women." They further assert that even as child socialization through oral traditions is declining while school and media forms are expanding, the influence of the patriarchy is evident in socialization at the family and community levels: schools, peers, recreation, religion and media. Furthermore,

> Girls are socialised to be hard workers, many take on small errands and other work at an earlier age than boys. Roles assigned to girls tend to be more repetitious (toting water, washing dishes), just the same as their mothers. Girls are also trained to be softer, dependent, and beautiful (wearing earrings, plaiting hair, painting nails) while boys are trained to be tough, protectors (guns, bows and arrows are their toys).[17]

In this quote, Mukangara and Koda do not specify where these boys and girls belong. Are they talking about village boys and girls, or are these urbanites? Additionally, are these low class boys and girls, or middle and upper middle class? These general views on socialization in Tanzania help to show a larger socialization process in which Zaramo girls participate even as the Zaramo *mwali* is prepared in the ways of Zaramo culture to fulfill her social role. The *mwali* ceremonies help in gender socialization.

During the *mwali* confinement she must look after her *mwana hiti* as her child, for, as Chuma asserts, Zaramo women perceive the *mwana hiti* trunk figure as the *mwali's* symbol of her baby. Obviously, the figure works like a tool to gauge how the *mwali* will take care of her baby when she has one and to teach how to look after herself beauty-wise. In this way, *mwana hiti* acts as a symbol of womanhood. That would explain why, as Mwanamkulu Lamba, Ramadhani Minyimkuu, Mode Kuga, Zena Mwinyihija, and Chuma submit that the *mwali* bathes the figurine with a mixture, rubs it with oil, dresses its hair in a popular Zaramo hairstyle (the two-part hairdo) which she also wears, and feeds it (though symbolically). While in seclusion, the *mwali* is forbidden from using water except for washing after her periods. Instead, she applies a mixture to clean herself and lighten her complexion and repeats this procedure on the figurine. Thus, the *mwana hiti* object serves a dual purpose: as a teaching tool and a ritual symbol marking the *mwali's* passage from childhood into womanhood. In a sense, the *mwali* would see the object as a representation of a child as well as a representation of herself primarily because in seclusion the *mwali* is still a child and after undergoing the rites of maturity she becomes a woman. The *mwali* identifies with the figurine since it becomes the central object which she interacts with throughout the confinement—she takes care of the object as she does of herself. Using the *mwana hiti* object coupled with other *mwali* instructions, a Zaramo girl is taught in the Zaramo women's ways, especially the expected role she would fulfill in society as a woman and mother. In view of the *mwali's* future roles and expectations, *mwana hiti* is used for instilling and developing a caring, nurturing consciousness in the *mwali*.

Among the Kwere the *mwana hiti* is directly linked with the fertility of the *mwali*. Wembah-Rashid has observed that

> the girl is plainly told to exercise great care over the doll that she may be bestowed with fertility. It is also clearly stated that if she does not show the necessary motherly love to the doll, she would be punished by being denied fertility.[18]

This shows the Kwere way of preparing girls psychologically for conception. While the Kwere women whom Wembah-Rashid interviewed did not clarify who would ascertain the appropriateness of the *mwali's* behavior, they asserted that the figurine possessed strong powers which could work either way, depending upon the way the *mwali* treated it. In the case of the Zaramo, Chuma states that Zaramo women believed that a Zaramo girl who does not use the figurine when undergoing initiation may not bear a child. Seen in this light, the objective of the figurine is to socialize the girl to the idea of wanting and desiring a child, not to establish a one-to-one fertility relationship. Though in Tanzania "each woman is socially expected to get married," in Zaramo culture getting married is not as important as undergoing the *mwali* practice and the coming-out. For traditionally, a Zaramo girl who had undergone the *mwali* custom could have sex after she comes out. This suggests the importance attached to bearing children. And as Cuthbert Omari writing in 1995 has put it, the need for children in African societies is connected with cultural and economic goals. For cultural considerations, he cites the desire to have children in order to perpetuate and strengthen the clan's name and family tree, and to offer security in old age. The economic motives for having offspring rest on the theory that many children will create wealth for the family. It is not explicit the number of children a *mwali* may have by adhering to the *mwana hiti* tradition among the Zaramo or the Kwere. It is explicit, though, that she needs the *mwana hiti* to strengthen the odds that she will bear children.

The trunk figure also serves as a *tambiko* or sacrifice. For example, a married Zaramo woman who experienced difficulty in conceiving may be asked to repeat caring for *mwana hiti* as in the *mwali* rite. This works on the principle that you get what you desire and will. And one whose first child has passed away might be told to go through another period of seclusion and care for *mwana hiti* as a *tambiko*, a rite meant to gain and sustain a favorable tie with her ancestors.[19] Though the assumption is that she probably did not take proper care of *mwana hiti* while she was shut in, it is not clear whether repeating the rite in form of a *tambiko* resolves the misfortune of not bearing children.

Mwana hiti's Form, Style, and Symbolism in a Changing Social Climate

Part of the problem of understanding symbols inscribed in art objects and their meanings lies in the nature of symbols and the methodology employed to interpret them. This includes some measure of their inaccessibility to the uninitiated or outsiders seeking information about them. To understand symbols belonging to another culture is cumbersome, more so if the cultures

in question are not related and are separated in space and time. Moreover, symbols are not static but change over time and space and acquire new meanings. Meanings are locally produced and negotiated. To cite an example, research associates who seem knowledgeable in the symbols of a particular culture and are willing to divulge information on them may fail to do so. Part of the explanation is because they do not really know the symbols and the meanings embedded in them. But also, they may have to adhere to strict prohibitions on a cultural form, its symbols, and their esoteric meanings. And since in a majority of cases such knowledge is the preserve of only the initiated members of that particular society, it becomes obvious that the knowledgeable members may not offer information of that kind to foreigners crossing cultures. When they divulge such information to "uninitiated peoples, especially foreigners," Felix, for one, experienced that there is a limit to the information provided. Research associates who have no knowledge of the symbols and meanings may conceal their ignorance by offering wrong exegeses to researchers as they may feel uncomfortable in refusing to cooperate.[20] It is increasingly clear how pinpointing meaning can be extremely difficult because it depends on gaining often privileged information. In any case, my analysis of *mwana hiti* avoids the problem in that I speak Kiswahili. Furthermore, this analysis is complemented by systematic cross-checking and critical review of other people's interpretations. On the same token, I am not suggesting that this analysis resolves the variance in reading the *mwana hiti* symbol among the Zaramo and scholars, upon whom my interpretation primarily rests.

With these insights in mind, I attempt to analyze the symbolism and meaning of *mwana hiti* not only to understand it, but also to discover its importance in Zaramo culture. At the same time I will also address the significance of forms in Zaramo culture. For example, what does *mwana hiti's* jewelry signify? What are its various levels of meaning? The same applies to the *mwana hiti's* sagittal crested head. What is the significance and status of women in Zaramo culture? I utilize the six wooden *mwana hiti* objects (figs.1.2, 4.2-4.6) for illustration and I integrate other people's interpretations of the figurine in this analysis.

Sculpturally the wooden *mwana hiti* appears to depict a female body. For M-L. Swantz, *mwana hiti* is "a stylized figure that symbolizes at once the vagina, the penis, a child, and the clan."[21] It is unclear whether M-L. Swantz's interpretation derives directly from Zaramo research associates or if it is her own reading. To be sure, even among the Zaramo there is a variance in interpretation of the sculpture and the symbols encoded on it. Different readings are a common phenomenon in symbolic analysis. For instance, Felix received varied responses on what the trunk figure represents. Answers

included that it symbolized an old lady, the spirit of a clan founder, a woman, a baby, a boy, a fetus, a young girl, the male and female founders of the clan, a penis, a man, a portrait of the first woman, and the first two human beings.[22] All of his research associates, however, were in agreement on one single item: that the figure resembled a human being. In my own research[23] I found that whereas Sultani Mwinyimkuu told me that *mwana hiti* does not represent a human being, Chuma saw that it was a shade of a human being and a representation of the *mwali's* baby. Furthermore, Omari Abdallah, Ramadhani Mwinyimkuu, Selemani Mungi, Cheusi Abdallah, and Mwanamkulu Lamba interpreted the figurine as representing a child. They called it *mtoto*, a baby. Lamba narrated how Zaramo women would commission a carver to create *mwana hiti*: "*Kanikatie mkongo unifanyie mtoto*" meaning, cut an *mkongo* and make a child for me. However, Mode Kuga stated that it represented the *mwali*. Zena Mwinyihija, Yusufu Mgumba, and Ali Bilali related *mwana hiti* with the *mwali's* hairstyle when in seclusion. Mjema affirms that *mwana hiti* is a wooden high quality piece of art symbolizing a female body but incorporating male sexual organs. It represents the unity, circle, and continuation of life. In a nutshell, fertility and reproduction. I might add that a simpler interpretation would be that though the figurine is not a lifelike representation of a human being, it may represent a human body given some resemblance with the morphology and features to that effect.

Differing interpretations of the icon further complicates the quest for meaning. For instance, even what appeared as obvious human organs—a head with a crest, breasts, a navel, and a waist (fig.1.2, 4.3)—are open to different interpretations.[24] Those asked about the head almost unanimously said it was indeed a head, even though some thought it represented the glans of a penis (fig.4.2). Because of what appear to be breasts (fig.4.5), logic would dictate that the figurine symbolized either femininity or fertility. However, some saw the navel (fig.4.3) as a penis, rendering the evident breasts those of "a fat, wealthy male." When I asked Mwanamkulu Lamba why legs were not depicted, she stated that doing so would necessitate the depiction of genitalia as well. Asked why sexual organs were not visible, some rightly said it was rude to show them while others argumentatively explained that because *mwana hiti* is both male and female, it is not necessary to be explicit. It becomes increasingly clear that just as various interpretations were given on the image, its features or symbols were also interpreted differently. But the inconsistency in interpretation of *mwana hiti's* features should not be surprising considering the emphasis and level of information offered about the *mwali*. Also, variations in the ways people understand the image and its connotations within the culture complicate the matter. If in fact, the *mwali* is told that *mwana hiti* is

essentially *mwanasesere/mtoto wa bandia* (not really a child, but a doll that stands for a child), it may follow that not many *mwali* would bother with interpreting the image since for her its use is purely practical. Because there is no definitive artistic, stylistic, or cultural meaning, the *mwana hiti* is invested with a polyvalent quality in which all interpretations have value.

Writing on traditional sculptures of the matrilineal societies of East-Central Tanzania, Castelli contends that the dominance of the female figure in the art of the area indicates the significance and centrality of the female. The female figure is identified by features such as pointed breasts, a navel, and elaborately carved hairdo. These female sculptures provide an image of a maternal figure—the mythical grandmother perceived as the symbol of fertility and motherhood with the ability to bear many children. For Castelli, pointed breasts and a navel on these figures show that the sculptures depict a human body. Pointed breasts (fig.4.4-4.5) signify beauty of a *mwali* after a long seclusion. Further, hairdo symbolizes the artistry and smartness of the initiated. Ultimately, the female sculptures attest to the continued tradition of celebrating the female body and the ability to bear children through art objects and puberty ceremonies for girls.

Commenting on the *mwana hiti,* some art historians argue that its appearance corresponds to its meaning—that some of its aspects refer specifically to the *mwali*. This observation also suggests that the metal chains and string of beads around the neck of some figures (fig.4.3, 4.4, 4.6) correspond to the necklaces that the *mwali* wears. Following M-L. Swantz in her 1970 study, Pelrine submits that in a number of Zaramo clans the *mwali* wears such necklaces as

> a symbol of their taboo concerning a large python and a prohibition against pulling anything along the ground so that it leaves a line resembling the path of a snake.

However, in her 1995 book M-L. Swantz offers another interpretation of these necklaces. She claims that the chain represents a snake which has significance in traditional symbolism and that the white beads, which now replace the snake vertebrae that were used in the past, symbolize children and the chain of generations. Mjema informed me that

> the chain of pearls (beads) or iron is given by the aunt (father's sister) and is hung on the girl's neck throughout the seclusion. It is a family heirloom which symbolizes the snake. The snake in turn represents a male symbol.

The problem with Pelrine's, M-L. Swantz's and Mjema's reading of these matters is that rather than elucidate the problem they further cloud it. Their interpretations do not provide a persuasive analysis of the figurine. So, we may as well agree with some Zaramo who, for the most part, take these metal chains and strings of beads only as decorations. Yet interesting enough, the beads around the waist of *mwana hiti* (fig.4.4, 4.6) possibly represent the waist beads worn by Zaramo women when seeking to sexually please and arouse a man. A woman who does not wear waist beads is considered incomplete. At any rate, the metal chains and strings of beads as items of decoration do not rule out other symbolic meanings that the chains may hold. Indeed, they add a crucial element to the formal design of *mwana hiti* as mixed media, not just sculpture. It is worthwhile noting that the interpretations need not be mutually exclusive.

The *mwana hiti* hairdo is generally viewed as representing female sexuality, or fecundity. M-L. Swantz's assessment is that it "has its hair parted down the middle from front to back, a separation symbolic of the vagina." Recounting her *mwali* initiation experiences, Mjema recalls:

> My hair had been braided with the separation in the middle for the whole time. They call it moja-moja, 'one and one' because it is parted in the middle. The part in the middle means the vagina.

In our *mwana hiti* examples showing the crest with hair (fig.4.3, 4.6) actually we do not see the moja-moja hairstyle, but figure 4.2 gives a sense of what it looks like. That is, if we can imagine hair or fiber pasted on either side of the separated head from front to back. There is every likelihood that some of the figures were carved in this style to show the two-part crest. Certainly this does not explain some *mwana hiti* styles whose head is different from the one in figure 4.2. It is also unclear whether such styles had a crest of hair and how the fiber that represented hair was attached to the head. The crest of *mwana hiti* seemingly depicts an old-fashioned hairstyle—the two-part hairdo that was characteristic of Zaramo women and noted by early European travelers passing through Uzaramo. The Zaramo were distinct because of their clay-plastered hairstyle, usually parted in the middle (fig.4.7). Though Felix was told in the field that the crest shows this typical Zaramo hairdo, some of his research associates (mainly female) stated that

> only initiated women knew that this crest was in fact a vagina, and that the labial hypertrophy it depicted was a sign of beauty and a sexual asset.[25]

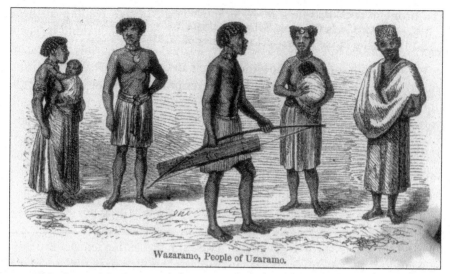

Wazaramo, People of Uzaramo.

4.7 A nineteenth century drawing of the Zaramo. Note the two-part hair style

Of more interest here is that the two-part hairdo is still worn today (without clay) and not simply a thing of the past. Mjema wore it during her puberty ritual confinement in 1973. Also, some *mwali* continue to wear it at the culmination of the *mwali* seclusion. Some striking similarities exist between Zaramo women's ornamentation and decorations on some *mwana hiti*. But this cannot be said for all *mwana hiti* largely because of variations in style among the families' *mwana hiti*, and because of other forces of change in Zaramo culture that have influenced the making and embellishment of the figures.

Though the *mwali's* style of ornamentation and decoration differs from that of the past, these elements remain important in the *mwana hiti* and the coming-out celebration. As noted in Chapter 3, early European visitors reported that Zaramo women wore abundant jewelry. A correlation can be made regarding the profusion of beads on some *mwana hiti* (fig.4.6) as reflecting the jewelry that Zaramo women wore. On this issue of jewelry, it is useful to compare figure 4.6 with figure 1.2, 4.2-4.5. Though Chuma asserts that the coins stuck in *mwana hiti's* hair were meant to beautify it, he did not make a parallel observation with decorations on the *mwali* as Pelrine has done. In her 1991 study Pelrine suggests that parallels between the *mwali* and the icon are coins in the hair of some *mwana hiti* and in the *mwali's* hair, those given as gifts to her during her coming-out ceremony (fig.4.8). Harding noted

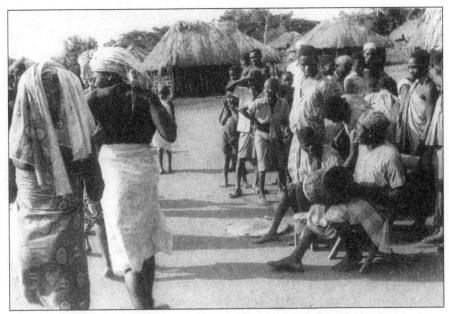

4.8 A *mwali* coming-out celebration in Bagamoyo District, 1974

in 1961 that "the *mwali* received gifts of clothes; the *mwali* doll was hung round her neck and cent pieces were laid on her head." She goes on to write that the coins were called "celebration cents" since they were given to the *mwali* at the dance marking the end of her rites of maturity and identity.[26] What Harding says here may still apply to some Zaramo families at a *mwali* coming-out celebration with the exception of these "celebration cents." Given the monetary value of the Tanzanian currency today, the girl is likely to be offered currency notes, not coins. As previous *mwali* practices and current ones compare on the *mwali's* decorations and ornamentation, today the coming-out event is also a day for showing the wealth and prestige that the family bestows upon their daughter, hence, all the gifts she is given are displayed in the yard. Mjema observes that the *mwali* is given different kinds of presents, but most presents are for use in the future. In her case, she received gifts of sofa sets, a cooker, beds, dining table, wardrobes, among others.

Though the *mwana hiti* trunk figure has been interpreted as a phallic symbol, there is a general disagreement on this interpretation among scholars and among the Zaramo. What does this variance in symbolism mean? If everyone is in disagreement, how can one interpret meaning? How does this disagreement relate to symbolism in the face of change?

Although we have seen that certain characteristics of the wooden *mwana hiti* are female, M-L. Swantz (in her 1970 work) and Harding claim that the general form of the figures is phallic. Though Mjema saw that the figure "is symbolic of the female body but also combines elements from the male sexual organs," she does not tell us what these sexual organs are. Her comment does not affirm that *mwana hiti* is phallic; rather, that Western gaze is responsible for the idea that cylindrical columns are erect penises. The kinds of questions we pose on this figure, the people we direct them to, the ends they will serve, and the location we ask them, by and large determine the responses elicited. Arguably, perhaps many scholars are not as deeply versed in Zaramo culture as they ought to be and instead they project interpretations for the issues they raise. For example, in 1989 at Kisangire, Kisarawe District, Felix asked Zaramo elders (he did not say whether they were female or male or both) how one *mwana hiti* figure "could represent the spirit (*mzimu*) of both ancestors." Felix wanted to know the role of *mwana hiti* as an ancestral couple in a form of a *tambiko*. He states that the elders told him (seemingly without variation): "the figure is both male and female since the general (phallic) shape is obviously male whereas the details are female."[27] My point here is that the thrust of Felix's question elicited the anatomy-focused response that he projected. Had Felix specifically asked about the relation between the figure and the *mwali* or aspects of her initiation, the response would have significantly differed. I am not suggesting that the thrust of Felix's question negates its legitimacy. Doing so would presuppose that *mwana hiti* is only used in puberty rites. As already noted, the image is used in many ways. But the type of questions interviewers pose and the responses offered conveniently fit into their visionary boxes. In some societies, ancestral couples appear in pairs, and apparently Felix had not encountered such a pair among the Zaramo. So he might have wondered, given the *mwana hiti*'s so-called "phallic" structure, whether the figurine represented the Zaramo's ancestral couple. In view of this variance, we need to be cautious on the supposed phallic element of *mwana hiti*.

Although Pelrine does see a logical parallel between the "phallic representation" and some elements in Zaramo rituals as well as the nature of Zaramo society, her analysis poses similar problems of interpretations. She observes that,

> This duality is reflected in other aspects of male and female maturity rites, as well as in practices such as healing ceremonies and funerals. However, it is especially appropriate for figures such as these that are so closely connected with ideas about fertility and continuity, for it not only underscores the fact that both men and

women are necessary for the creation of life, but also emphasizes
the bilineal nature of Zaramo society: descent is traditionally traced
from the mother's line, while authority in spiritual matters—such
as whether a *mwali's* figure should be a wooden one or a gourd—
comes from the father's clan.[28]

Yet Pelrine also writes that though "Zaramo believe that the calabash also has
both male and female qualities," none in the field "noted the male/female
qualities of the wooden figures." Why is that the case, considering that both
versions of *mwana hiti* served the same purpose? Again, Pelrine's findings of
the phallic element of these Zaramo objects reinforce the argument that they
are not clear-cut issues because they lie on the intersection of changing
symbolism and meanings. To be sure, like any other symbol *mwana hiti* also
changes in meaning over time. And yet on the overall form of wooden *mwana
hiti* as phallic, the Zaramo refuse to sanction this duality since spirits are not
gendered, and if it is a fertility object, it must bring out both female and male.
Therefore, the Zaramo lack this duality about the phallic aspect of *mwana hiti*
figures as a reflection of dualism in Zaramo society. So the matter is complex.
Also, it does not appear as pronounced to the outsider who knows little they
would have us believe. Such overly sketchy reductions are not supported by
data even if they conveniently seem to back-up arguments or some designs in
our projects. Therefore, I would argue that first, in Zaramo culture emphasis
on phallus is not there or is minimal. Second, such descriptions come from
not knowing the sort of questions to ask, and so, interviewers focus on the
"apparent" and stereotypical to legitimize their vision. Third, the emphasis on
procreative organs is part of the colonizing rhetoric Europeans used to render
exotic the sexuality and fertility issues of Africa.

From what we have discussed thus far on the forms or styles, symbolism,
and meanings of *mwana hiti* in the face of change, it can be difficult to
pinpoint changes in the figure's form and symbolism. Part of the confusion
here lies with the unstable nature of interpretation of the figure. For some it
means one thing, and for others something completely different. It is
worthwhile to emphasize, however, that differences in interpretations are not
confined to the Zaramo. Even the readings of the few scholars we have
incorporated vary. Needless to say, one way of looking at interpretations of
scholars is that they basically rely on the information generated by their
research associates whose aesthetic scheme is imbued with vitality. Even the
Zaramo readings of the figure are at variance, showing a vital aesthetic
universe with multiple opinions and interpretations. These matters exemplify
that just like any other icon, the trunk figure embodies a variety of meanings.

And this goes for the symbols encoded on it as well. This is not to say, however, that the inconsistency in Zaramo interpretations of the *mwana hiti* symbolism is unexpected, especially within the framework of changing traditions. Taking into account the complex origins and composition of Zaramo society, not least the cultural influences, it is not surprising that such complexity and diversity in their symbolism is manifest.

On this ground I contest the interpretations of the image like M-L. Swantz's when she claims that *mwana hiti* "symbolizes at once the vagina, the penis, a child, and the clan." My research has not shown this symbolism. Though she has done elaborate work on Zaramo rituals, it does not augur well to be as emphatic on Zaramo symbolism as she is. We must seriously rethink this issue of symbolism since the Zaramo themselves are not as concerned about the interpretations of some of the symbols on *mwana hiti* as students of their culture appear to be. For example, when I asked a number of Zaramo about carved representations on Zaramo figures including things like chains, and a string of beads on *mwana hiti*, the responses were, *ni mapambo*—they are decorations. We have seen that Mjema attempted to offer more information probably because of relentless interrogation. But we must remember the trunk figure's function in the maturity rites and its significance in Zaramo culture. Just as Wembah-Rashid has observed among the Kwere, *mwana hiti* need not be seen simply as an expression of the wish to have fertility but as a symbol of a baby and motherhood. It is useful to add that because of the figure's striking similarity with the *mwali*, its role as a symbol of gender, especially womanhood, is emphasized.

To establish meaning in the *mwana hiti* we must examine its social function and its custodians, who are exclusively women. Zaramo women begin with the commissioning of the figure, in some cases decorating it, to giving it to the *mwali* who takes custody of it throughout the seclusion up to the period when it is returned to her natal's family. In this way, *mwana hiti* is essentially a women's object affirming female gender identity and the importance of women in society, stating and defining their responsibilities and expectations and strategies to fulfill them. The *mwana hiti* plays a central role in Zaramo society and contributes to the formation of Zaramo female identity. In its connection with the *mwali* rites, the object not only expresses the centrality of motherhood in female identity, it also helps in perpetuating Zaramo cultural identity. In ritual confinement the *mwali* interacts with the figurine in a variety of ways, keeping it as a surrogate child. Furthermore, the *mwana hiti* figure may be perceived as an image of a hoped-for child to an initiated Zaramo woman who has not yet conceived but carries the object like a baby. In short, the function of the trunk figure dictates the meaning. This links

mwana hiti with motherhood, fertility, the position of the woman in Zaramo society, and the source of continuity for the Zaramo people. The *mwana hiti* defines their culture and identity.

Though some Zaramo view the *mwana hiti* as their *mila*— tradition—they believe the figure does not change. Now, nothing cultural remains the same. Certainly the *mwali's* and *mwana hiti's* practice have changed in their changing social context, but changes on the form of this sculpture have been subtle. My research on *mwana hiti* trunk figure reveals changes in style, but its overall shape and main features basically appear the same, at least from the examples I have seen. Since style may vary from one area to the next or from one artist to another, studying *mwana hiti* pieces can reveal differences of style within a region such as Uzaramo. At the same time, it is possible to talk about a *mwana hiti* carved in a Zaramo style. Compared to what is now generally considered Zaramo *mwana hiti* style—the abstract sculptural form representing a female torso with a head, neck, breasts, a navel, and a waist, as figures 1.2, 4.2-4.6 illustrate, those of the Zaramo's neighbors such as the Doe, show a naturalistically-carved head with detailed facial features (fig.4.9). Indeed, Zaramo *mwana hiti* figurines collected in late nineteenth century show this abstract style and notches suggesting facial features rendered schematic instead of naturalistic. Even so, it is unclear whether in the mid-1940s this Zaramo's *mwana hiti* style actually changed given *mwana hiti* sculptures in a style resembling the Doe's. Also unclear are the reasons for the change and how popular this style was. If it was popular, was the popularity an indication of a significant style shift after this period or was the change simply a minor variation from the Zaramo abstract style? Harding (in her 1961 paper) has a rendition of a wooden *mwana hiti* collected between 1944 and 1947, whose head is naturalistic—having fairly well-depicted eyes, nose, mouth, and ears. Thus, I am not foreclosing Zaramo *mwana hiti* representing the face with details such as eyes, nose, mouth, and sometimes ears. Instead, I emphasize the less-realistic composition of Zaramo examples. Variations of types of *mwana hiti* (wooden or gourd) resulting from the preferences of clans led to changes on the figures. Variations within clan uses of the figures aside, there must have been other changes which sculpturally influenced the making of *mwana hiti*. Certainly one factor behind this "resistance to change" or the continuity of the form of the trunk figure can be explained by the fact that the object is passed down the generations. There is no need to commission another *mwana hiti* as long as the family takes good care of their figure.

Changes are evident in the ways the objects were decorated. Whereas in the past the hair of the *mwali* was actually used, it is unlikely that such conventions are still followed. This could signify that some of the trappings of the tradition

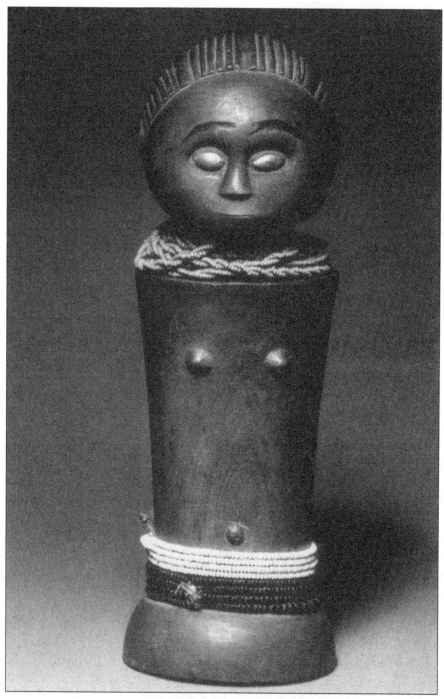

4.9 Doe *mwana hiti*

have literally been stripped away (the hair) but the tradition itself persists. We cannot underestimate diffusion of ideas, techniques, and materials, through contact even in a seemingly "conservative" culture like the Zaramo. Needless to say, these cultural changes have contributed to the instability of *mwana hiti* symbolic meaning. For example, Felix discerned changes on ritual objects in 1974 when he first conducted field research in East-Central Tanzania and in 1989 during another research trip. He writes,

> The objects that I saw being made in 1974 for ritual use looked different from the ones made prior to World War II that I observed *in situ*, and the objects made today exist in a very limited variety of types. This presumably reflects a simplification of initiation rites as well as the erosion of ethnic distinctions and the introduction of new political systems and creeds.[29]

This insight highlights some of the social changes affecting the production, use, and symbolism of Zaramo art objects such as *mwana hiti*. Also, the close cultural and social relations between the Zaramo and the Swahili have had impact on Zaramo traditions including art and crafts. Many craft objects like basketry especially mats, and wooden objects like *mbuzi* cannot easily be distinguished as belonging to the Zaramo or the Swahili because of similar style, techniques, and materials. The Swahili also seclude their young girls at puberty and written sources indicate that they have used sculpture in these rites. But we lack information on the form and style of this sculpture. In this sense, *mwana hiti* is a typical Zaramo sculptural object even as there are cultural and artistic qualities that overlap between the Zaramo and the Swahili.

The relevance of puberty rites in Zaramo culture still remains strong. It can be measured by noting that it is still considered a shame for a Zaramo girl to admit openly that she has not gone through these rites. However, this does not mean that Zaramo girls approve of the ways the rites are conducted. For example, some Zaramo girls feel that it is inappropriate to take the *mwali* to the *mkole* when dressed only in a loincloth, exposing her chest. At the *mkole*, everyone is welcome, both men and women. Since Zaramo women run the *mwali* rites, they are in a good position to adjust these rites in concert with some of the changes occurring in society today. At any rate, due to the burgeoning *mwali* coming-of-age rites, the one piece of sculpture which plays such an important role in the instruction of the *mwali* still has a place. The Zaramo appear not to depend upon modern means and agencies like schools, religious institutions, homes, and the mass- media for teaching young girls about adulthood. Although Zaramo girls are exposed to all these means, they

are also taught in the Zaramo ways through the pedagogical tool, *mwana hiti* and the rites. Some of the lessons which the *mwali* receives during seclusion are practically demonstrated by utilizing *mwana hiti*. This object simplifies the instruction especially considering that much of it is done through symbols. When *mwana hiti* is used in this way, it becomes unnecessary to engage in long discussions. The *mwana hiti* object provides for the girl to grasp the symbols of womanhood and their meanings. *Mwana hiti* and the ceremonies of which it is an integral part educate young Zaramo girls about being a woman, honoring women, and acknowledging and celebrating their important place in Zaramo culture. Furthermore, they help to carry identity history, cement family ties, and unify the Zaramo people.

CHAPTER 5

VILLAGIZATION AND THE ZARAMO GRAVE SCULPTURES
The Adverse Effects of Modernization

THE PRECEDING CHAPTER ADDRESSED THE IMPORTANCE OF *mwana hiti* in gender construction and socialization, and also its artistic and aesthetic considerations to the Zaramo. In doing so, the book continues its theme on the role of artworks, and of people's interaction with the objects. To understand and appreciate fully the distinctness of *mwana hiti* in Zaramo culture, it is necessary to remind ourselves that the image or image on the form is used in other Zaramo household and ritual objects. Some of these objects we saw earlier in Chapter 3. As noted, some Zaramo grave markers have carved human representations as their top parts, for example symbolic carvings in the shape of *mwana hiti* (fig.5.1). In the present chapter, though, I give full attention to Zaramo figurative grave posts (an age-old Zaramo art form), thereby extending the discourse on the *mwana hiti* figure by examining grave markers that incorporate it.

As the Introduction notes, the Zaramo have used different forms of grave markers some of which have been extensively utilized by the Zaramo. Social and cultural effects on Zaramo society have contributed to the seemingly gradual transformation of these objects. Here I describe carved Zaramo grave markers, comment on the concept of space and death, and discuss the position of the grave markers in the context of modern Zaramo society as people interacted with Swahili culture and Islam. I also pay close attention to the effects of the national program of Villagization on sculpture forms. Therefore, the discussion examines the types and styles of grave markers, changes of

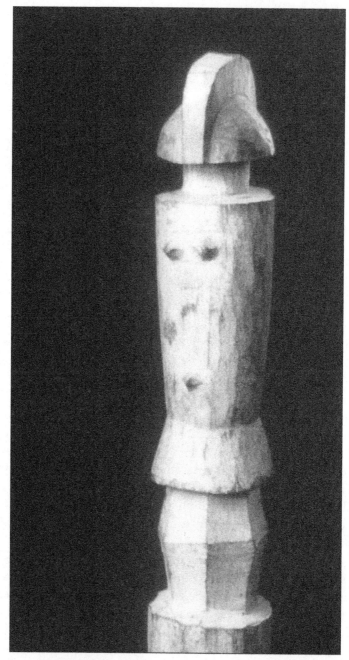

5.1 A stylized wooden grave marker of the Zaramo

material used in making grave markers, types of figuration, and characteristics such as shape, and details of grave markers. Also, I discuss the important aspect of space and people in the marking of graves, coupled with the significance of the Zaramo philosophical construction of reality in relation to the dead.

Zaramo Concept of Space and Death

Since death ends bodily life, the definite and infinite qualities of death compel social and religious responses toward it. Utilizing space, materials, memories, and traditions, individuals and communities make grave images fixing death in space and suspending it across time. Doing so is perhaps their attempt to mark a rupture between life and death. Zaramo society serves as a good example for demonstrating this view. However, I will not offer a detailed theoretical exposition of the concept of death and space among the Zaramo. Instead, I provide basic information to grasp the interrelationship of these concepts as I analyze Zaramo grave markers. This will help the reader understand the significance of figurative grave posts in Zaramo lived reality today.

The Zaramo attach great significance to the dead. This is vividly demonstrated by the kinds of social behavior and actions that the Zaramo living kin take after the demise of one of their own members. More poignant in this regard is these living kin's employment of objects like grave markers, and rituals that collectively act as crucial links with their ancestors. For instance, even today rarely will a Zaramo make an excuse from participating in a burial of a close relative. After a burial, family relatives of the deceased periodically visit the grave to clean it and perform rites. "Death is a continuation of life," says Mjema, hence, the perpetuation of the tradition about grave visits and rituals:

> in our clan we have continued with that tradition. . . . I have to make a trip to the graveyards. Since we are so much mixed, we have Christians and Muslims in our extended family, the graveyard is divided into two. So we have to go clean the graves of our Muslim relatives every 3rd month of the Islamic calendar (*mfungo tatu wakati wa Hijja*) and for the Christian relatives every Lent season. Since the two sites are only some few meters apart, we normally tend to visit both sites twice.[1]

The Zaramo's high regard for the dead may also be perceived as a mixture of respect and fear. In this connection, the arrangements of a deceased Zaramo's

burial and his/her funeral rites are undertaken by *watani*, joking relations.[2] *Utani* is a form of social intercourse between two categories of people who have a history of clan or ethnic group relations. It is characterized by mutual obligations and privileges, including elaborate jesting often accompanied by abusive behavior such as obstructing a wedding procession or cursing the union—which the *watani* must tolerate. Through *utani* an individual or group undertakes social and ritual functions for their *watani* such as burial arrangements, protection during wars, and to assist in ceremonies. A *mzimu* (pl. *mizimu*) among the Zaramo is a general term which may refer to ancestor spirit—the essence of people belonging to past generations or the things in which their spirits reside, like a tree or a grave. Things containing both the life essence and the body dirt or death of an individual, as well as a shrine to ancestors, may also be called *mizimu*.[3] Not only do the Zaramo believe in the continual existence and power of the spirit beyond death, but their fear is exacerbated by their belief that the spirits of the dead, *mizimu*, bring nothing good to the living. The misfortunes that the *mzimu* of a dead person is believed to bring to those living include poor harvests, illness, and barrenness. Because of this dynamic, the living Zaramo members envision an on-going antagonism with the spirits of the dead. For instance, a *mzimu* may inflict illness upon a living member who has neglected to take care of his/her grave, like clearing and cleaning the grave-site. As with a large majority of African people, illness and other problems that the Zaramo face may necessitate the consultation of a diviner to establish what caused them. The diviner will suggest the reason for a particular condition or situation and its treatment. For example, a *mganga* may be sought to propitiate a perturbed spirit. Gifts and incantations are means employed to appease spirits.

Since the spirits of the dead affect the welfare of the living Zaramo, these living kin are obligated to maintain ties with the spirits of ancestors. But the Zaramo do not worship their ancestral spirits. Rather, they appease them to prevent illness and misfortune. Because the Zaramo have ritual obligations towards family *mzimu* and spirits, a Zaramo clan must perform an annual ritual offering, *tambiko*. In this *tambiko*, all living members of the clan participate. Activities in the *tambiko* (different from that performed with the *mwana hiti*) include the cleaning of the grave of the ancestor, thereafter the offering of cereals like millet or rice and *pombe* (beer) to the *mzimu*, followed by the sharing of the family meal. The *tambiko* may constitute the rebuilding of a small spirit hut which acts as a shrine where clan members make offerings and prayers to the ancestors and certain spirits. This shows further that in the Zaramo philosophical conception of ancestors, the departed ancestors are very much a part of the lives of the living kin. There is constant interaction between

the living and the departed—a process that greatly dissolves the split between life and death. Furthermore, the departed ancestors have to be remembered and propitiated to forfend calamity.

The death of ancestors continues to figure in modern-day Zaramo. For example, a general trend since the 1960s is that Zaramo increasingly wish to be laid to rest in their home villages with the ancestors. In the event that a Zaramo died away from home, kin and friends pooled monetary resources to help transport the body to the home village. But this is not to say that today every Zaramo is buried on family land. Given the migration of people especially to urban centers, a Zaramo may be buried in a public cemetery where she or he has made a home. This could be at Kigogo or Buguruni in Dar es Salaam, instead of say, Msanga near Maneromango, from where one hails.

In their home districts/villages some Zaramo families may choose between family land and a church cemetery, or utilize both. For instance, in Mjema's family relatives do not normally bury in community cemeteries: "Even when we bury them at church cemeteries, we have our own special area so we don't just mix with other clans." When a stranger dies in the area he or she is buried in a section of the church cemetery called "*Makaburi ya Wazungu*" or Europeans' Graves— the part of the cemetery where the graves of all the missionaries who worked in the area are to be found.[4] The other area where Mjema's relatives are buried is on family land, actually "the original family land before Villagization." Mjema asserts that when she visits this original family land containing her ancestors, this becomes a crucial connection to her tradition, her history, and her pride. At this grave-site the living kin

> say some prayers and feel the continuity of life and death. That is one thing that gives us some sense of roots, wherever we go we know there is a place where we can always go and say this is home.[5]

This burial space where Mjema's ancestors lie and which she calls a home, a sacred home where one goes in peace with no ill-feelings, is a shaded area. Trees are not cut. She was quite surprised, therefore, when she visited her in-laws for the first time in Same (another district far from Uzaramo) and saw grave-sites with no trees. She states that in Zaramo tradition, there must be a shade in the grave-site, perhaps to offer some kind of shelter or protection.

Wherever the place of burial, graves have to be visible and identifiable. To achieve these ideals graves are elevated from the ground and demarcated by stone, bricks, or wood. The question this prompts is, have the Zaramo been

putting up markers on their graves in order to facilitate the visibility and identification of the graves? Apart from crosses, stone, and concrete slabs usually used by Christians and simple posts with no figurative representation or stone slabs embellished with Islamic motifs that Muslims would more likely use, the Zaramo are known to have utilized other styles of grave markers. These are grave figures with moveable limbs— legs and arms that might have been marionettes (fig.5.2), stylized posts depicting the *mwana hiti* image (fig.5.1), and naturalistic objects representing a human figure which the Zaramo call *vinyago*, that is, sculpture showing people (fig.1.1, 5.3). In some literature, the phrase, *nguzo za makaburi* (grave posts—a literal translation) is used to refer to figurative grave posts. I have also heard some Zaramo refer to grave figures as *mashahidi wa makaburi* (grave witnesses), which suggests figures that tell who is buried at the grave-site. In this sense, the figurative depiction is a witness/representation of the dead person. Indeed, one might reasonably suppose that the post bears testimony to, or is a reminder of death. Yet the notion of *mashahidi*, might also represent the place upon which the sculpture stands, indeed, a grave-site. In this way, the grave sculpture can signify the dead and the space they have taken through the act of death. We can grasp this matter by considering the space he or she occupies in the spiritual and physical realm, for example, in the world of spirits, memory, and the wood. Additionally, we should not forget that the carved object affirms the boundaries of the grave-site where the deceased actually lies. Indeed, death is fixed in space.

Visibility and identification of graves facilitate the strengthened bonds and ritual obligations that the Zaramo living kin maintain with their family ancestors. Visits and pilgrimages to the ancestor's grave serve as an example of this. In the event that the whereabouts of a grave is unknown, such crucial visits for things like sweeping the grave will be hampered, and ritual requirements will be unfulfilled. Today, the issue of visibility and identification of grave-sites has reached another dimension in view of increased land scarcity in the urban and suburban areas of Uzaramo. In this regard, the magnitude of land shortage in 1999 hit Dar es Salaam city's cemeteries because of double allocations of building plots and burgeoning squatter settlements in the city, among other factors. Land scarcity had given rise to a trend in which more than one body shared a grave. Deaths do not keep pace with City Council's plans and mechanisms to answer the shortage of burial spaces facing a city such as Dar es Salaam. In view of the foregoing, a clearly demarcated grave will not easily fall prey to encroachment. The marking considerably minimizes chances of someone else mistakenly or by design being buried in a grave already occupied by another dead.

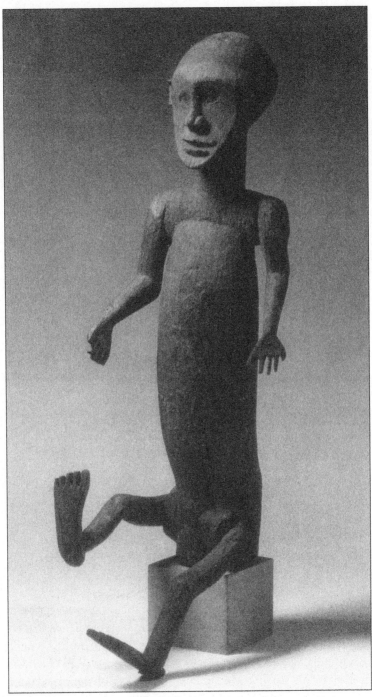

5.2 Zaramo funerary sculpture with movable arms and legs

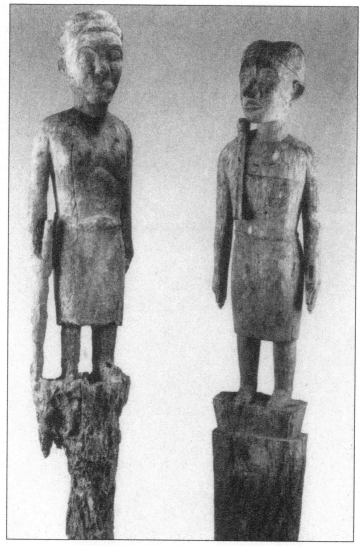

5.3 Two Zaramo wooden grave posts depicting a couple

In addition to preventing multiple burials in the same grave, grave markers help to obviate wrongful exhumation of the dead in a burial area that is cleared so that the land can be used for other "development" purposes. I will illustrate with an example of a cemetery in Dar es Salaam as reported in two newspapers in April 1999.[6] This small grave-site was in the way of the construction of a new road, Kawawa Road (fig.5.4), which would lead to the intersection of Nyerere Road and Chang'ombe Road in Dar es Salaam. The government

5.4 Kawawa Road, Dar es Salaam City, 2004

ordered 343 graves to be dug up and the bodies to be exhumed for reburial in a new cemetery at Tegeta. Relatives of the people buried there were paid Tsh. 68,000.00 (about $100) compensation.

The modernizing policies of exhuming the bodies at this grave-site created problems. Although government involved local leaders to ascertain the relatives of the deceased buried at the grave-site to facilitate the process of identifying graves, paying compensation, and transporting the remains for reburial at Tegeta, some people who lacked proper identification as set down by the government claimed that their relatives were buried there. Others, taking the opportunity to make easy money, would claim graves not guarded by relatives and organize people to dig the graves, finally collecting compensation from the officials. Thus, relatives were forced to stand vigil guarding graves of their loved ones for the length of the workers' day lest grave snatchers stole remains of their relatives. The government, according to one local leader, set down the following procedures for the identification of the persons whose loved ones were buried at the site: the relatives must be accompanied to the site by their *wajumbe wa nyumba kumi* (ten-house leaders), must have names of the deceased, and must be photographed at the grave; one photo was to be retained by the relative and another was to be kept in the Dar es Salaam City Council's records. Also, since in some graves there

101

were three or more bodies, the strategy was to dig the graves very carefully while checking the coffins for identification. One local leader, Mwajuma Abdalah, stated that the trend of burying three or more people in one grave at this site began in the 1970s because other cemeteries had begun to fill up. The City Council had set aside the cemetery for burial of unknown people up to the 1950s. In 1999, identification of graves in the graveyard was also complicated by the fact that some of the graves could not be identified, in part because they were not built of cement or stone and markers, such as crosses with names of the deceased, had weathered and disintegrated. Or they had been destroyed by termites, and new ones had not been put up. This example of the post 1950s graves desecration of known people exemplifies the ways modernizing policies undermine ancestral land thereby inflicting trauma and dislocation on the people whose relatives were buried in the cemetery.

Of the markers themselves, Zaramo sources maintain that their grave sculptures were mnemonic devices to honor the dead. An example is grave markers thought to be marionettes:

> Two different Zaramo informants have told me that in precolonial days, at the funeral of an important man at a special grave site . . . and in the absence of male children to praise the deceased over his grave, a large wooden doll (*mtoto wa bandia*), with articulated arms and legs . . . dressed in cloth . . . was erected at the graveside. It was manipulated by a specialist who played the role of the eldest son or nephew and sang the praises of the dead person. They said that this figure would move and talk, and having heard this information more than once, I tend to believe that this specialist was in fact a ventriloquist.[7]

I should point out that this type of grave marker is no longer used by the Zaramo. Also, grave posts topped with *mwana hiti* can be seen as a relic of the past because they are no longer common. Some date at least to the second quarter of the 20th century, according to examples in museum collections.[8] In Chapter 3 I indicated that the Zaramo erected wooden figural human markers on graves of important people like headmen or chiefs. It is plausible, therefore, that the post-independence Tanzanian government's political decision to abolish the position of chief as a government executive may have contributed substantially to the decline of markers topped with symbolic figures of *mwana hiti*. The decline of markers topped with *mwana hiti* signifies the political and social role of chief in society. At any rate, the "marionettes" have all but disappeared.

Apart from the more obvious function of Zaramo grave sculptures—as grave markers and memorial devices—we should also consider another important function that the objects serve: they decorate the graves. We may easily overlook this element amidst the purpose of the sculptures to honor and commemorate the departed who in effect go to the other world of human existence. In addition to the aesthetic considerations of the carvings (figs.1.1, 5.3, 5.5), research has shown that some of these were embellished with pieces of white and red fabric or ceramic shards whose symbolism is unclear. A Zaramo told Pelrine that a man would erect a figure on the grave of his father

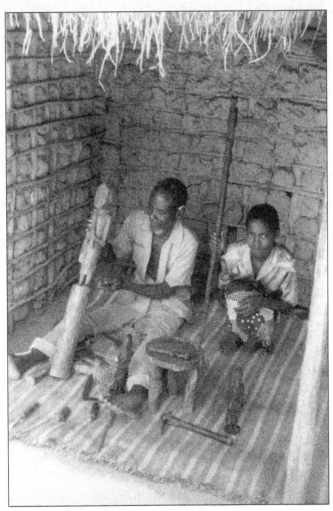

5.5 Zaramo carver Mirambo making a wooden grave post of a human figure, Kisarawe District, 1989

and show it to his children to perpetuate the memory of their grandfather. In the same vein, Yusufu Mgumba and Ali Bilali informed me that those who went to clean the gravesite, for example, young Zaramo kin, would relate a grave figure carved in the naturalistic mode with the deceased, such as a grandfather. Therefore, they would learn that their departed grandfather looked like that (the image). And upon seeing the naturalistic grave post, people would comment on the likeness of the figure with the deceased: "*Huyu kama ndiyo yeye.*" ("This is just like him.").[9] Though the figures could be carved for anyone provided they could meet the costs, we saw in the case of Kolahili that grave sculptures marked the graves of Zaramo leaders and important people.

There appears to be a variation in the actual time when a grave marker is put up. Some Zaramo claim that the figures were placed on graves during the funerary ceremonies that were performed seven days after the burial, and there is an account describing a string of funerary ceremonies performed within the year that death occurred.[10] Ramadhani Mwaruka provides details on the death, funeral, and burial arrangements of an important person among the Zaramo, whose dead body is called *tagala*. He mentions the placement of markers on the grave immediately after burying the dead and covering the grave, but he does not say what these markers are.[11] The data of the Museum and House of Culture in Dar es Salaam on a Zaramo grave post that I saw in 1997 maintain that such a figure was placed on the grave after an undetermined passage of time.[12] Given the craftsmanship and beautiful finish of some grave posts (fig.5.3), it is hard to imagine that these took seven days to execute. Perhaps these practices varied within a basic time-frame.

Influence of Islam on Zaramo Grave Posts

In view of the importance of Zaramo *mizimu*, ritual obligations connected to these *mizimu*, and figural posts that mark Zaramo graves, a critical explanation on why today the Zaramo have almost given up using grave posts is sorely needed. The general assessment concerning the non-proliferation of these grave posts point to the erosion of Zaramo beliefs in and practices of the custom. The issue of concern, then, is to understand the impact of social factors on these objects. Even though the custom continues, the Zaramo are increasingly aware of changes on the markers and have pointed to factors behind the breakdown of traditional beliefs and practices bearing upon the tradition. For example, Chuma does not explain why he believes that placing carved wooden markers on graves is a tradition of the past, but he affirms that many Zaramo now use planks of wood and brick/slab markers. In Mjema's experience of grave posts she says,

In many places I have seen slabs being put up in their place. However, people still try to find other figures to replace broken ones.

The use of slabs on Zaramo graves is not a recent practice. Even so, the question that is difficult to answer is: how extensively had the Zaramo utilized slab markers? To put the issue in a proper historical perspective, let us look briefly at what happened at a carver's yard in a village in Kisarawe District in 1989, and further back in time to grave markers used in Uzaramo in the nineteenth century.

The documented information relating to figure 5.5 in this study describes it as showing Zaramo traditional woodcarver Bwana Mirambo in the process of carving a naturalistic grave marker in 1989 in Kisarawe District.[13] Also sculpted by Mirambo is the wooden staff held by his daughter (seen in the picture), which seemingly represents a human figure at its top end. The illustration suggests that naturalistic grave posts were still being created in Zaramo society. This data shows the Zaramo's continued use of figurative grave posts in naturalistic style, a practice first reported by European travelers crossing Uzaramo in nineteenth century. According to the earliest information on the Zaramo, at least by the middle of the nineteenth century the Zaramo placed vertical, carved markers representing human figures on their graves. The practice was maintained up to the second quarter of the twentieth century, as figure 5.3 shows, and clearly as late as 1989 attested to by figure 5.5. European explorers Richard Burton and James Grant saw Zaramo graves as their expeditions passed through Uzaramo in 1857 and 1860 respectively. Burton's ethnocentric, biased description of Zaramo graves is overly degrading:

> The Wazaramo tombs, especially in the cases of chiefs, imitate those of the Wamrima. They are parallelograms, seven feet by four, formed by a regular dwarf paling that encloses a space cleared of grass, and planted with two uprights to denote the position of head and feet. In one of the long walls there is an apology for a door. The corpse of the heathen is not made to front any special direction; moreover the centre of the oblong has the hideous addition of a log carved by the unartistic African into a face and a bust singularly resembling those of a legless baboon, whilst a white rag tied turbanwise round the head serves for the inscription 'this is a man.'[14]

James Grant also gives a description of Zaramo grave markers as "single tombs with large dolls of wood or broken bowls of delf."[15]

During this time these kinds of markers were evidently a common feature of Zaramo graves. Interestingly, in 1991 Pelrine writes that when Franz Stuhlmann, the German cartographer and zoologist, passed through Uzaramo in late nineteenth century, the kind of figures that Burton and Grant saw on Zaramo graves were not as common as previously noted. Considering the widely circulated notion of Islamic aversion to art, the fact that Islam may discourage representational forms, possibly led Stuhlmann to suggest that these naturalistic grave posts were affected by Islam—a development gradually giving rise to more stylized representations, simple posts, or stone slabs. While this may be a concern of Islam elsewhere, it is not so in Tanzania because of the nature of the process of Islamization and its results in indigenous Tanzanian societies. Spencer Trimmingham (see M-L. Swantz 1976) saw the interaction between Islam and African cultures as a new religious-social pattern; an interaction resulting from the reciprocity of cultural contact which led to the process of assimilation, dualism, and with the passage of time, to parallelism. And M-L. Swantz notes that because of the different factors affecting "the religious and social developments at the juncture of traditional and Islamic forms of life," no one model or generalization is adequate to explain the process of Islamization in Tanzanian societies. As previously noted concerning the Zaramo from the 1960s to the 2000s, M-L. Swantz also shows an interdependence of traditional and Islamic religious practices. Stuhlmann asserted that these simple posts or slabs were wrapped with a "turban" of white cloth as if to portray a carved figure.[16] The Zaramo's presumably long use of vertical figurative commemorative grave posts is still alive since the objects continue to appear on graves. This continuation indicates that considering the incorporation of Islam in Zaramo life, Islamic effect on the use of Zaramo figurative posts has been a rather gradual phenomenon instead of a severe break.

Islam is not wholly responsible for the increasingly popular shift from wooden figurative posts to slab and ceramic markers. Though according to Pelrine, many people have stated that due to Islam and literacy in the Uzaramo of the 1980s the Zaramo are now more likely to utilize markers with ceramic shards, or markers containing written inscriptions of the names of the deceased. This shift was more likely precipitated by the costs incurred in commissioning a grave post when compared to slab markers. This issue of cost may reasonably explain the use of simple wooden posts instead of those with carved figures. The benefits of more durable material (like bricks, stone/ceramic) as compared to easily perishable ones (wood) may also be a

factor rather than simply the erosion of a custom due to a religious orientation. Again, this is not meant to deny influences of Islam on Zaramo grave markers. Islamic elements in grave markers can readily be seen in slab markers embedded with broken ceramic pieces which is a Swahili tradition. We have already seen that Islam has influenced both Swahili and Zaramo culture. So, given the Zaramo's extended interactions with Swahili culture and Islam, it is hardly surprising that such a cultural practice is exchanged. This is another strong visual reminder of how Swahili cultural elements have been incorporated into Zaramo culture, and how Islamic elements surface in slab markers with written inscriptions. Additionally, the strength of these Swahili and Islamic cultural influences upon the Zaramo, especially considering the Zaramo's embrace of such core and sensitive matters centering on the death of individuals and markers erected to honor and commemorate them.

Islamic/Swahili cultural elements are further reflected in the twin figurative grave posts (fig.5.3) of the Zaramo and the Museum and House of Culture in Dar es Salaam. The said Zaramo twin grave posts (fig.5.3) were sculpted in naturalistic composition and date the second quarter of the 20th century. The two posts were most likely made from *muharaka* wood, a common kind of wood used for sculpting Zaramo grave figures. The bottom end of the post on the left is severely eroded, understandably because this part was stuck in the ground. On the whole, both posts show evidence of weathering. The posts depict a couple; some representations of these figures are worth discussing here. This pair of carvings show that it was created by the same artist because of the overall strikingly similar carving style. The appearance of the man on the left and the woman on the right provide insights to aspects of the society of the day.

Though the figures portray mature people, it does not appear that the objective of the Zaramo was to represent the deceased. I pointed out in Chapter 3 that Kolahili carved images of Zaramo headmen or chiefs for use as grave figures. Presumably these were representations/witnesses rather than actual portraits of the deceased leaders. Regarding the husband and wife (fig.5.3), the attire and implements on them attest to their maturity and possibly their social status. The *shoka* (axe) on the shoulder, staff, *kofia* or cap, and *mkanda* (belt) around the *kikoi* (loincloth) could be interpreted as indicators of worldly wealth and also as insignia of religious and political office. The axe carried by the woman might represent a utility tool in the home especially if we recall that the Zaramo are known for their skills in ironworking. Similarly, it could have been a status symbol since in Zaramo society women held positions of authority. Felix notes that axes were mainly status symbols for male titled elders in East-Central Tanzania. Though time

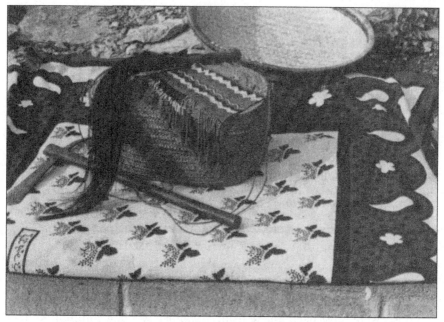

5.6 Zaramo *mganga's* symbols: an axe and a wild-beast tail whisk lying on a medicine bag

and again Zaramo elders explained to Felix about ritual axes and the importance of these in initiation ceremonies, Felix has "never seen one that was undoubtedly made by these people." But L. Swantz's 1990 publication shows a Zaramo ritual axe together with a tail whisk that are symbols of a Zaramo *mganga* (fig.5.6).

The man wears an embroidered cap whose motifs are at one with Islamic/Swahili decorative patterns. The *kofia, kikoi,* and *mkanda* are clearly influences of Islamic/Swahili cultures' dress codes on the Zaramo. Thus, in one piece of sculpture we see reflected elements of Zaramo and Islamic/Swahili cultures. This Zaramo figurative sculpture goes a long way to underscore cultural overlap and the assimilation of cultural elements, but also the Zaramo translation of cultural influences and borrowing in three-dimensional form. The hairdo that the Zaramo woman wears characterizes the style that was the fashion in the old days as reported in the earliest European chronicles of the Zaramo. Here it may be taken to represent the fashion of the day when the figure was created. Still, this hairstyle is sometimes worn by the Zaramo *mwali* at initiation ceremonies as we saw in the case of Mjema in 1973. In this way, the hairdo becomes a symbol of Zaramo female identity since it continues to be perpetuated in figurative art and in real life situations such as ritual.

The collection records of the Zaramo grave post in the Museum and House of Culture show that it was carved at Maneromango and that the Museum acquired it from a Zairean (now Congolese) "curio dealer" in January of 1994 at Palm Beach Hotel in the city. The Museum's estimation of the marker's age was between 20 and 40 years. One should consider this age in the time frame prior to the marker's 1994 collection date. The eroded end of the post that is usually placed in the ground bears testimony that the marker either weathered and broke down or it was uprooted from the grave. During my field research in 1997 the Zaramo told me that at a fairly recent date, foreigners visited Maneromango seeking traditional Zaramo art objects.

In the process, some of these objects including *mwana hiti* figures and grave markers were stolen and sold to these foreigners. For example, while grave markers were removed from graves, *mwana hiti* figures were sought in the homes where they are usually kept as family treasured heirlooms for use in the *mwali* initiation. In illustration, in 2004 Mwanamkulu Lamba narrated to me an incident involving her grandchildren who searched her house in vain for her coveted *mwana hiti* and *mwanasesere*, which she had safely locked in her trunk! She showed me the objects, the *mwanasesere* partially damaged, which she attributed to rats (fig.5.7). Thus, there is a possibility that in this process of disruption amid the search for traditional Zaramo artifacts, this particular grave post fell into the hands of the "curio dealer" prior to its acquisition by then the National Museum of Tanzania.

The post was also carved from a *muharaka* wood. At its top end it represents a man kneeling with each hand placed on each knee. This posture suggests that the man was in prayer, but it could also be a traditional Zaramo posture. Can this tell us about the religious affiliation of the person? The posture suggests that he was affiliated to Islam. The head of the man is proportionately large compared to the body which suggests either an individual carving style or an emphasis on the importance of the head. The head and chest are bare. Museum records maintain that this is one of the two posts that are put up at either end of a Muslim's grave. Whereas the one put at the foot of the grave is usually square and geometric, this particular example representing a human figure was erected at the head of the grave. The records also reveal that the figure would show the gender and status of the dead person. Again, can we comfortably infer on the basis of this data that the sculpture was made to look like the deceased? It may very well be if we consider the naturalistic composition, the kneeling position, and this information pertaining to a Muslim grave. As I see it, it would be rash to reach such a conclusion without enough corroborating evidence. Yet it is possible that the Zaramo aimed to create witness posts rather than life-like depictions of the dead.

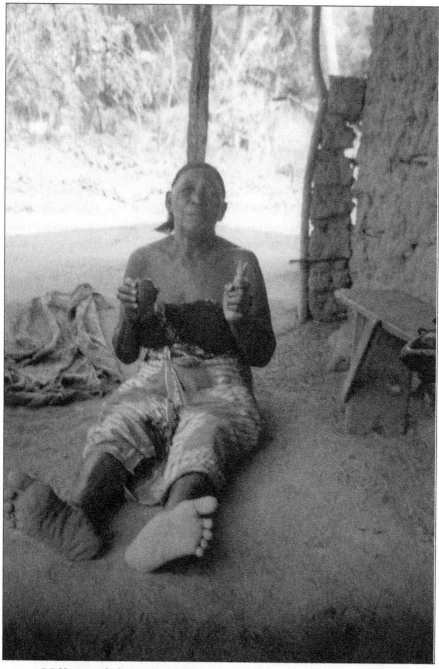

5.7 Mwanamkulu Lamba holding her *mwana hiti* Maneromango, 2004

The analysis of these Zaramo grave posts not only reveal the adaptive character of Islam in a localized situation, that is, Zaramo society, but the accommodative aspect of Zaramo culture as well. Therefore, the inventive nature of Zaramo culture demonstrates that change is a two-way process. In view of these concrete details, what appears a weighty argument advanced by the advocates of Islam—that Islam had a major negative effect on Zaramo figurative grave posts giving rise to the growing trend to utilize other types of markers[17]—is considerably weakened.

Having commented upon Islam and Zaramo figurative sculpture, it is unclear how literacy has contributed to the decline of Zaramo grave sculptures, as Pelrine has it. Is she making a connection here between a figurative grave post representing the deceased and a slab marker with written inscriptions to tell the identity of the deceased? Or has the former kind of marker given way to the latter because the Zaramo are now literate? And what about stylized markers that incorporate *mwana hiti* instead of representing a human figure, that is, the dead person? In what ways was the image understood? Chapter 4 explains about variations in interpretations of the *mwana hiti* image across individuals in Zaramo communities. It would be interesting to inquire whether when the *mwana hiti* image was used in grave posts to honor and remember the dead, it meant to symbolize regeneration and continuity of the family-line, or political and religious status, especially in cases where the deceased was a leader?

Pelrine looked only at Islam and literacy, but other social and political forces of post-independence Tanzania have affected Zaramo figurative grave posts. My consideration of other social and political developments of post-independence Tanzania on these posts does not deny the process of Islam and literacy, but it is certainly quite a task to measure specifically the extent of their eroding power on this custom. I consider here what we have seen thus far, and what is presented below.

In the late nineteenth century, for instance, Stuhlmann attributed the decline of these sculptures to Islam. However, it merits noting that while hard evidence is scant to show that Zaramo figurative grave posts proliferated, we have seen that their use continues today *in spite* of Islamic influence. To examine some agents of change that may have contributed negatively to Zaramo posts, Zaramo social and cultural life should be situated in the framework of the 1960s and 1970s period, focusing specifically on the Villagization process mentioned in Chapter 2. Villagization and modernization negatively impacted on Zaramo grave posts since Zaramo's conception of space and their culture radically changed. Consequently since Villagization was geared to modernize Tanzanian villagers, and since grave

witness posts are a long Zaramo tradition perpetuating Zaramo culture, not Tanzanian per se, a negative contemporary influence on an age-old sculptural form resulted.

The Effects of Villagization on Zaramo Grave Sculptures

Although scholarly research has shown experiences of disruption and trauma that villagers endured in the compulsory Villagization campaign across the country, an analysis of the effects of this program upon grave markers and practices connected with their placement on graves is yet to appear. As Chapter 2 notes the Villagization program aimed at creating permanent villages in the countryside by bringing together otherwise scattered homesteads closer to basic social services. In his 1994 essay, for instance, Castelli notes that the time-honored Zaramo tradition of using figurative grave posts was alive up to the 1960s when the Villagization program curtailed it. The collection records on the Zaramo grave post in the Museum and House of Culture also confirm that almost no grave posts were created after the formation of *ujamaa* villages in the 1970s. The reason given is that the mass movement and resettlement of villagers across Tanzania forced them to abandon their family cemeteries and this ultimately resulted in the demise of the practice of making grave posts. But in the case of the Zaramo, the carving of grave posts as well as their use has not been completely abandoned, illustrating their determination to survive. At the risk of repetition, it merits stating that the policy of Villagization appears to have contributed to the severe erosion of a number of cultural practices and beliefs of Tanzanian villagers because of their removal from their ancestral land to villages planned by the government. For example, beliefs and practices revolving around funerary ceremonies and the putting up of figural wooden markers on graves were affected.

The compulsory modernizing policy of Villagization, its intrusion upon the villagers' conception of space and its undermining of ancestral land use was resisted through confrontation. The confrontation was mounted by a Zaramo named Juma Mwenegoha before an MP, M. Zavalla Pazi, at Msanga in Kisarawe District. Serving also as a spokesman for others, Mwenegoha declared:

> I stand here as a man who does not fear anybody and these are my words. We have built Msanga since time immemorial and are living as socialists. . . . And I tell you this independence we have today was demanded first by my grandfather who died in the hands of the Germans. . . . We got our independence peacefully but now you

want to embarrass us by demolishing our houses so that instead
we go to the bushes, leaving our property behind. . . . I say I and
my brothers of Msanga are not moving . . . and we do not want
anything about socialism or living together. . . . Therefore
honourable M.P. I say and I am asking you to tell your bosses that
Juma Mwenegoha and all my brothers in Msanga do not want
socialism neither living together.[18]

The major problem that we can glean in this statement is how socialism, or to
put it simply, "living as socialists" as Mwenegoha took *ujamaa* and
Villagization to mean, was understood by Tanzanian villagers. In the villagers'
view, their conception of *ujamaa* and Villagization was the same as TANU and
the government's.

In Mwenegoha's correct reading of socialism, he and the villagers of Msanga
were practicing it all along. Yet he saw that the Party and government did not
seem to care about their plight because by implementing the Villagization
policy, they were forcefully making the villagers abandon their land, and
nutritional and economic trees (like coconut, cashew) without negotiation.
In Uzaramo, ownership of trees on a certain area had also in practice, meant
ownership of the land. This type of land ownership was well understood,
supported, and enforced by the whole community. Even though in the
Villagization process TANU and the government's conception of space did
not rhyme with the villagers,' it defined and allocated land for them. To cite
an example, a large number of villagers in Uzaramo were removed from their
land and were resettled on areas with trees owned by the previous occupiers.
This meant that the resettled villagers came to occupy land and property which
customarily did not belong to them. Seen in this light, restructuring of land
ownership during the implementation of the Villagization policy created
extensive changes in the living patterns of villagers. For this reason, the Msanga
villagers were not ready to accept the form of socialism defined by the Party
and government. That is, to put *ujamaa* and Villagization in motion
constituted demolishing the villagers' houses, and making them abandon other
family properties. But perhaps most germane, it shifted the villagers from their
land where they were deeply rooted and where they felt their ancestors were
present. Also, as we saw in Mjema's family, Villagization removed families from
land near the graves of their ancestors and their commemorative posts. The
policy of Villagization paid little regard to beliefs and practices about ancestors
or those of the making and use of grave markers.

Perhaps the best explanation of the shortcomings of the *ujamaa* policy of
Villagization can be found in the ways Party and government leaders in post-

independence Tanzania understood and approached development and the building of national culture. It should not be forgotten that efforts directed to building national culture in the aftermath of colonialism have been hampered by the question of what culture is and its place in a list of national priorities. For example, taking stock of Africa generally, development programmers Damien Pwono and Jacques Katuala maintain that some of the constraints lie in the approaches to development and culture utilized by colonial regimes, and which were later perpetuated by independent African governments. Indeed, Pwono and Katuala offer an informed overview of culture and development in Africa, the problems plaguing cultural institutions and activities, and solutions for redressing the pathetic state of affairs. I have to disagree with their overemphasis on the donor community to help out Africa in the fields of art and culture, however. The cardinal issue here is not so much that Africa cannot use the resources that donor agencies would generate; rather, it revolves around the misleading advice that Pwono and Katuala offer Africa. That is, to continue toeing the line of essentially western donors even in the very sensitive and vital areas. For as the saying goes, "The one who pays the piper calls the tune." By implementing the suggestions that Pwono and Katuala make, it is not difficult to see who would define and control culture in Africa. At any rate, Pwono and Katuala go on to observe that colonial regimes misunderstood African cultures as static and backward. But it defies common knowledge that

> after independence, a large number of African policymakers and members of the intelligentsia continued to stick to this view of development, which precluded the utilization of local knowledge, know-how, beliefs and traditions, memory, collective imagination, and aspirations.[19]

Historically African culture has been misunderstood. Though Pwono and Katuala cite Julius Nyerere and Kwame Nkrumah as personalities behind original approaches for cultural liberation and development in Africa, it would appear that on the whole, African culture has not been clearly understood, hence misused:

> African culture, although used by political leaders for personal political gain, was perceived by many postcolonial governments as an impediment to a development that was defined entirely in economic and physical terms and that stressed solving problems such as those of health, sanitation, housing, and roads. Even though

one can identify on the policy side a new dynamism in African arts and humanities in the 1960s through the creation of bodies in charge of guiding research on the arts within government bureaucracies, the opening of several research centers and institutions devoted to the arts, and the appropriation of generous budgets for the arts and humanities, the narrow intellectual conformism to the former colonial powers' perceptions continued with the rise of dictatorial regimes.[20]

Here we can see the disconnection between African governments and their cultures, and how these governments follow colonial regimes in marginalizing culture. With respect to Tanzania, Mlama is insightful when she argues that while in 1967 the state adopted *ujamaa* to direct economic development and came up with policies like *Mwongozo* (TANU guidelines), nationalization, and socialism and rural development, no cultural policy was formulated to cater for the demands of *ujamaa*.[21] And as Pwono and Katuala also observed, development was narrowly visualized, at most, in economic terms eclipsing cultural matters.

The misconception of culture in Tanzania may be seen in what was referred to as "the Africanness of 'national culture'" as frequently expressed by elite politicians. In this sense, these leaders usually referred to works of art such as music and dances, hardly mentioning religious aspects of culture.[22] By and large these politicians' conception of culture was severely limited. Yet even their attention to the cultural value of dances devalued them:

> A particularly conspicuous element of national culture was the *ngoma*, dances which were frequently performed at various occasions. Traditionally, dances often had a religious purpose or formed a part of a religious ritual. When such dances were transformed from being 'tribal' to being 'national,' their original purpose or function could not always be retained. As 'nationalized' dances, performed by professional dancers, their function usually became one of entertainment.[23]

David Westerlund expresses here what I take as a deliberate misuse of ethnic *ngoma* as seemingly part of Tanzanian national culture to serve political purposes and commercial ends, especially in the urban areas. But in spite of this sad fact, it is misleading to put this practice in the past tense because the trend continues. As Mlama argued in 1983, culture in Tanzania was largely taken to be a collection of recreational as well as entertaining activities together

with traditional arts and crafts. This reflects the narrow version of culture that the Ministry of Culture mainly focused on developing. Mlama who has served as chair of the Tanzania National Arts Council summed it up nicely in 1995 when she remarked,

> Now more than ever before, it is important to assert Tanzanian identity. We need to come up with deliberate policies or we will end as a nation all over the place. At the moment, I don't see a cultural direction.[24]

Nyerere's contribution in shaping the Tanzanian society is an acknowledged fact. In his 1995 essay "Contribution to Rural Development: *Ujamaa & Villagisation,*" education philosopher Donatus Komba examines Nyerere's role in *ujamaa* and rural development in Tanzania. Komba submits that Nyerere's vision of a Tanzanian society was one that would

> give the majority of the people a sense of hope for a better life . . . to be achieved through rural development based on agricultural transformation.

It follows that Nyerere's ideas helped in

> the creation of a substantial number of *ujamaa* villages as institutions for socialist rural development. The intention was that these would eventually be producer and marketing co- operatives based on egalitarian or *ujamaa* principles of living together, working together and sharing together their fruits of common labour as well as the major means of production. Besides raising the standard of living of rural people, who formed the majority of Tanzanians, a new mode of production and self-generating economy, and an egalitarian society, would come into being to replace what Nyerere considered embryonic capitalist socio-economic development in rural Tanzania, a legacy of economic dependency and inequality with its disastrous socio-political consequences.[25]

Komba further analyzes Nyerere's contribution:

> His concern for the creation of *ujamaa* villages as an approach to rural development was a creative response to the issue of whether and how Tanzania could develop in a modern way without having

to abandon its treasure of long-cherished cultural values. Certainly, to raise this issue at a time when modernisation was conventionally understood to entail the elimination of traditional African values was quite revolutionary.[26]

Certainly this is a pertinent matter at the heart of building *ujamaa* in Tanzania. It was to realize the vision of the Tanzanian village

> as the focal point of a socialist society that inspired Nyerere to take a further initiative which may as well mark his most significant and, in retrospect, most controversial contribution to the process of development in the African context.[27]

Our concern is with this failure of Nyerere, TANU, and the government to deal effectively with modernizing Tanzania without abandoning its traditional African values as Komba defined them. Precisely, the government moved to modernize the villagers at the expense of local cultures and traditions, as well as ignore the involvement of local structures of authority in the planning and implementation of the program. While all the more preoccupied with the success of the Villagization campaign, TANU and government unleashed the state machinery upon the villagers apparently without seeking the best approach which would consider "building on the best of local tradition and culture instead of ignoring or actively destroying it."[28] In this apparent contradiction of introducing modern development to Tanzanians while safeguarding and promoting traditional cultures *ujamaa* and Villagization clashed with local cultures and traditions. In Tanzanian society of this period the cult of the ancestors was greatly affected by this new social order.

With independence in 1961, but particularly after 1967, the primary aim of TANU and the national government was to transform Tanzania in concert with *ujamaa*. Now, along with this transformation of the Tanzanian society, entrenched grave customs like the Zaramo's placement of posts of their ancestors (fig.5.1) stood in the way of building the modern society. This is because by and large such objects, practices, and philosophical formations of understanding reality were expressions of ethnic religions and cultures—they were not expressions that advanced the *ujamaa* cause. As localized traditions and ritual expressions specific to a group of people, such customs in turn reinforced ethnic tendencies and helped in building the respective cultures. They also continually defined and bolstered grouping of Tanzanian people along ethnic lines, a development to which *ujamaa* was basically opposed and subsequently combated and strove to transform, or eventually eliminate.

It is hardly surprising, therefore, when Westerlund points out that a large number of local leaders and TANU members were reluctant to embrace the changes engendered by the new social order. Consequently, the ruling elite were often at loggerheads with the interests of the people in the rural areas on matters of religion and many aspects of culture. It became increasingly apparent that *ujamaa* as a rule was not an outgrowth of the African extended families as Nyerere had hoped, but a top-down strategy. Even more poignant, the large majority of those who directed *ujamaa* were Christians or Muslims whose religious attitudes were different from those of most villagers. In John Iliffe's view, "TANU leaders were modernists who, like Nyerere, habitually spoke of indigenous religions with an embarrassed smile."[29] Along this line, Westerlund's perception of *ujamaa* was that it achieved the status of an elite phenomenon, the civil religion of the country whose well-springs were not the African religions and cultures. What is increasingly evident is that *ujamaa* could not amply accommodate some core religious and cultural values of Tanzanian villagers, in part because it did not emanate from the grassroots: the villages themselves.

Scholars have noted that many villagers were reluctant to move to the newly established villages during the peak of Villagization between 1974 and 1976 because they did not want to abandon the land which contained the graves of their ancestors. The rather moving Msanga scene involving Mwengoha should amply illustrate this point. Granted, Mwenegoha did not make specific reference to the *mizimu*, or to the small huts used as family shrines, to family graves, and grave posts. However, his words are telling: "now you want to embarrass us by demolishing our houses so that instead we go to the bushes, leaving our property behind." Since matters concerning graves and the dead are very sensitive and rarely discussed in the public sphere, they are likely implied rather than explicitly stated in Mwenegoha's speech to the Member of Parliament.

Clearly the Villagization scheme together with urbanization contributed to a decrease in the significance of the cult of the ancestors. However, it is noteworthy that this cult had already been declining prior to Villagization, which appears to have been a general characteristic in Africa. Indeed, the cult was on the decline before Tanzania's independence, though this cult certainly created quite a bottleneck during the Villagization program. This big problem can be understood when we note that the importance and continuity of the cult of ancestors revolved not only around family shrines, but also around those of the community often located in rocks, groves, river banks, mountains, caves, and waterfalls. The villagers' eventual shift from the space they were occupying denied a close link with these crucial entities. Certainly graves and

shrine groves remained behind in the old habitations when the villagers were uprooted from their permanent villages. In Mjema's words,

> Villagization had severe effects on the Zaramo way of life, and this includes burial grounds. In most cases the people continued to visit their family graves for many reasons, not only to clean them, but also for ritual reasons.

But for some Zaramo families, it meant traveling some distances to these areas where their family graves were located—the land that they had vacated because of Villagization. In one sense, this disruption of space and people (particularly where the distance between the new home and vacated land with graves was great) may have contributed to the neglect of a grave-site in the old habitation. Figure 5.8 shows a special grave-site for important Zaramo people in Kisarawe District in 1974 with old, decayed grave posts. The unkempt condition of the site, especially noticeable through the encroaching bushes, gives the general impression of abandonment of this burial ground, the graves, and the grave posts.

Ultimately, the people whose links with their ancestors were broken became victims because of what they considered meaningful beliefs and practices. In essence, the villagers were deprived of the very physical manifestations and mediums that connected them with their ancestors. This state of affairs, that

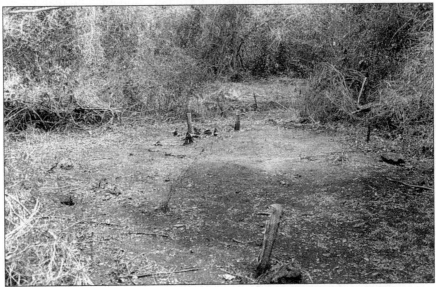

5.8 A Zaramo gravesite showing old grave posts, Kisarawe District, 1974

is, to deny the villagers of their connection to the ancestors, appears quite out of place considering the approach to culture Nyerere adopted after the first anniversary of the country's independence.

In his 1962 inaugural speech to Parliament as President of Tanzania, Nyerere explains his objective in establishing the new ministry, Ministry of National Culture and Youth. Nyerere said:

> I have done this because I believe that its culture is the essence and spirit of any nation. A country which lacks its own culture is no more than a collection of people without the spirit which makes them a nation. Of all the crimes of colonialism there is none worse than the attempt to make us believe that we had no indigenous culture of our own, or that what we did have was worthless—or something of which we should be ashamed, instead of a source of pride. . . So I have set up this new ministry to help us regain our pride in our own culture.[30]

These words cogently express the seriousness with which Nyerere viewed Tanzanian culture and the intent for its promotion. However, in July 1969, in a speech appearing in the Tanzania *Nationalist* paper, Nyerere is reported to have stated that

> living in isolation would not bring forth development, and that it was absurd for a people to cling to an isolated place on the grounds that he was guarding his forefathers' graves.[31]

Though one might interpret Nyerere's statement differently, in my view, it would seem that *ujamaa* was given precedence over belief in the ancestors. In addition, religious beliefs posed to take *ujamaa's* position or obviate the development of this new social order had to go. Clearly, TANU and government disregarded Tanzanians' traditional beliefs and ways of understanding their realities.

The implementation of the rural development policies of *ujamaa* like Villagization were accompanied by the indoctrination of the *ujamaa* ideology. This ideology placed emphasis on egalitarian principles, on working together, and on sharing the products of collective efforts. However, it was not only the majority of villagers in the country who were hard-pressed to distill the ideological message embodied in *ujamaa*, and doubted its soundness, but local leaders were not committed to *ujamaa* either. Apart from the seeming ambiguity and uncertainties of this ideology to deliver the goods of socialism,

it was not easy to persuade the villagers to move into the unknown. And perhaps the villagers philosophized that since their communities were built upon the principles of the African extended family, it was reasonable to see that they were basic to fulfilling the role *ujamaa* was advocating.

Also, the villagers may have seen a contradiction in *ujamaa* and the Villagization campaign even as Nyerere, TANU, and the government were recasting the social order. Nyerere aimed to build *ujamaa* upon the basis of traditional African societies. He said:

> We are not importing a foreign ideology into Tanzania and trying
> to smother our distinct social patterns with it. We have
> deliberatively decided to grow, as a society, out of our own roots.[32]

But on the same token, it was indeed a paradox to trivialize the belief in ancestors' relationship to land and conception of space in the very communities Nyerere wished to utilize in building *ujamaa*.

The decrease in adherence to the cult of ancestors and other practices connected to graves was perhaps welcomed by advocates of *ujamaa* such as top TANU and government leaders. Westerlund notes this was

> because this cult had tended to promote and preserve the affinity
> within the extended families, the affinity that *ujamaa* was supposed
> to extend. A condition for the success of *ujamaa* was that
> traditional social ties began to be affected or 'extended,' and since
> the ancestors were the most important members of the families, a
> decline of their significance could affect the traditional social
> structure.[33]

Although the kinship structure was not broken in the new villages, on the whole, many people were reluctant to accept *ujamaa* advocated by the elite as an ideology geared to foster national integration since clearly the fountain-heads of this national morality were not recognized authority figures and traditional beliefs. Therefore, though religious beliefs thought to reinforce important divisive morals such as belief in ancestors were combated by the government, many people clung to their traditional customs rather than follow the laws of the nation.[34] In this sense one may understand the "survival" of the Zaramo practice of putting carved grave markers on their graves as well as rites connected with graves and shrines where pilgrimages and offerings are still made. *Ujamaa* has not managed to wish these away.

Beyond Villagization?: Zaramo Grave Markers amid Change and Continuity

It is difficult to assess the proliferation and prospects of Zaramo grave posts following the adverse influences of the social factors examined in this chapter. This is both because of sketchy evidence of Zaramo responses to a myriad of ongoing changes, and a lack of detailed individual/family preferences on the use of grave markers and changing practices connected to graves. In general, we may take the continued making and placing of figurative wooden posts on Zaramo graves as a form of perpetuating Zaramo personal/individual and cultural identity despite the cultural and socio-political forces the Zaramo have experienced. As Zaramo carver Mirambo told Felix in 1988/89, naturalistic posts that mark recent Zaramo graves are testimony that the person buried there was a traditional believer who settled for visually more modern and realistic sculptures.

A logical question to pose here is: did the Zaramo in 1988/89 perceive grave posts topped with *mwana hiti* symbolic figures (fig.5.1) as things of the past? If so, and that appears to be the case, may we presume that a grave post incorporating a *mwana hiti* carving suggests an outdated tradition? Similarly, it is interesting to ponder the reasons for the relative continuation of *vinyago* markers (figs.1.1, 5.5) at the expense of the *mwana hiti* witness posts (fig.5.1). This trend can be explained as a matter of preference or taste, as Mirambo intimates, but it raises questions about the social factors stimulating this cultural phenomenon. Though *ujamaa* and Villagization negatively affected both the belief in the spirits of ancestors and the witness posts, the process was not selective on forms of grave sculptures. Other important questions concerning Mirambo's insight are if, indeed, today the Zaramo do not appreciate a grave marker topped with *mwana hiti*, why do they utilize the same image (*mwana hiti*) in the *mwali* custom? Does the image embed a different dimension of significance in the girls' coming-of age-rites? If so, is it because the *mwali* trunk figure is mostly kept indoors except at her coming-out ceremony, whereas a grave marker with a *mwana hiti* image at its top is erected in the open and everybody can see it? It does not suggest an embarrassment about the figure.

The traditional believer who uses naturalistic grave posts, who Mirambo mentioned, clearly identifies him/herself with Zaramo cultural traditions. This identification is especially significant considering the decline of traditional beliefs and practices like the cult of the ancestors and the use of commemorative grave sculptures among the Zaramo. So, too, is the placement of the post on a grave-site amidst other new, presumably "modern" forms of grave markers made from material other than wood. As the central theme of

this discussion, it should by now be understood that changes concerning the Zaramo's shift toward the utilization of types of markers such as slabs, ceramic shards, crosses, and simple wooden ones with no figurative representations are indicative of a perpetual break from the figural markers. As I have repeatedly shown, the process of modernizing increasingly affected this age-old Zaramo art form and resulted in the use of other forms and styles of markers. Apart from the issue of changes of material and the configuration of the physical object (the grave marker), the beliefs connected with the use of witness grave posts were also negatively affected by *ujamaa* and Villagization. Thus, the use of a *kinyago* marker today may be interpreted as an assertive measure to maintain ties with what may be seen as past traditions. Its use evidences a shunning of new forms of grave markers and, I might add, some new ways of doing things.

The Zaramo's wariness in approaching social and cultural change is tempered by the example of Dar es Salaam's influence upon the Zaramo, where they demonstrated ingenuity in making cultural choices that only improved their lot. In proximity to and within the modernizing influences of the modern city of Dar es Salaam, the Zaramo have embraced some forms of modernization like Islam, possibly because it embodied a promise of a new way of life. And yet within the culture that Islam could offer, the Zaramo saw that it could easily be adapted into traditional Zaramo culture. So, with the conservative elements of Islam having accommodated themselves to traditional elements of Zaramo life, Zaramo culture was no longer threatened by Islam. The faith and its culture have not destroyed traditional aspects and other core values of Zaramo life such as initiation rites, curing rituals, ancestral beliefs and ceremonies, or figurative objects connected to these religious, cultural, and art forms. This evidence, coupled with the negative effect of post-independence Tanzanian social, political, and cultural policies on Zaramo figural grave markers, undercuts the analyses that blame Islam for the non-flourishing of these Zaramo objects. By failing even to suggest, let alone show that modernizing policies of *ujamaa* were adverse to the proliferation of Zaramo grave posts, the analysis of scholars such as Pelrine has misinterpreted the Zaramo social and cultural process. Even though traditional Zaramo culture lost some elements because of Islam, many of Zaramo core values and symbols continue.

Other forms of modernizing influences such as Western education were not as enthusiastically accepted by the Zaramo as other Tanzanian peoples. The main obstacle was Islam, which the Zaramo were already affiliated with. Understandably, Zaramo Muslims feared that their children would be converted to Christianity when attending Western schools. In Uzaramo, most

of these schools were run by Christian missions, a point not lost upon the Zaramo Muslims. The Zaramo rejected Christianity and Christian missionaries faced difficulties converting the Zaramo to the Christian faith. It is interesting though not surprising as L. Swantz has noted, that at one time, one third to three-fourths of all the children in the Lutheran Church schools followed Islam. We can speculate that these children may have been encouraged to convert to Christianity, but I have no data to support this contention. This example, though, demonstrates the flexibility that the Zaramo imposed on Christianity as they used its institution to attain their goals. In the process, Western values were reshaped to the Zaramo irrespective of their religious affiliation.

Although the social, political, cultural, and economic changes brought by *ujamaa* and the Villagization process negatively affected the use of Zaramo grave posts, this has not led to a total demise of the tradition. Creating figurative memorial posts and placing them on Zaramo graves now serves as an example of cultural resistance. It may be a way of registering Zaramo apprehension of the government-induced changes that have adversely touched Zaramo daily life. M-L. Swantz wrote in 1995 that the Zaramo supported TANU and the governments that followed Tanzanian independence but Zaramo expectations of improvement in life were not realized, in part because their conception of development appeared to differ from the government's. M-L Swantz gives an example of the Zaramo of Bunju village when asked to choose development projects for the village. The villagers could not mention any, though finally they suggested a telephone as something useful irrespective of the poor state of their village. They felt that a telephone was important for communication with kin members about family events or in times of need. The aspect of continuity of family ties is crucial for the Zaramo. It is clearly expressed in ritual obligations like the annual *tambiko* toward family ancestors that requires the participation of all living family members, or a yearly spirit exorcism that Zaramo families have an ancestral obligation to fulfill. The continuation of family ties helps to share the values and cement the bonds that define them in a social and cultural space that has witnessed great changes. The government brought changes through *ujamaa* and Villagization, but in the Zaramo point of view, these changes resulted in erratic and intrusive policies that did not significantly improve Zaramo life.

There is no question that Zaramo art objects affirm and perpetuate Zaramo social, religious, and cultural identity. Figurative grave posts provide a meaningful connective space that serve the living kin to celebrate, remember, and punctuate the place of departed family members. As the living Zaramo use figurative grave posts to suspend death in space across time, these posts

continually serve as useful reminders of the ancestors who are memorialized and honored in family genealogies, rituals, traditions, and histories long after they have died. In spite of the social and political negatives of *ujamaa* and Villagization that have worked against these Zaramo grave sculptures, creative pathos, wishes, and needs propel the Zaramo to make and adorn their graves with these objects. To be sure, this testifies that *vinyago* markers are likely to act as decorative and memorial features on Zaramo graves for generations to come.

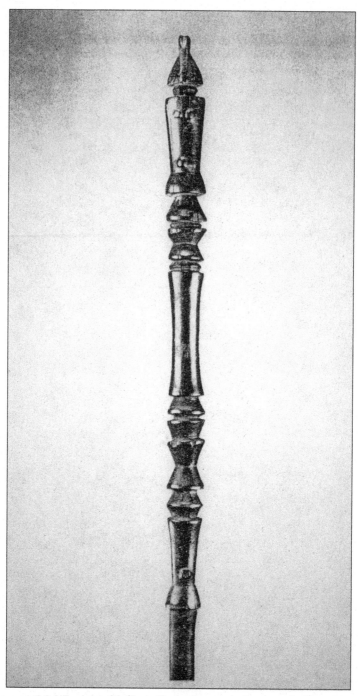

6.1 A Zaramo chief's staff—*kome*, topped by *mwana hiti*

CHAPTER 6
DRESS CODES AND PRESTIGE STAFFS
Constructing Political Authority with Staffs

I N THE PREVIOUS CHAPTER WE SAW THE M.P., M. ZAVALLA PAZI, challenged by a Zaramo villager Mwenegoha because Pazi was part of a leadership structure in the Tanzanian political landscape that was recasting the existing social order: effecting radical social, political, and cultural reforms partly responsible for destroying Tanzanian traditional forms and practices of constructing reality. As noted previously, a variety of political decisions made after independence in 1961 and the implementation of post 1967 modernizing policies of *ujamaa* contributed to the breakdown of traditional political, cultural, and religious systems of authority that supported the use of traditional Tanzanian art objects. For example, linguists, healers, diviners, chiefs, and leaders of secret associations utilized objects such as staffs. Following the establishment of modern forms of political administration, not to mention new creeds and improved science, some of these art forms and symbols died out. Others, though, survived and have been used with transformed meaning. For instance, a Zaramo *mganga* still uses his staffs in healing rituals, but *kome* (fig.6.1), which were perhaps preferred by Zaramo chiefs and headmen, are no longer used that way. In the same vein, whereas in the early years of independence Tanzanian political leaders used examples of *fimbo* (walking staffs) like *kome* (fig.6.2-6.3), today they would probably prefer *kifimbo* (fig.6.4). In this sense, *kifimbo* staff of Zaramo ritualists (fig.6.5) mapped new meanings in a contemporary context as politicians and military leaders utilize them. Consequently, they effected the survival of a tradition in a new society.

6.2 An early official portrait showing Nyerere with his *fimbo*

Though staffs come in different materials and forms, most examples in Africa are made of wood and are most commonly used for walking, though some staffs serve as ritual items and as symbols of authority. For example, chiefs, diviners, and linguists own staffs connected with their obligations. This is not to say that such types of staffs are used on a daily basis. Rather, these items are employed during special events and for performing specific tasks. These include chiefs who display them to legitimize their title, and to represent

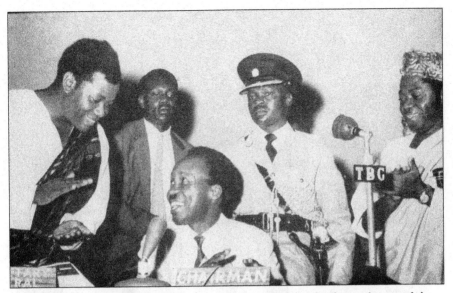

**6.3 Nyerere at a conference with Kambona and Kawawa both wearing _mgolole_.
Note Kawawa with his _fimbo_. Moshi, Tanzania, 1963**

their realm and power. Healers and diviners also utilize staffs in their activities,
as do linguists, orators, and leaders of associations. To cite an example, in
Ghana, major Ashanti chiefs have an _okyeame_ or public spokesman who holds
his staff as he speaks to underscore his authority and message.

While the woodcarver was the main creator of staffs, the chief or title-holder
could ask other artisans like a smith to work with the carver. Indeed, a
combined effort perhaps depended on the materials that a staff demanded. If,
for instance, metal such as iron and copper was needed, then specialists in this
field of metallurgy were called upon to contribute their expertise. In another
example, a bead-worker may be involved together with a woodcarver in the
creation process if a staff was to be decorated with beads. Considering the
crucial functions of staffs, it would seem that after the creation process is
completed, other actions may be taken upon the objects. For example, a
practitioner would be given the task of manipulating a staff with view to
consecrate it, thereafter the object is given to the titled person.

In this chapter, I examine Zaramo _kome_, _mganga_ staff, and _kifimbo_ (though
it is not exclusively a Zaramo object) in order to explore the ways these staffs
have been used in dress codes and as prestige symbols to construct political
authority. I might add that for the most part in this discussion, _kifimbo_ features
in the national political context of Tanzania. So, I analyze the three types of

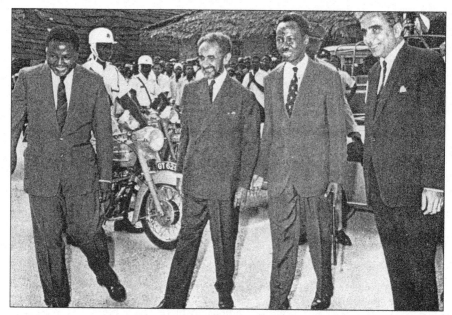

6.4 Nyerere holding his _kifimbo_ while flanked by Emperor Haile Selassie of Ethiopia and Tanzanian government ministers Shaba and Jamal, Dar es Salaam, June 1964

staffs within the contexts of changing cultural traditions, social statuses, and especially political authority and power. I shall demonstrate that individuals who own staffs continually recreate, reposition, and manipulate the staff to suit their needs. Although the focus here is on staffs used in political institutions, curing rituals, and ceremonial contexts, I also make a general reference to staffs that lie outside of these areas of social life. Since these objects embody an element of continuity, I make a parallel discussion between traditional forms and contemporary transformations. This bridges the temporal gap between old and new and allows us to see patterns of continuity and patterns of difference.

Because of the introduction and dissemination of new ideas and technologies, and the resultant changes that many societies in Tanzania have undergone, the staff's use has declined overall. When it is employed, however, it is with changed meaning. The variety of changes that staffs have undergone range from materials for constructing staffs, shapes of staffs, decorations and symbols, and uses, to the institutions in which staffs are found. As we examine the three types of staffs: _kome, mganga's_ staff, and _kifimbo,_ we might benefit by rethinking the assumption that:

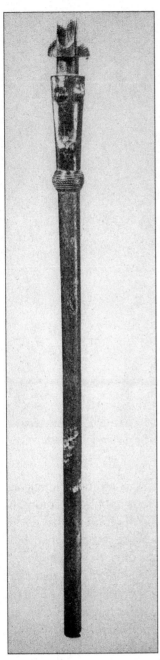

6.5 A Zaramo _kifimbo_

All societies that are in contact with each other eventually exchange materials, items, and ideas. If two societies are in long-term contact, and are at greatly different economic and technological levels, great modifications are introduced into the material culture of the less-developed societies.[1]

In the course of the discussion, I will highlight Zaramo and Tanzanian responses to these staffs as they relate to socio-cultural factors of change and re-socializing processes. For our present purpose, however, I explain those responses connected with European modes and cultural values, politics of nationhood, modernization, dress codes, as well as ethnic and cultural identity.

Dress Codes and Prestige Staffs

It was a general practice among men of many ethnic groups in Tanzania to carry a walking staff as an important accessory—a part of dressing, when going on a trip or when attending a public event, since traditionally walking staffs were objects of prestige. Walking staffs would also act as means of support, especially for old men and women. Obviously some of these walking sticks could be used as weapons when a quarrel broke out and also to deter animals. But because of changes related to dressing patterns, and changes upon traditional institutions in which staffs were usually utilized, the custom of carrying walking sticks has now declined. The practice now is to dress without carrying a walking staff. For example, one does not often come across Tanzanians in the urban areas carrying staffs.

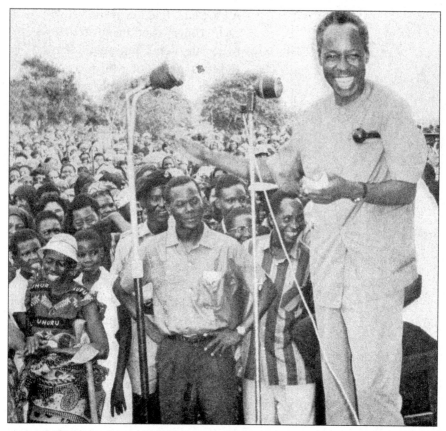

6.6 Nyerere clasps his *kifimbo* under his armpit as he delivers a speech

However, even as this custom of using walking sticks as prestige symbols is declining, *vifimbo* (pl.) staffs, which also act as prestige symbols, are common features among officers of the Tanzanian armed forces. The *kifimbo* has taken the place of walking sticks, not in the everyday dress of the common man, but in the military, the political leader's strong arm. Since the *kifimbo* is not used for walking support, but as a symbol of prestige and authority, its shape or design differs from the walking stick's. In his short paper on staffs of office of Central and Eastern Africa, Leo Polfliet appears to refer to these objects as *kifimbo*.[2] However, I understand *kifimbo* as a small stick—a literal translation since *fimbo* means stick in Kiswahili. The prefix, *ki* denotes size, quality, and quantity. In this case, small, refers to size. *Fimbo/gongo/mkongojo* also means staff. The version of *kifimbo* that concerns us here is a rather small and very short staff (fig.6.4-6.7) usually held by hand or clasped under the armpit (fig.6.6-6.7). It is in this sense that *kifimbo* is also referred to as a "hand stick."

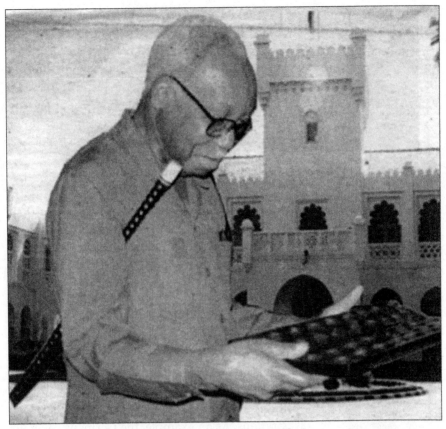

6.7 Nyerere with his latest *kifimbo*

In terms of size, it is obvious that this small staff, as shown in figure 6.5, differs from say, the chief's staff (fig.6.1), *mkomolo* (fig.1.4, 6.8) or walking stick (fig.6.2). The continued (and changed) use of staffs (*kifimbo*) in the military shows how these objects are utilized with changed meaning: as a part of dress, and as symbols of authority and leadership.

Traditional cultural forms in which a variety of staffs were utilized were fertile ground for the use of staffs in other aspects of society. In other words, the practice of carrying staffs spread beyond the confines of ritual and political/administrative contexts. This can be seen in the trend in which people (who are not connected with these contexts) carry prestige enhancing, embellished walking sticks as well as objects such as fly-whisks. As mentioned in Chapter 3, for instance, when the Zaramo were still under the rule of chiefs, they produced staffs called *kome la pazi*—carving of chief/headman. Examples of such elaborate sticks appear to have been used beyond the institutions of

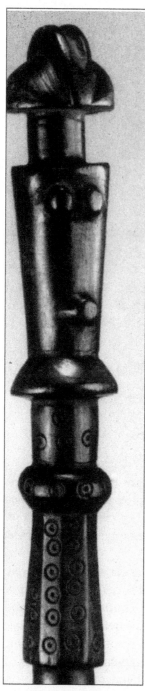

6.8 *Mkomolo* staff of the Zaramo with a *mwana hiti* figure

Zaramo local leaders given that it was considered a part of the "dignity" of a man to carry a big, nicely carved stick. *Kome* in their old form have disappeared because the headman institutions linked to them are no longer in place, or they have been replaced. I refer here to the executive position of chief among the Zaramo. As noted previously, chiefs were relieved of their political powers throughout Tanzania in 1963.

The political turmoil in Tanzania after independence affected the meaning of staffs. Although staffs continued to be used, their meaning was transformed since the contexts where they were found changed. As mentioned, there was a change in the use of staffs and *kome* after the cessation of local political leaderships— a move that TANU and government took to consolidate the state, to forge national unity, and strive to build a national culture. To provide a short historical perspective of the position of chiefs under colonial rule, it is worthwhile mentioning that colonial governments utilized local leadership structures in their administrations. As an example, the Germans generally accommodated existing chiefs as their agents in government service. In cases where such local leaders were not available, however, the Germans appointed *akidas*, who came from the coast, whose duties were to try cases and collect taxes. For their part, the British adapted Indirect Rule as the official policy of Tanganyika from 1925 until after World War II; that is, ruling indirectly through a local authority structure first experimented with in Nigeria. This was Lord F. Lugard's "Dual Mandate" philosophy under whom Donald Cameron, the Governor of Tanganyika from 1925-1931, served in Nigeria.[3] The philosophy meant that the British colonies be developed in relation to the world and with the benefits of the indigenous people in mind. Lugard

strategically sought to answer the shortage of administrators while at the same time restrain ambitious political innovations of the colonized politicians. In a nutshell, the policy aimed at strengthening traditional political authority, preserve African traditions and customs as well as place emphasis on the growth of local economies. In other words, give the Africans a form of government connected to African roots, similar to the one they had before the onset of colonial rule. The British envisioned that upon this foundation coupled with their guidance and control, the people will ultimately reach a point where they will be able to govern themselves. But in actuality, the policy had little practical effect. L. Swantz, in his 1965 work, notes that in Uzaramo the British had a District Officer with assistants; however, 132 village headmen, *wandewa*, each with a local court—*baraza*—were responsible for legal proceedings and local civil affairs. When these local political leadership positions were functioning staffs and *kome* flourished. After independence the post of chief as an executive was annulled throughout the country and local authorities were integrated in local governments. In 1964, for instance, TANU introduced an organization of ten-house leader—*balozi/mjumbe wa nyumba kumi*—in both the rural and urban areas, and whose roles were political and administrative. However, the people clearly understood these ten cell leaders in their role as witnesses and arbitrators in councils for settling family disputes than political. It is noteworthy that Tanzania has witnessed much restructuring of political organization over the decades especially, in the post 1967 period. Thus, the political reorganization affected use or meaning of staffs and *kome*.

The continued use of staffs resembling Zaramo *kome* is testimony that traditional forms are perpetuated, or modified and utilized in contemporary situations. In this connection, given that contemporary designs of walking staffs differ from traditional forms of *kome*, understanding the form and symbolism of *kome* allows us to gauge meaningful change in the staffs. Reckling, in his 1942 work, describes *kome* as often carved from blackwood or *mpingo*, taller than a man, and embellished with human and animal figures. Whereas in the past the *mwana hiti* image may have served as the top of Zaramo staffs (fig.6.1), Pelrine submits that today one is likely to see a naturalistic representation of a human figure (fig.5.5). She asserts that the depicted figures are female though she does not offer further explanation. *Kome* were status symbols associated with the office of a chief. Furthermore, *kome* served as prestige walking sticks (fig.6.1). It appears that some of these *kome* were the property of Zaramo *waganga*. For example, Pelrine offers an example of such a staff topped by a *mwana hiti* image held as a walking stick by its owner; an *mganga* of Kibaha District in Uzaramo. It is difficult to piece together the form and symbolism of these *kome*. Presumably, since staffs of

title-holders serve important functions connected with the holders, some of these objects carry symbols whose significance may not be apparent to everyone. And perhaps these aspects varied in correspondence with the title-holder to whom a staff belonged. Felix describes briefly the chief's staff (fig.6.1) as follows:

> Chiefs used to have rare staffs that depicted two *mwana hiti* ... The one on the top was definitely female and the one that could be male was at the midpoint of the shaft.[4]

I disagree here with Felix's reading of the male and female *mwana hiti*. Aside from the elaborate carving work on the staff, it is difficult to tell whether the two *mwana hiti* images are male and female representations. It appears that Felix's interpretation is based on the characteristics of the image at the midpoint of the staff. This image has a protuberance that may represent a navel—it does not have depictions that in other *mwana hiti* we interpreted as breasts. In spite of these differences, it could be misleading to make a rash judgment that the figures stand for the two genders. What if the carver chose to exclude the other representations of organs commonly found in the *mwana hiti* image? In fact, even the "head" of the so-called male representation of *mwana hiti* found in this staff is unlike much of other representations of the head. We do not have interpretations for other carved sections of the staff which look like mortars or miniature stools. What is apparent to me is the rather plain section below the top of the shaft. This seems to be the part where one would hold the staff. This assumption is supported by practical reasons. Given the length of the staff (46.4 inches), the ideal part for grasping or holding the stick would be the plain section below the top image (6.4 inches). Moreover, the top of the staff was by all accounts a showcase, not a place to put the hands. Doing so would prevent the viewers from seeing the image since this was the focal point of the staff—the area onlookers would direct their attention to when the staff was held for its various purposes. Though much of the symbolism concerning this intricately sculpted staff seems to escape us today, at least we can appreciate the beauty of the object. This piece further exemplifies the imagination and the artistry of its Zaramo creators.

Like walking staffs, fly-whisks have become invested with political meaning. Traditionally, fly-whisks were usually used by courtiers and ritual and spiritual leaders, although some old folks utilize them to chase flies since they may sit at one spot for a long time. Thus, they are a part of dressing as well. Among African national leaders, Kenyatta, at least from the early 1960s until his passing in 1978, used to carry a fly-whisk even in the political arena. Among

the Maasai, fly-whisks have been used by leaders as devices for blessing. A fly-whisk, once dipped in traditional beer, is waved over the group giving everyone a taste.[5] Some of the leaders have waved a fly-whisk to show their agreement with a certain decision. Zaramo *waganga* use these items in cleansing rituals. It becomes clear that walking staffs and fly-whisks have served as both dress codes and authority objects.

Other factors responsible for the decreased use of prestige walking staffs are increased urbanization, forms of acculturation, expansion of European forms of education, and improved transportation systems. These factors have contributed to increasing the pace that consequently altered and shaped much of Tanzanian societies. For example, initiation rites, healing and cleansing rituals, and traditional forms of leadership for the majority of Tanzanian peoples have entirely disappeared. These forms have for the most part been replaced by modern agencies like schools, religious institutions, the mass-media, modern medicine and ways of healing, as well as new systems of leadership. Needless to say, European ways of dressing and European accoutrements included walking sticks such as canes, which were borrowed or adapted and often modified by Tanzanians. Such notable imposition of European cultural values upon Tanzania society detrimentally affected staffs by rendering them less authentic and meaningful.

Mganga's Ritual Staff of the Zaramo:
Interpreting Traditionalism and Modernity

To a considerable degree, the Zaramo have meaningfully taken hold of a basic sense of their own form of reality by continually following specific social practices they have considered important to their way of life. A case in point is the continuation of social rituals in which several types of staffs can be utilized and interpretation of traditionalism and modernity made. In this connection, traditional designs of staffs and traditional social rituals have been adapted to modern uses. As pointed out in the Introduction, in Zaramo society, tradition and modernity exist side-by-side in the social order. Thus, the rituals and staffs used therein are *mila* (tradition) even as they are practiced in a modern social context. In this way, they can be seen as modern practices that are acculturated and have become *mila*.

In Zaramo society, in addition to headmen, other ritual specialists who have used staffs in different ways include diviners, exorcists, witch hunters, and healers. Despite the erosion of influences discussed in the previous chapters, it is not difficult to understand that some objects in the Zaramo staffs' corpus have persisted because the ritual contexts in which they appear are still important to the Zaramo and thus continue to be followed. For instance, I

pointed out in the Introduction that carved staffs are still used in ritual contexts such as in the initiation ceremonies for Zaramo youths where a staff called *mkomolo* (fig.1.4, 6.8) appears. A clan leader would hold this staff as a symbol of his title. The Zaramo *mganga* also utilizes *mkomolo* in a spirit possession rite called *madogoli* (the plural form of *dogoli*) which is the drum utilized during exorcism rites. *Madogoli* also refers to the actual exorcism rite, the healing ritual. M-L. Swantz, in her 1995 work, states that *madogoli* drums and dancing are used when the spirits to be exorcised are *kinyamkera* and *mwenembago*. She observes that these two categories of spirits affect the Zaramo more than any other spirit. Furthermore,

> *Kinyamkera* is said to be a female spirit, the mother of all spirits, who is helpful to the *waganga*, appearing to them in dreams and giving them the necessary information concerning the problems and cure of the *mteja*. *Mwenembago* is a male spirit to whom great physical strength is attributed. He is considered evil in his intentions. Both *kinyamkera* and *mwenembago* can affect either women or men, although the male spirit often affects women and the female spirit affects men. If the *mteja* is very ill, a short rite called *saba* will be performed first. This is a promise given to the spirit that the full ritual will follow ... It also gives the kin-group a chance to get the resources together because a full *madogoli* is an expensive ritual. The *madogoli*, which in earlier times lasted seven days and nights, now consists of a whole night and day *ngoma*-dance, in which the spirits are raised. The ritual is an encounter between humans and spirits. It is a feast given to the spirits in which they come and take part by being raised to the head of the *mteja* and the *waganga* ... In the end, the spirit within the patient eats and drinks the offerings of cooked rice, sweet bananas, and other foods. In the late afternoon of the day of the *madogoli*, the *mteja* goes with a *mganga* to make offerings and prayers at a large tree or at a pond. Prayers are made to the known bilateral ancestor spirits up to four generations, especially to those who are known to have practiced *uganga* and whose practice the patient and the *mganga* are continuing. Their cooperation is evoked. It is believed that the deceased use the spirits with whom they communicated while living to keep the contact with the living. By fulfilling obligations to deceased elders, the living also continue to uphold the kinship ties among the living kin.[6]

The study on *waganga* in Dar es Salaam that L. Swantz conducted in the 1970s found that not only does the *mganga* still occupy a prominent position in a modern environment, she or he also preserves traditional Zaramo culture since the *mganga* acted as a bridge for the Zaramo "to adjust to the modern world."[7] Zaramo *waganga* have also used another heavier and shorter, elaborately carved version of staff which was stuck in the ground, where upon the patient could lean against it as a backrest during exorcism and healing rites. Some of these staffs of the *waganga* have wooden hooks (part of the staff) for suspending gourds containing medicine. In addition to their use in healing rituals, Zaramo staffs with hooks from which small gourds of traditional medicine can be hung, are implanted in the ground during initiation ceremonies.

As Zaramo social rituals continue to be practiced in contemporary Zaramo society, staff design also reflects tradition and modernity. In other words, traditional staff design that incorporates the *mwana hiti* image as found in *mganga's* staff appears in healing rituals in the 2000s Zaramo society. A good example of this traditional staff design is the *mkomolo* staff (fig.6.8) that exhibits fine execution which is testimony to the great traditional artistry and craftsmanship of the Zaramo carvers. This exquisite piece is not only topped by a *mwana hiti* figure, but below this image is another elaborately carved section. This part of the staff is decorated with the "circle and dot" motif. The section below the beautifully embellished section of the shaft is plain. As noted in Chapter 4 the *mwana hiti* image is repeated in Zaramo objects used in ritual, including musical instruments, thrones, fly- whisks (fig.5.6), wooden grave sculptures, medicine gourds, staffs, and posts. Thus, as the *mwana hiti* image proliferates and permeates these important objects, it is understood by the Zaramo to signify reproduction and continuation of the cycle of life; simply, that life goes on. The image also fulfills the purpose of ornamentation on the objects which incorporate it. With respect to the "circle and dot" design, apart from decoration, its other significance among the Zaramo is unclear at this point. But this design can be examined in relation to the geometric designs comprised of rectangles, squares, and circles found on many objects belonging to people living on the East African coast.

The general impression of these geometric designs was that they were merely decorative devices deriving from coastal culture, and that coastal craftsmen applied them on objects used in Swahili and Islamic communities on the coast. In view of fairly recent research, however, this theory, which traced the designs to Islamic craftsmen among coastal Swahili communities, has been challenged.[8] For example, Castelli argues that among several Bantu peoples in Tanzania and Kenya, line symbols served a memorial function—

such as a form of writing to communicate and symbolize the spiritual and secular position of lineage and association leaders. Additionally, the lines were used as design elements on all the objects belonging to these leaders. In any case, it seems conceivable that the designs may have crossed over from either of these cultures and were adapted to suit particular cultural situations, thus gaining new importance. This assumption bears some validity when we take account of the exchanges that have occurred in the areas of language, dressing, crafts, architecture and other crucial elements of social and cultural life between the Zaramo and the Swahili.

Though the "circle and dot" design utilized in Zaramo objects like staffs as well as the so-called "Swahili" designs can be considered as traditional designs, they are also modern. Indeed, Chuma's intricately carved door at the Simba Grill of the Kilimanjaro Hotel in Dar es Salaam (fig.3.9) recalls chip-carved Islamic patterns principally patronized by Swahili artisans. I also observed that Zaramo carvers working essentially for the tourist art market at "Uzaramo Uchongaji Sanaa" cooperative in Dar es Salaam (fig.3.10) continue to apply these patterns as surface decorations on items like wooden treasure chests, which are associated with Swahili coastal culture. Again, this is a clear indication of exchanges and development of ideas and techniques that have occurred in cultures on or near the East African coast. At any rate, the foregoing shows not only trends in which traditional items and motifs of Zaramo social practices are interpreted into modernity, but the ways such cultural phenomena are also perpetuated as *mila* in contemporary Zaramo culture.

Despite the multitude of changes, the Zaramo have preserved the integrity of their way of life by following specific social practices crucial to their livelihood. The continuing use of *mganga* staff, and the ritual and ceremonial forms of which they are an integral part, evidently points to the significance they possess in Zaramo cultural and social life. We have already observed that the Zaramo have experienced an array of changes resulting from social, political, religious, and economic developments. Urbanization, Western education, Christianity, Islam, colonialism, post-independence government policies, and processes like *ujamaa* and Villagization, have significantly contributed to altering Zaramo life. Though she did not include art objects in her analysis, M-L. Swantz, in her 1995 work argues that the Zaramo have shifted focus to protect their core since they are not in a position to close entrances and defend the boundaries of their society. My integration of art objects in the investigation of aspects of change in Zaramo cultural forms needs to be seen as an effective approach geared to expose these developments.

Kifimbo: Constructing Political Authority with Staffs

Vifimbo of the Zaramo (fig.6.5) are said to have been used by leaders as symbols of rank, though for the most part, ritualists utilized them to cast spells and cleanse people and houses.[9] As can be seen from this Zaramo *kifimbo*, it is topped by a *mwana hiti*. Although examples of this style of staff, produced by people such as the Gogo of Central Tanzania, have figurative representation, some lack such depictions. Instead, such a *kifimbo* may consist of a plain shaft with a slightly bulbous top (figs.6.4, 6.6).

Other examples of a similar style that I have seen in Tanzania also serve as personal weapons. In such a style, the shaft has a dual purpose. It is the main part of the *kifimbo* as well as the sheath for the long slender iron blade like a stiletto, whose handle is the top of the staff. This means that the *kifimbo* is comprised of two main parts: a wooden shaft and a knife. Once the staff is assembled, the latter is hidden in its case. In the event of an attack, the owner/holder of the *kifimbo* would feign to strike with the staff, thus luring the assailant to hold the lower part of the shaft or case. This would trigger at least two responses: if the assailant holding this opposite lower end (the sheath) pulls the shaft towards him/her, or the owner of the staff also pulls the upper section of the weapon, the move would release the long knife out of the sheath. In this way, the assailant will be faced with a man holding a knife in an advantageous position for attack. This *kifimbo*-cum-knife may have "tell-tale" marks to indicate that it is not the ordinary type. For example, an iron ring/band is to be found just below the top of the staff. Its placement there could as well serve as a design element, but also to strengthen the top end of the wooden case. *Vifimbo* are carried by Tanzanian politicians, and just like walking staffs these small items can be found among *wazee* of Tanzania. *Mzee* (pl. *wazee*), literally means old man in Kiswahili. Another popular reference to *mzee* is a man in a high position of authority or a rich man/successful businessman and the like, irrespective of age. In Tanzania, relatively young men have been called *wazee* due to their prominent statuses or material ownership.

Carrying a *kifimbo* appears to have become a relatively popular trend instead of *fimbo* or *bakora*. The latter accessory item may now be seen held by *wazee* who use it for support when walking and may be a sign of their seniority, age-wise. In rural Tanzania, staffs may be carried in social and cultural events such as community meetings, weddings, or ceremonies involving traditional authorities. For example, the Maasai (who live in Tanzania and Kenya) have sections' spokesmen for every age-set whose function is to preside over meetings and secular activities in the council of

their age-mates. These spokesmen have a club (*olkuma*) of *mpingo*, or rhinoceros horn.[10] In Maasai society, a club and a fly-whisk are emblems of leadership. Also in Tanzania, a *kifimbo* that is not a ritual item may be carried by *wazee* and not *vijana* (youths). One such *mzee* who was hardly seen in public without his *kifimbo* was former President of Tanzania, Julius Nyerere (figs.6.4, 6.6).

I use Nyerere here to illustrate the transformation involving the use of *fimbo*—staffs similar to *kome* of Zaramo chiefs—to *kifimbo* (fig.6.4). One might also say, he transformed the use and meaning involving a *kifimbo* like the Zaramo' that ritualists utilized to cast spells, to a Tanzanian staff that came to be used for building political authority. Furthermore, though Nyerere's *kifimbo* was an effective mechanism in enhancing his personal identity, this *kifimbo* also served as a symbol of male elder identity, given the placement of this staff in the center stage of the national political space that Nyerere occupied for a considerable number of years. Nyerere was the country's leader for 24 years before his retirement as president in 1985, and almost 30 years before stepping down as Party leader. Thus, Nyerere's *kifimbo* enables us understand the manner in which individuals tenaciously hold on to objects that accentuate their positions in social and political arenas.

Mwalimu Nyerere, as he is popularly known, used the long walking staffs at least since the 1950s up to the early 1960s before settling on *kifimbo* (figs.6.4, 6.6, 6.7). I have pointed out that in Tanzania men would carry *fimbo* when attending important functions or when on a journey. Nyerere was not an exception in this regard. He carried a walking stick when holding TANU meetings in the 1950s.[11] During this time Nyerere was in his thirties; therefore, carrying a walking stick was more in concert with his political eldership role than old age. Nyerere also carried a staff when he was Prime Minister and then President of Tanganyika and Tanzania respectively, as well as TANU and CCM Party chairman. In the early years of independence, Nyerere appeared in public holding his *fimbo*.

A fine example to this effect is Nyerere's early official portrait (fig.6.2). At the time, such a staff was one of the popular accessories for middle-aged men like Nyerere, and needless to say, for old men as well. Apart from its prestigious symbolic aspect, I would argue that it was also a means for Nyerere to assert his preference for traditional African cultural items, similar to contemporary African leaders. That is, Nyerere utilized traditional African cultural items to redefine and reassert the African personality. But Nyerere was caught in a bind. On the one hand, he appeared to side with African culture—if we recall his compelling speech to the Tanzanian Parliament in December 1962 when he was forming the first ministry of Culture. On the other hand, Nyerere

contradicted himself in the *ujamaa* policy of Villagization when he attacked without discrimination the very traditional beliefs and authority figures of Tanzanian culture that he was utilizing to construct a national culture after a period of colonial subjugation and misrule. In light of these developments, while we may ask what culture Nyerere was building, his strategy seems to have been to coopt culture for political ends.

Nyerere's use of traditional African emblems was probably found useful by other African leaders seeking political dominance. Among Nyerere's contemporary African leaders who used traditional African accessories, especially in the 1960s (the dawn and hey-day of African nationalism) through to the 1970s, we might mention Nkrumah, who often appeared in the public sphere wearing a traditional clothing called *ntoma* in Ashanti—some kind of a toga. Kenyatta with his *fimbo*, but more characteristically, his fly-whisk; President Mobutu of then Zaire, now, Democratic Republic of the Congo, donned his famous leopard-skin-patterned cap while brandishing his elaborate staff, among others.

In Tanzania, for example, a 1963 photo (fig.6.3) shows Nyerere wearing a Western suit while two members of his Cabinet, Rashidi Kawawa and Oscar Kambona, donned a traditional toga. In this case, they wore an *mgolole*, a large sheet of cloth usually worn over another dress. As can be seen in this figure, the *mgolole* does not cover the right upper part of the shoulder. In certain groups of Tanzania, it was a custom for chiefs to wear an *mgolole* and carry staffs. And Nyerere also wore a toga. In the picture, Kawawa is seen holding his *fimbo*. Appearing in this apparel, one may reasonably intimate that perhaps the ministers were identifying with the dresses and accessories of traditional chiefs. Indeed, with regard to these emerging leaders in Africa, it was an opportune moment at which to return to African cultural roots and celebrate African heritage after a period of cultural subjugation under colonialism. The dresses and accessories these leaders found fashionable was a powerful statement of pride about the aesthetic importance and relevance of traditional African culture.

But these new leaders of Africa were, for political purposes, merging traditionalism with modernity by coupling traditional dress and accoutrements with Western or Eastern attire. In a sense, synthesizing the old with the new, but marketing it as old. Nkrumah not only adopted Maoist and Euro-American dress,

> his adoption of paraphernalia associated with Asante royalty underscored a desire to appropriate traditional significations of authority.[12]

Nkrumah, apart from adjusting his traditional attire to correspond with "the voting alliance," the sword carrier and the orator followed Asante models, as did virtually all of the arts that his administration commissioned.[13] Regarding dress, Nyerere's trademark from about 1966 on was the Mao-style safari suit (fig.6.6). William Smith observes that, many Europeans and Americans in East Africa already uncomfortable with Nyerere's growing ties with China, had circulated a story that the suit was another indication that Nyerere was "going Chinese," but Nyerere is said to have first seen the suit in Zanzibar and adopted it for its simplicity. Having worn its top myself, we knew it as a "Tanzanian suit" because Tanzanians were following Nyerere's lead in donning it. However, I vividly remember that Tanzanians called the suit's style "Chou En-lai," after the then Chinese Premier Chou En-lai. But Smith submits that Chou En-lai himself, on a State Visit to Tanzania, had stated that the "suit was not heavy enough for the Chinese climate." Though its marker was Chinese, it was a truly Tanzanian suit. Often Nyerere's headgear was a Muslim/Swahili embroidered *kofia*. In an incident about this cap, initiated by a local elder of TANU, mainland Tanzania's political party at the time, Nyerere injected sentiments of nationalism.

'Why do you wear that?' the elder asked Nyerere. 'It is a Zanzibar cap.' 'No,' quipped Nyerere, 'it's a Tanzanian cap.'[14]

Through his emphatic response Nyerere may have meant to illustrate the concept of Tanzanian Union which still appeared unreal, but he may also have aimed at a fusion of and identification with all the cultures of Tanzania.

Regarding accessories, it did not take Nyerere long to switch to *kifimbo*, further illustrating political investment in traditional garb. For example, in a photograph taken in June 1964 with Emperor Haile Selassie of Ethiopia, who was on a State Visit to Tanzania, Nyerere is seen holding his *kifimbo* (fig.6.4). The *kifimbo* would increasingly become a conspicuous accessory of his presidency and his tenure as the Party leader (fig.6.4, 6.6). Nyerere, even after retiring from both the government and Party positions, continued to carry his *kifimbo* whenever he attended public events. As I pointed out previously, this item helped to give Nyerere another sort of identity. For in Tanzania, besides his title of *Mwalimu*, Nyerere attained a nickname of *Mzee Kifimbo* (Elder with *Kifimbo*). Interestingly, one is prompted to ask whether the mere habit of carrying the small staff resulted in this name. Certainly the Nyerere *kifimbo* does not serve the purpose of a walking staff since it does not reach down to the ground. Yet for Nyerere the *mzee* carried his favorite hand stick around, though clearly the reason for doing so was not for walking support.

Like other politically charged objects, we can liken Nyerere's *kifimbo* to Kenyatta's flamboyant fly-whisk or Kenneth Kaunda's famed white handkerchief. The objects also became symbols of national identity/national dress taking into consideration the people involved here. Other than being men, they were national leaders. They may have fancied holding these items just as any other person would or might wear a hat. But once such an item becomes a key characteristic of a national political leader's attire, it then acquires the added dimension of political tool. It may become an issue for discussion and a contested terrain because of the status of its owner. Why is the leader using it? What ends does it serve? Is it for political/social purposes, for example? With respect to Nyerere and his *kifimbo*, Tanzanians have since raised similar questions. A common question revolves around the issue of whether the *kifimbo* has contributed to advance Nyerere's political career. It seems that even as Nyerere dominated the national political landscape in Tanzania, his use of the *kifimbo* led to its recognition as an emblem of his leadership largely because the object attracted national attention as well. So his employment of the staff was a success. In the first instance, his new image vis-a-vis the *kifimbo* may have come about because of the *kifimbo* he owned and flaunted. But secondly, it could be due to the power, real or imagined, that the staff is said to embody.

Nyerere's *kifimbo* achieved both political and cultural significance (fame) in that an entire folklore developed around it. Though Nyerere's *kifimbo* is associated with superstitions— especially as a magic device—it carries no sacred airs. The earlier version (fig.6.4, 6.6), carved from *mpingo*, was rather plain with no intricate carving work. The late example (fig.6.7), also of the same kind of wood, is elaborately executed while the tip section of the shaft appears to be of bone. It has been rumored that Nyerere's *kifimbo* was essentially a magic wand for his protection, especially in view of the dangers associated with his holding the highest public office in the land. Furthermore, Tanzanians circulated stories which increasingly fueled this magic wand myth. One story is told of an occasion in which Nyerere forgot his *kifimbo* somewhere. Nobody was able to pick it up until Nyerere himself realized that he had left the *kifimbo* and came to fetch it. Another story has it that when Nyerere became uncertain about a trip he was about to make, he would point his *kifimbo* in the direction he would take. Were the staff to bend, that was an indication that the journey would not have a happy ending, that danger lay ahead of him. As such, Nyerere would cancel the trip. However, I have no evidence to support these stories though by all accounts Nyerere's staff is surrounded with mystery whose validation is hard to ascertain.

We might intimate that the superstitions about these objects and the leaders who own them constitute some power. But it is not necessary to examine the mechanisms leaders in Africa have used to achieve political authority and invest legitimacy and longevity into their regimes. Doing so would move us beyond the scope of this inquiry. Instead, it is enough to recall Nkrumah's beliefs connected to his accoutrements, and which like Nyerere may have contributed to his mystique and political strength.

> Nkrumah was credited with the power of witchcraft, for example, as a consequence of his residence in the town of Nzema; his white handkerchief and walking stick, and his practice of leaving his hair unparted, were associated with 'the accoutrements of traditional fetish priests,' and he was said 'to commune periodically with Mame Wata,' an act 'which gave him privy to information about the machinations of imperialism.'[15]

Additionally, Nkrumah was

> believed to communicate with a Muslim advisor from Kankan, who gave Nkrumah herbs to bathe in and ingest in order to retain his power.[16]

This shows that the folklore surrounding these objects and their owners equals a kind of power in itself.

Another way of considering the Nyerere *kifimbo* is as a practical aid which probably helped in creating and reinforcing an aura of mystique and enormous political power. Often Nyerere used his *kifimbo* to wave to his supporters, make certain gestures when addressing political rallies, and in some instances, use as a pointer. In other occasions, he would clasp it under his left armpit, or place it on the table. But some superstitious minds would probably interpret these movements of the Nyerere *kifimbo* as constituting the casting of spells upon those he led. We may recall that the Zaramo *kifimbo* was also used by ritualists for casting spells and cleansing people. So regardless of the practical uses of Nyerere's *kifimbo*, its *supposed* uses wielded a large degree of power.

Whatever interpretations one may generate on the manner Nyerere handled his *kifimbo*, his was not an isolated case in the African leadership circle during the post-independence era. One of Nyerere's nationalist contemporaries, Jomo Kenyatta, used a popular slogan before addressing a political rally. He would say, *harambee*! (let's all pull together—a call upon Kenyans to pool resources/

efforts together in community development or self-help projects) while at the same time making a swirling movement of his fly-whisk in the air. The multitude would respond, *heee!*, signaling agreement with Kenyatta. Interestingly, Daniel arap Moi, who became President after Kenyatta passed away in 1978, also carried a small club-like staff called *Fimbo ya Nyayo*. Dikirr told me that this *kifimbo* of Moi is carved from ivory and decorated with gold rings. Furthermore, when not in use, Moi would put the staff on the table, but when he spoke, he raised the *Nyayo* staff in the air to let people know that he is in total command and were one to err, he had a way of punishing people. It can be seen that in this context, the staff serves to enhance Moi's image as an authoritative figure. Moi's nickname is *Nyayo*, which is Kiswahili for footsteps, and following the promise he made to Kenyans when he was sworn in as President of the Republic of Kenya he continued his predecessor's policies. To put it in another way, Moi pledged to follow Kenyatta's footsteps in presiding over Kenya. So, when Moi held the *Fimbo ya Nyayo* in the air and said, *harambee*, the response was *nyayo!* Through this staff, Moi also combined traditionalism and modernity to construct and advance his political authority and foster nationhood.

It is fruitful to consider the political leader's *kifimbo* with the positions of teacher, leader, and elder. In Tanzania, a teacher is seen as someone who is knowledgeable and who imparts knowledge to others. He or she is also seen as a leader, since a teacher becomes a role model for his or her students. Likewise, an elder is perceived as the store of knowledge and wisdom that he or she has accumulated over the years. Ideally, in a community's perception of the wise elder, he or she is expected to pass on this heritage from one generation to another through the process of socialization. Kenyan writer Micere Mugo describes the prestigious status and roles of elders in pre-colonial Gikuyu Kenya as follows:

> Elders were viewed as the embodiment of all that the community cherished— wisdom, justice, understanding, dignity, visionariness etc. ... They would sit for hours in council, listening to the complaints and defenses. Their sense of fairness was unquestioned. Through proverbs, sayings, stories and illustrations they would counsel, to show what needed to be done to remedy a given situation. They were the preservers and protectors of wisdom, accumulated through long years of communal experience. They were the guardians entrusted by the community of the living and the dead (the ancestral spirits) to ensure that there was harmony, coherence and well-being in the community.[17]

There is a Swahili saying popularly used in Tanzania which beautifully captures and illustrates these notions of the *wazee* (elders): *Penye wazee haliharibiki neno*. That is, in the attendance of elders a problem does not get out of hand because it is resolved.

Nyerere's association with his staff parallels the roles of teacher, leader, and elder. His practical use of the *kifimbo* possibly has its roots in his former teaching profession, and which he symbolically perpetuated as leader of the country. In Tanzania, teachers in primary and secondary schools carried sticks. Some teachers employed the staffs as pointers while others used them to discipline their students. In politics, carrying a stick symbolizes the act of leading. That is, showing the way that those under his/her jurisdiction ought to take: it does not carry the dual meaning of a leading and a punishing symbol. There is the example of the biblical Moses and the staff he carried when serving as the Israelites leader. He even used his staff to perform miracles. Interestingly, another nickname for Nyerere, which was current at least in the late 1970s and the early 1980s, was *Mzee Musa,* named after the Moses of the Bible. Tanzanians likened Nyerere's with the biblical Moses who led the Israelites out of Pharaoh's Egypt towards the Promised Land, only to wander in the wilderness. It was said that Nyerere did the same to Tanzanians economically since he ignored advice given him by his economic advisors.

While in public office, Nyerere utilized his teaching experience and the staff to create an atmosphere of teaching and learning rather than govern. On the whole, Nyerere displayed an uncanny ability to render complicated matters in simple language and speech. In addition, he was a charismatic speaker and a great debater. One characteristic phrase, *nitarudia* (I will repeat), which punctuated Nyerere's public speeches, is reminiscent of a teacher emphasizing a point to his/her students. It thus joins Nyerere's governing skills with the pedagogical skills of his former profession. Teachers identify, incorporate whips; that is their symbol of authority as it is Nyerere's image as President. To put it in another way, *kifimbo* as cane is similar to "teacher's" power-cane. Indeed, what could be handier to augment his political messages than the *kifimbo*? Finally, his hand stick must have gone a long way toward reinforcing some of his mannerisms when conducting public business.

The *kifimbo* that Nyerere carried as leader of Tanzania helped to recreate and augment his personality and build Tanzanian nationalism. The *kifimbo* sat well with Nyerere's other title of *Baba wa Taifa* (Father of the Nation), though some Tanzanians were irked by this title, and derogatorily called him Father of CCM. They did so in part because of Nyerere's apparent favoritism towards his CCM party in national politics. Indeed, the hand stick led to Nyerere's nickname of *Mzee Kifimbo* and obviously, without the staff that

6.9 A Zaramo *mganga's* staff – *mkomolo,* seen during a madogoli rite of the Zaramo

name would not have been given. But besides the fact that this nickname is associated with Nyerere's possession of the *kifimbo*, it may also lie on his apparent manipulation of the object in the political arena. In this way, the *kifimbo* became a national symbol connected with a national leader who charted the country's destiny. In the same way that traditional African chiefs, linguists, and national leaders like Moi held their staffs to stress their authority, so did Nyerere. These uses of the *kifimbo* have transformed it within the modern political and administrative landscape. The staff that Nyerere or any other national leader carries today may not have sustained symbolic proportions as did the staffs of African chiefs or ritual leaders. Despite the absence of those elements, however, the positioning and use of the object remains central: it is an emblem of authority for the leader who owns and uses it to further his/her administration.

The *kifimbo* appears to have achieved a significant presence when Nyerere made important decisions affecting the health of the nation. In this sense, Nyerere's use of his staff compares with the Zaramo *mganga* (who tackles health issues and other social predicaments facing the Zaramo) and his staffs, such as the *mkomolo*. For example, figure 6.9 depicts a scene of *madogoli* rite of the Zaramo with *waganga* in the curing act:

The woman sitting on the mat, legs stretched out, a black cloth on and a three-colour turban around her head, is the patient sitting against the *mkomolo* stick. The medicine bag is placed on a three-legged stool, the tail-whisk is on the ground ready for the patient, *mteja* as soon as she in trance gets up and begins to dance. An assisting woman keeps on putting water with herbs in it over the patient. The *waganga* wear a black and white headcover of a colobus monkey.[18]

A *madogoli* rite is also attended by relatives of the patient as seen at the bottom right of the figure. These participants may also take part in the singing, which is another component of the rite. Similarly, Nyerere may be perceived as a ritualist who took care of Tanzanians' array of problems as a Zaramo *mganga* does. To illustrate the power that Nyerere wielded in the country after leaving office, in 1995, during the first multi-party elections in the country, he is said to have been an influential force behind the CCM's nomination of Benjamin Mkapa to run for President of Tanzania. Nyerere even went a step further and campaigned openly across the country for this CCM presidential candidate, his former student and colleague in the CCM. Eventually, Mkapa won the presidency. Mkapa's successor to the presidency, Jakaya Mrisho Kikwete (popularly known as JK), is said to have been given a *kifimbo* by Coast Region elders where he hails. Kikwete was elected President of Tanzania on December 14, 2005. According to a feature titled "JK na kifimbo cha miujiza" (JK and Magic Stick) in a Tanzanian newspaper, *Komesha*, of May 20, 2006, the common belief was that in the same way that Nyerere was well-liked by Tanzanians ("a man of the people") and carried a *kifimbo*, President Kikwete was expected to succeed in his endeavors to improve the lives of Tanzanians as Nyerere did before him. It was noted that though Kikwete did not carry his *kifimbo* around, his owning such a short stick was expected to work magically along similar lines as Nyerere's *kifimbo* is claimed to have worked. This is another illustration of the folklore surrounding the *kifimbo* and the power associated with it and its owner, especially when the latter is a national leader.

Nyerere's public use of the *kifimbo* could band him together with the likes of Nkrumah, Kenyatta, Mobutu, and Moi, who appropriated and utilized traditional African objects and symbols to build and advance their political authority, while also muscling out their opponents. Yet Nyerere was markedly different, and he is respected for advancing the cause of his country folk and Africa. An elder statesman who had earned international respect due to his integrity, honesty, and intellect, Nyerere perhaps astounded the world when in 1985 he became one of Africa's few Presidents to retire voluntarily. Among

his many political achievements was his masterminding the Union between the Republic of Tanganyika and the People's Republic of Zanzibar in 1964.

Nyerere's personal conduct added another dimension to the *kifimbo*: that of a staff of morality, principle, and dignity. As head of State, Nyerere was known for his simplicity and humility. He shunned wealth and strove to involve his fellow Tanzanians at all stages of development, while also striving to improve their lot. This is not to say that Nyerere is above reproach; criticisms have been leveled against him and his administration. Given the myriad of problems facing Tanzania, Africa, and the world at large, Nyerere has not been an exception to the norm. But unlike many African leaders who preferred to be deified, Nyerere was opposed to a personality cult. A good example is his refusal of public glorification as Bismarck Mwansasu recounts:

> It has covered a number of areas ranging from his refusal to have streets and other places named after him to erecting his monuments.[19]

This is illustrated in the few streets and public facilities named after Nyerere. Smith observes that the Dar es Salaam City Council planned to demolish the famed Askari Monument in the commercial district of the city and put up a statue of Nyerere in its place, but Nyerere turned down the idea. In 1988, the University of Dar es Salaam constructed a stand in front of the Assembly Hall, also called Nkrumah Hall, with the view to put his bust on it, but again Nyerere would not accept. The project was abandoned forthwith. In this light, the *kifimbo* that Nyerere used should not be seen as an object of glory, but rather as a staff of morality, principle, and dignity. For this it fulfills the other meaning of an elder's staff. Whatever other ends the *kifimbo* served, it remained a personal accessory of the elder statesman.

In sum, the ways individuals relate to staffs and use them to advance their occupations or positions in society are numerous. Additionally, even as social and historical forces have transformed uses, contexts, significances, and forms of these objects, individuals continually recreate and reposition staffs to suit their needs. We have observed how *kome, mganga* staff of the Zaramo, and *kifimbo* registered changes while they continued to be relevant to their traditional institutions and contexts. For instance, the dressing patterns in Tanzania changed as prestige items like walking staffs became increasingly unpopular due to a variety of social and cultural factors. Similarly, *kome*-like staffs or *kifimbo* were utilized by new leaders in the 1960s, not only in Tanzania, but across Africa as part of dress that celebrated African cultural pride and formed their political presence. Another example concerns changes of form

pertaining to staffs used by Zaramo *waganga*. While for example, some have the *mwana hiti* image, today some examples portray a naturalistic figure. We cannot determine how successful a *mganga* is in his or her trade on the basis of figurations on *mganga* staffs. What is clear is the persistence, or reinterpretation of traditionalism and modernity with these staffs in the institutions they belong to. And although today a political leader in Tanzania may use a *kifimbo* instead of a *fimbo*, this does not suggest that such a person rejects a traditional accessory or symbol in favor of a modern one. Rather, such a leader may have chosen a staff that befits his specific purpose, since examples of these styles of staff have also been used in both traditional and contemporary African society. Perhaps this person may be following a fashionable style. African political leaders, though, have strategically appropriated traditional African paraphernalia, or merged these items with contemporary ones, to help the advance of their agendas. They combine and reinterpret traditionalism and modernity to dovetail with their political and cultural positions. It is not hard, therefore, to grasp the transformation of old into new forms—traditional forms into contemporary symbols of the new crop of political leaders, or the "new elders." Ironically, the continuation of the tradition of staffs is predicated upon ongoing change and transformation.

CHAPTER 7
CONCLUSIONS
Transforming Traditional Forms
into Contemporary Symbols

I N THIS BOOK I AIMED TO DEMONSTRATE THE RELATIONSHIP BETWEEN three types of Zaramo figurative wood sculpture—*mwana hiti* trunk figures, grave markers, and staffs—and Zaramo cultural identity that was affected by social changes, tradition, and history. To describe this relationship, I have focused on changes in form, style, function, and meaning of these three sculptures as they responded to a series of public policies and ensuing social changes of the 1961-1980 Tanzanian society. I have found that since art is an element of society, it is part of change occurring in the society. Also, art has the capacity to reflect change in society. Furthermore, since change is a two-way process, while undergoing change these Zaramo art objects reinvented new social meaning to remain relevant—traditional forms were reinterpreted into contemporary symbols.

So the findings of this work show that like other arts in a given society, Zaramo figurative wood sculpture changed as the Zaramo were continually shaped by societal factors from within Uzaramo and without. Also, Zaramo cultural and art forms have largely maintained a degree of continuity though Zaramo society has faced radical changes in view of its location at a complex intersection of crossing cultures, powerful forces such as independent Tanzanian cultural and socio-political processes, Islam, Christianity, and modern social and cultural values. In addition, the form and significance of *mwana hiti* sculptures, grave figures, and staffs were affected by the historical, religious, social, artistic, political, and economic changes that the Zaramo experienced. And for these sculptures to remain relevant, Zaramo culture had

to accept modifications. Thus, in modified form and significance these objects continue to be used today despite the contact they had with Islam, Swahili cultural influences, Westernization, radical policies of *ujamaa*, and the politics of national identity.

The Zaramo's adherence to the *mwana hiti* trunk figures in the *mwali* custom concretely illustrates the resilience of these cultural traditions. Additionally, Zaramo figurative wood sculpture did not completely break ties with the traditional cultural forms which patronized it. This is attested to by the Zaramo continuing to make *mwana hiti* figurines, naturalistic grave posts, and *mganga* staffs. But whereas *mwana hiti* trunk figures and grave posts had been wholly utilized by the Zaramo, *mganga's kifimbo* had its use and meaning transformed. It became de-ethnicized and attained a somewhat national status as it has been used by politicians in the Tanzanian national political sphere. This vividly illustrates the ways traditional forms have been transformed and interpreted as contemporary symbols. It goes further to show how transformed art objects acquire new meanings over time and space.

Of the several changes to Zaramo figurative sculpture, the first major change is the form of the art. The three types of sculptures that we have examined certainly have not remained the same. Obviously they were not expected to be unchanging. Some of the formal changes to these objects have been subtle, such as the form of *mwana hiti* trunk figure. We have already observed that save for variations due to dictates or preferences of Zaramo families, the form of *mwana hiti* has not changed much. Arguably one factor behind this state of "resistance to change," or the continuity of the form of the *mwana hiti* figure can be explained by the fact that the object is passed down the generations. As previously noted, it is only when a Zaramo family has lost their *mwana hiti* figure that one is carved to replace it in readiness for use in the *mwali* rites. Even so, another point for understanding the Zaramo *mwana hiti's* rather subtle formal changes could lie on the Zaramo's close adherence to their artistic and cultural symbols; this was their *mila*, the way those before them had done these things, so why change it? In illustration, a Zaramo reports that he basically accepts matters connected with the *mwali* rites because his mother also went through the rites. One can say that these crucial traditional values are entrenched in the Zaramo lived reality.

Other changes of form have been sharply pronounced as in the case of some grave figures. I may cite grave posts carved in a naturalistic style perhaps to represent the dead, in contrast to generic ones which depict *mwana hiti*. We have seen that *vinyago* markers continue to appear on Zaramo graves, but those topped by *mwana hiti* carvings are probably a thing of the past. However, this shift on representations of grave markers has not undermined the Zaramo

tradition of marking graves with wooden commemorative figures. Instead, I have argued that the practice went through changes as a result of the adverse impact of the Villagization program. It has given way to other forms of markers such as ceramic shards, stone, or brick slabs, and wooden planks with no figurative depictions. I briefly explored possible reasons for changes of materials on these grave markers. For example, I enquired whether they were the results of taste, costs, concerns for durability, or trends of modernity. With respect to formal and stylistic shifts of Zaramo sculptural pieces created for the art market, the shape and style of these sculptures took a decisive turn as a result of missionary initiative and support for Zaramo sculptors at Maneromango. Realistic and animal sculptures proliferated as this art was directed to meet the demand for curios outside of Zaramo society. Though once these sculptures were sold they met economic needs of the Zaramo artist, they were definitely not committed to serve Zaramo traditional cultural practices. This trend continues today: in a majority of cases, sculptures carved for sale as curios create a seamless whole with those of other peoples who also produce carvings toward this end.

The second major change to Zaramo sculpture is its function. In the 2000s, the Zaramo continue to follow their traditional cultural and social practices such as religious rituals, curing rituals, and rites of maturity in which carved figurative sculptures are utilized. However, much of Zaramo figurative sculpture now serves non-indigenous clientele. This development is a result of economics, the Maneromango school, and dealer influence. Zaramo carvers made choices; they had dialogues with Lutheran missionaries at Maneromango, curio dealers, and state patronage agencies in Dar es Salaam. In this way, Zaramo figurative wood sculpture changed in function as it was directed to serve the art market. Even though the missionaries' intervention played a part in Zaramo art's shift in focus to serve the art market, clearly the intervention does not fully explain this shift. Zaramo carvers were involved in this shift too. We need not overlook that Zaramo cultural forms required a few objects at certain times, for instance, during initiation rituals. And in cases where Zaramo families have taken good care of their art objects, the artist would not be commissioned to make new items. Presumably, this comparatively limited internal demand allowed the carvers to respond to both the missionaries' initiative and art demands outside of Zaramo society. Zaramo artists' carving relationship with the missionaries contributed to Zaramo sculpture's development in a market whose intensity and following spread beyond the borders of Uzaramo and Tanzania. To put it in another way, these Zaramo artists' alliance with the missionaries led the art to attain an international prominence and flavor. Curio dealers like Mohamed Peera took

over where the missionaries left off, supporting Zaramo artists in their endeavors and responses to the art market. The study has suggested that Zaramo carvers' work at Peera's warehouse yard and the support they received from him contributed to trends in these creations so as to meet the requirements and demands of the non-indigenous clientele.

National agencies of Tanzania maintained, with differences, this support line for Zaramo artists. Visualizing Tanzanian arts as one of the means to internalize and foster the spirit of economic self-reliance in the artists and the nation, the Tanzanian government nationalized the business of marketing wood carvings. Though the state endeavored to support the arts, state patronage lacked effective mechanisms for achieving this goal. The government failed to marshal the necessary means— skilled manpower, ample funds, coherent plans, and effective policies—to make headway in art development and promotion. So the end result for Zaramo artists and Zaramo figurative sculpture in this national space has been engaging in the development of dialogues with other artists from different ethnic groups (like the Makonde, Gogo, and the Kamba of Kenya) and art traditions respectively. Perhaps it has also meant that the art created in this national milieu became more and more national and possibly international than ethnic. Thus, the function of this art may have not been to fulfill the social requirements of Zaramo society.

Third, the significance and meaning of Zaramo figurative wood sculpture is closely related to its form and function. My study has demonstrated at length the significance and meaning of *mwana hiti* figures, figural grave markers, and staffs to the Zaramo. It is safe to conclude that Zaramo figurative wood sculpture is still meaningful to the Zaramo. Briefly, this matter can be seen both within Zaramo cultural traditions as well as outside of these forms. For example, wooden sculptures such as *mwana hiti* trunk figures, *mganga* staffs, *vinyago* grave markers, animal sculptures, and Maasai figures continue be created. One way of looking at it is in the continuation of the Zaramo cultural forms in which the carved pieces are an integral part. The Zaramo carving tradition continues to be important not only in Zaramo society and culture but in Tanzanian society as well.

The relevance and strength of the Zaramo rites of maturity can be understood by noting that it is still inconceivable for Zaramo girls to skip their coming of age rites. Also, it is unthinkable for the Zaramo to perform the *mwali* initiation rites, or curing rituals like *madogoli*, without the necessary *mwana hiti* figures or an *mganga's* staffs, respectively. *Mwana hiti* sculptures and *mganga's* staffs are not only part of these rituals, but are important symbols for mediating Zaramo values and approximating the construction of Zaramo perceptions or concepts of Zaramo realities.

The sculptures play an important role when the Zaramo perform puberty rites for their girls. Evidently, *mwana hiti* sculpture and the rites and the ceremonies associated with it are the vehicles for not only defining, expressing, and maintaining Zaramo female identity, but Zaramo cultural identity as a whole. They contribute significantly towards distinguishing Zaramo culture in the geographical and social space in which the Zaramo live. In addition, as death robs the Zaramo of their group members who transit to the other side of human existence, figural grave posts may be carved and erected on the graves to commemorate the departed and to adorn the graves. Furthermore, in troubling social situations, or life crises like illness, the Zaramo see the necessity of an *mganga* to resolve the condition, and carved staffs like *mkomolo* used by ritual specialists will be needed. Even though a gamut of socio-cultural factors of change, modes and values have influenced Tanzanian dressing codes and accoutrements, *fimbo* are still being used. And leaders in modern political and administrative structures who seek to underscore their authority and help the advance of political objectives may need staffs like *kifimbo* made for them. Finally, as collectors of art in Tanzania and abroad keep on collecting Zaramo sculptures, the carving tradition is bound to proliferate.

In this study we have seen important aspects of Zaramo *mwana hiti* trunk figures, figural grave markers, and staffs, the history and culture of the Zaramo people, and some of the social developments the Zaramo have experienced. I pointed out that perhaps the Zaramo continuing to carve and place figurative posts on their graves is an example of cultural resistance against adverse changes that the Tanzanian government brought upon Zaramo society, like the Villagization program, for instance. Thus, in affirming their cultural heritage, defining their society and cultural identity, the Zaramo may also be creating a form of cultural resistance to changes they consider meaningless to their society even as they have accommodated some social changes. Several indicators in this study support this position: the social and political effects of forces of modernization like Islam, Christian missionaries, colonialism and European education, Swahili cultural influences, and post-independent processes on Zaramo society and culture. We saw the results of these processes upon Zaramo culture, for instance, the ways the conservative elements in Islam were accommodated when the Zaramo embraced Islam. Eventually they became a way of life. We should not overlook the type of Islam introduced and embraced by the Zaramo, and the accommodative character of Zaramo traditional life. I have argued that this explains why Islam has not protested against the making and use of figurative wood sculpture in Zaramo society. But this should not obscure the truism that the Zaramo carving tradition is inextricably connected with Zaramo practices that define Zaramo cultural identity.

The Zaramo tradition of making figurative wood sculpture will continually be reinvented in Zaramo society in line with forces of modernization and social change. It is difficult to predict the kinds, the extent of changes, or results Zaramo sculpture will register because these will depend on a number of factors. At any rate, the factors will emanate from within Zaramo society itself and from without. Finally, the three Zaramo figurative wood sculptures we dwell on—*mwana hiti* figurines, grave figures, and staffs—have shaped and expressed essential elements, events, realities, and lives of the Zaramo people. Although some elements of these objects are difficult to grasp, as for example, interpretation of certain symbols they carry, still we have managed to gain some important data in this area. The book reveals variance in the interpretation of the symbols not only on the part of the students of Zaramo culture, but even by the Zaramo themselves. Diversity in reading symbols found in the objects we explored renders the study inconclusive in Zaramo symbolism. But when the Zaramo themselves do not agree on symbolic meanings, it would be foolish to assert here that there is one true interpretation of the sculpture's symbols. Even so, the data we have examined and reviewed has explained and clarified key aspects of the significance of these art objects to the Zaramo. For instance, the *mwana hiti* symbol permeates many Zaramo ritual items like grave sculptures, musical instruments, staffs, stools, initiation posts, medicine gourds, and *mwana hiti* figurines. Once again, it is beneficial to remind ourselves that for the most part, matters of symbolism and meanings of art objects are not definitive and exhaustive—symbols and meanings entail innovation, change, and reinterpretation. This is because some symbolic features and meanings they embody continually change in the same way a given living culture like the Zaramo's is in a state of change. In this respect, therefore, symbols found on the three types of Zaramo sculptures and the kinds of meaning attached to them will continually require further inquiry since the significance of these objects changes as do the levels of knowledge, perceptions, and experiences of Zaramo culture. Nevertheless, this discussion provides insights into the three Zaramo sculptures examined and to Zaramo and Tanzanian societies' responses to influences of modernization and social change from 1961 to 1980.

One final thought revolves around the characteristics that safely identify Zaramo figurative wood sculptures given the findings of this study—considering that Zaramo arts were involved in extended interactions with other cultures. In view of the influences Zaramo artists have received through contact with other cultures and art traditions, what are the features that safely identify figural wood sculptures as Zaramo? It is beyond the scope of this work to explore this matter further than what has been already demonstrated. If

one investigates the issue of origin of the three types of Zaramo sculptures examined, only *mwana hiti* figures are safely considered to have originated from the Zaramo. But several nearby groups like the Doe, Kwere, Zigua, Kutu, and Luguru also produce them. Carved grave posts and a variety of staffs have also been used by most of these groups. Sculptures made and sold in places such as the cosmopolitan city of Dar es Salaam are also difficult to pinpoint

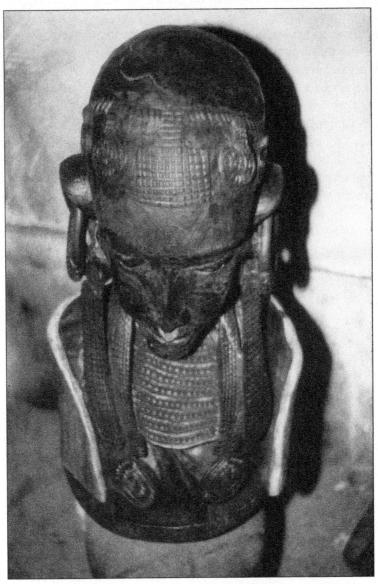

7.1 Chuma's finely executed carving of a Maasai head, 1998

to Zaramo. Apart from sculptures like Maasai representations, which Zaramo carvers predominantly make, much of the sculptures are "Makonde" in style. To problematize the issue further, the Zaramo sculptor Chuma created wood sculptures that he considered neither Zaramo nor Makonde. For example, Figure 7.1 shows a Maasai head. There are no indicators to tell us that this is a Zaramo object though we know that the artist is Zaramo. In a nutshell, the problem here revolves around what the parameters for distinguishing Zaramo figural wood sculpture are.

This brings us to areas one may consider for further research to expand this work. Although not much research has been conducted on Zaramo art traditions, two areas in the further study of Zaramo art merit attention. So far these themes have largely been overlooked in previous research on Zaramo art. The first one pertains to what Zaramo art is, considering the Zaramo cultural composition and somewhat fluid Zaramo identity. Second, the influence of post-independent politics on the contemporary arts of the Zaramo and its relationship to national identity.

In Uzaramo and national space where ethnic groups exchange creative genre and style, are such creations a result of economic motivations, or are they also influenced by the politics of national identity? I hope that research will be pursued along these lines to shed more light on Zaramo and by extension Tanzanian art traditions.

GLOSSARY

akidas – junior officers in the German colonial administration

baba – father

baibui, also buibui – a long cloth worn by women in East Africa

bakora – walking stick

balozi, also called mjumbe (pl., *wajumbe*) – ten-house leader

bandia – dummy

baraza – an old term for a local court; also mean a porch

binadamu – Makonde carving genre of human figure(s) carved naturalistically; human

haliharibiki – not go wrong, bad

heena – a cosmetic used by women who apply it to the feet and on hands

huyu – this

jando – Islamic male circumcision rite

kama – like; as; looks

kanikatie – cut for me/cut on my behalf

kanzu – a long gown

kanga – cotton factory-made printed fabrics with borders on the four sides worn by women in East Africa, but mostly on the coast

ki – a prefix meaning "of," as in Kizaramo

kifimbo – a hand stick

kigoda – a stool

kikoi (pl., *vikoi*) – loincloth. Other types are *msuli, shuka, kitambi*

kinyamkera – a Zaramo female spirit

kofia – a cap; a hat

kome – a type of long walking stick/staff for Zaramo headmen

kualikwa – seclusion; to be invited

kumi – ten

kungwi – the older female relative who cares for the girl in seclusion. Older male relative who cares for the boy in the initiation

kwenda – go

madogoli – an exorcism rite

majini (sing., *jini*) – dangerous coastal spirits of Islamic origin

makaburi (sing., *kaburi*) – graves

mapambo – decorations

mashahidi – witnesses

mchakamchaka – a dance style

mganga (pl., *waganga*) – a medicine man or woman. In this book *mganga* refers to a traditional healer, diviner

mila – tradition

mkanda – a belt

mkole – the tree of symbolic significance that the Zaramo use for some of the rites in the girls initiation

mkomolo – a staff used by a Zaramo *mganga* in healing rituals. It is also used by Zaramo clan elders in initiation ceremonies

mkongo – a tree; wood from this tree

msondo – a dance style; type of drum

mteja – a patient in traditional healing; now the word refers to a client and customer

mtoto – a child

muharaka – a tree; wood from this tree

mwali – often refers to a girl in seclusion and to a boy in initiation

mwalimu – a teacher; Muslim teacher

mwana hiti – the wooden sculpture symbolizing a child used in puberty rites

mwanasesere – the gourd version of *mwana hiti*

mwenembago – a Zaramo male spirit

mwongozo – TANU party guidelines issued in 1971; guidelines from authorities

mzimu – a spirit

na – a conjunction denoting "with" or "and"

neno – issue/matter; a word

ndiyo – that is; yes

ngoma – dance(s); a public celebration involving dancing and drumming; drum(s)

nguzo – post(s); pillar(s)

nyumba – house(s)

pazi – a title for a Zaramo headman, also mndewa (pl., wandewa); Zaramo clan name

penye – a state, a place having/with . . .

pombe – beer

saba – seven

shangazi – father's sister

shetani – Makonde carving genre depicting abstract figures; spirit; evil spirit; the devil or Satan

shoka – an axe

sokomoko – a dance style

taifa – a nation

tambiko – offering or sacrifice usually connected with ancestor

tumba – gourd container(s) for storing medicine

uganga – practice of *mganga*

ujamaa – African socialism

ukoo – clan; lineage

unifanyie – make for me

ushungi – a way of veiled dressing

wakati – time

watani – those who practice joking relationship (*utani*)

wazungu – Europeans

ya – a prefix denoting "of," as in Zaramo's . . .

yeye – him; her

REFERENCES

Abrahams, Raymond G. ed. *Villagers, Villages, and the State in Modern Tanzania*. Cambridge: The Center for African Studies, 1985.

Allen, James de Vere. *Swahili Origins: Swahili Culture and the Shungwaya Phenomenon*. London: James Currey, 1993.

Alpers, Edward. "The Coast and the Development of the Caravan Trade." In *A History of Tanzania*, ed. I. N. Kimambo and A. Temu, 35-56. Nairobi: East African Publishing House, 1969.

Anthony, David III. "Culture and Society in a Town in Transition: A People's History of Dar es Salaam, 1865-1939." Ph. D. dissertation, University of Wisconsin Madison, 1983.

Beidelman, Thomas O. *The Matrilineal Peoples of Eastern Tanzania (Zaramo, Luguru, Kaguru, Ngulu, etc.)*. London: International African Institute, 1967.

Bordogna, Charles, and Leonard Kahan. *A Tanzanian Tradition: Doei, Iraku, Kerewe, Makonde, Nyamwezi, Pare, Zaramo, Zigua and Other Groups*. Tenafly, NJ: African Art Museum and Kahan Gallery, 1989.

Bravmann, Rene. *African Islam*. Washington, D.C.: The Smithsonian Institution Press and Ethnographica, 1983.

Brown, Roland, and Irene Brown. "Approach to Rural Mass Poverty." In *Mwalimu: The Influence of Nyerere*, ed. C. Legum and G. Mmari, 9-22. London: Britain-Tanzania Society and James Currey, 1995.

Burton, Richard F. *The Lake Regions of Central Africa: A Picture of Exploration*, 2 vols. New York: Harper Brothers, (1860). Reprint, New York: Horizon Press, 1961.

Carroll, Father Kevin. "Yoruba Craft Work at Oye-Ekiti, Ondo Province." *Nigeria Magazine* 35 (1950): 344-54.

Castelli, Enrico. "Uchongaji wa Kimila kutoka Kati ya Tanzania Mashariki." In *Tanzania: Meisterwerke Afrikanischer Skulptur/Sanaa za Mabingwa wa Kiafrika*, ed. J. Jahn, 105-9. Munich: Verlag Fred Jahn, 1994.

Cole, Herbert. *Icons: Ideals and Power in the Art of Africa.* Washington, D.C.: The Smithsonian Institution Press, 1989.

Coulson, Andrew, ed. *African Socialism in Practice: The Tanzanian Experience.* Nottingham: Spokesman, 1979.

Dick-Read, Robert. *Sanamu: Adventures in Search of African Art.* New York: Dutton, 1964.

Dikirr, Patrick. "Decentralized Government, Cultural Identity, and a Pastoral Mode of Subsistence: A Case Study of the Maasai of East Africa." An Unpublished Seminar Paper, Department of Art History, Binghamton University, May, 1997.

Elkan, Walter. "The East African Trade in Woodcarvings." *Africa* 28, no. 4 (1958): 314-23.

Eyo, Ekpo. "Ekpo Eyo." In *Perspectives: Angles on African Art.* J. Baldwin, et al., 33-47. New York: Center for African Art and Harry N. Abrams, 1987.

Felix, Marc. *Mwana hiti: Life and Art of the Matrilineal Bantu of Tanzania.* Munich: Verlag Fred Jahn, 1990.

_____."Vinyago vya Kimila vya Tanzania." In *Tanzania: Meisterwerke Afrikanischer Skulptur/Sanaa za Mabingwa wa Kiafrika*, ed. J. Jahn, 75-92. Munich: Verlag Fred Jahn, 1994.

Freyhold, Michaela von. *Ujamaa Villages in Tanzania: Analysis of a Social Experiment.* New York: Monthly Review Press, 1979.

Graburn, Nelson. "Introduction." In *Ethnic and Tourist Arts: Cultural Expressions from the Fourth World*, ed. N. Graburn, 1-32. Berkeley: University of California Press, 1976.

Graham, James. "Indirect Rule: The Establishment of 'Chiefs' and 'Tribes' in Cameron's Tanganyika." *Tanzania Notes and Records* 77 and 78 (1976): 1-9.

Grant, James A. *A Walk Across Africa or Domestic Scenes from My Nile Journal.* London: William Blackwood, 1864.

Gray, Sir John. "Dar es Salaam under the Sultans of Zanzibar." *Tanganyika Notes and Records* 33 (July 1952): 1-21.

Hackett, Rosalind. *Art and Religion in Africa*. New York: Cassell, 1996.

Harding, J.R. "'Mwali' Dolls of the Zaramo." *Man* 61, no.83 (1961): 72-73.

Hartnoll, Morwenna. "A Story of the Origin of the name of Bandar-es-Salaam, which in the old days was called Mzizima." *Tanganyika Notes and Records* 3 (April 1937): 117-9.

Hartwig, Gerald. "Sculpture in East Africa." *African Arts* 11, no.4 (1978): 62-65, 96.

Hassan, Salah. "The Modernist Experience in African Art: Toward a Critical Understanding." In *The Muse of Modernity: Essays on Culture as Development in Africa*, ed. P.G. Altbach and S. Hassan, 37-61. Trenton, NJ: Africa World Press, 1996.

Hatch, John. *Tanzania: A Profile*. New York: Praeger, 1973.

Hess, Janet. "An 'Irrational Eschatology': Nkrumahism, Post- Nkrumahism, and the Discourse of Modernity." In *Issues in Contemporary African Art*, ed. N. Nzegwu, 173- 81.Binghamton, New York: International Society for the Study of Africa, 1998.

Holy, Ladislav. *The Art of Africa: Masks and Figures from East and Southern Africa*. London: Hamlyn, 1967.

Hulten, Ida Pipping-van. *An Episode of Colonial History: The German Press in Tanzania 1901-1914*. Uppsala: The Scandinavian Institute of African Studies, 1974.

Iliffe, John. "Tanzania under German and British Rule." In *Self-Reliant Tanzania*, ed. K.E. Svendsen and M. Teisen, 46-62. Dar es Salaam: Tanzania Publishing House, 1969.

_____."The Age of Improvement and Differentiation (1907-45)." In *A History of Tanzania*, ed. I.N. Kimambo and A. Temu, 123-60. Nairobi: East African Publishing House, 1969.

Jahn, Jens, ed. *Tanzania: Meisterwerke Afrikanischer Skulptur/Sanaa za Mabingwa wa Kiafrika*. Munich: Verlag Fred Jahn, 1994.

Jegede, Dele. "Patronage and Change in Nigerian Art." *Nigeria Magazine* 150 (1984): 29-36.

Jules-Rosette, Bennetta. *The Messages of Tourist Art: An African Semiotic System in Comparative Perspective*. New York: Plenum Press, 1984.

Kasfir, Sidney. "Patronage and Maconde Carvers." *African Arts* 13, no.3 (1980): 67-70, 91-92.

Kiyenze, Bernard. *The Transformation of Tanzanian Handicrafts into Co-operatives and Rural Small-Scale Industrialisation.* Helsinki: Finnish Anthropological Society, 1985.

Komba, Donatus. "Contribution to Rural Development: Ujamaa & Villagisation." In *Mwalimu: The Influence of Nyerere*, ed. C. Legum and G. Mmari, 32-45. London: Britain-Tanzania Society and James Currey, 1995.

Korn, Jorn. *Modern Makonde Art.* London: Hamlyn, 1974.

Leslie, James. *A Survey of Dar es Salaam.* London: Oxford University Press, 1963.

Listowel, Judith. *The Making of Tanganyika.* New York: London House and Maxwell, 1965.

Lorch, Donatella. "Bagamoyo Journal: An Art School in Search of a Soul." *New York Times*, November 22, 1995.

Lugalla, Joe. *Crisis, Urbanization, and Urban Poverty in Tanzania: A Study of Urban Poverty and Survival Politics.* Lanham, MD: University Press of America, 1995.

Martin, Stephen. "Music in Urban East Africa: A Study of the Development of Urban Jazz in Dar es Salaam." Ph. D. dissertation, University of Washington, 1980.

Mazrui, Alamin M., and Ibrahim N. Shariff. *The Swahili: Idiom and Identity of an African People.* Trenton, NJ: Africa World Press, 1994.

McHenry, Dean E. Jr. *Tanzania 's Ujamaa Villages: The Implementation of a Rural Development Strategy.* Berkeley: Institute of Development Studies, University of California, 1979.

Middleton, John. *The World of the Swahili: An African Mercantile Civilization.* New Haven: Yale University Press, 1992.

Miller, Judith von. *Art in East Africa: A Guide to Contemporary Art.* London: Frederick Muller, 1975.

Mlama, Penina. "Tanzanian Traditional Theatre as a Pedagogical Institution: The Kaguru Theatre as a Case Study." Ph. D. Thesis, University of Dar es Salaam, 1983.

Mmari, Geoffrey. "The Legacy of Nyerere." In *Mwalimu: The Influence of Nyerere*, ed. C. Legum and G. Mmari, 176-85. London: Britain-Tanzania Society and James Currey, 1995.

Mohl, Max. *Masterpieces of the Makonde*, 2 vols. Heidelberg: Max Mohl, 1990.

Mount, Marshall. *African Art: The Years Since 1920*. Bloomington: Indiana University Press, 1973.

Mshana, Fadhili S. "Art Promotion in Tanzania: Problems and Perspectives." Unpublished B.A. (Ed.) Degree dissertation, University of Dar es Salaam, 1987.

_____."Zaramo Sculptor Salum Chuma." *Baobab* 1 (1997): 47-58.

Mudimbe, Valentin Y. *The Invention of Africa: Gnosis, Philosophy, and the Order of Knowledge*. Bloomington: Indiana University Press, 1988.

Mugo, Micere M. *African Orature and Human Rights*. Roma, Lesotho: Institute of Southern African Studies, National University of Lesotho, 1991.

Mukangara, Fenella, and Bertha Koda. *Beyond Inequalities: Women in Tanzania*. Dar es Salaam: Tanzania Gender Networking Programme and Southern African Research and Documentation Centre, 1997.

Mwaruka, Ramadhani. *Masimulizi Juu ya Uzaramo*. London: McMillan, 1965.

Nanji, Azim. "Beginnings & Encounters: Islam in East African Contexts." In *Religion in Africa: Experience & Expression*, ed. T.D. Blakely, W. van Beek, and D. Thomson, 47-55. London: James Currey, 1994.

Ngugi wa Thiong'o. *Decolonizing the Mind: The Politics of Language in African Literature*. London: James Currey, 1986.

_____. *Moving the Centre: The Struggle for Cultural Freedoms*. London: James Currey, 1993.

Nkhoma-Wamunza, Alice. "My Life is a Life of Struggles: The Life History of a Young Barmaid." In *The Unsung Heroines: Women's Life Histories from Tanzania*, ed. M.K. Ngaiza and B. Koda, 35-60. Dar es Salaam: Women's Research and Documentation Project, 1991.

Nyerere, Julius K. *Freedom and Unity. Uhuru na Umoja: A Selection from Writings and Speeches*, 1952-65. Dar es Salaam: Oxford University Press, 1966.

_____. *Freedom and Socialism. Uhuru na Ujamaa; A Selection from Speeches and Writings*, 1965-1967. Dar es Salaam: Oxford University Press, 1968.

_____. *Ujamaa-Essays on Socialism.* Dar es Salaam: Oxford University Press, 1968.

Nyumba, Nassoro. "A Comparative Study of Artistic Themes between Zaramo and Makonde Carvings." Unpublished B.A. (Ed.) Degree dissertation, University of Dar es Salaam, 1979.

Nzegwu, Nkiru. "The Concept of Modernity in Contemporary African Art." In *The Africa Diaspora: African Origins in New World Self-Fashionings,* ed. I. Okpewho, C.B. Davies, and Ali Mazrui, 391-427. Bloomington: Indiana University Press, 1999.

Omari, Cuthbert K. "Fertility Rates and the Status of Women in Tanzania." In *Gender, Family and Household in Tanzania,* ed. C. Creighton and C.K. Omari, 253-268. Aldershot: Averbury, 1995.

_____. "The Management of Tribal & Religious Diversity." In *Mwalimu: The Influence of Nyerere,* ed. C. Legum and G. Mmari, 23-31. London: Britain-Tanzania Society and James Currey, 1995.

Pelrine, Diane. "Zaramo Arts: A Study of Forms, Contexts and History." Ph. D. dissertation, Indiana University, 1991.

Polfliet, Leo. *Kifimbo: Zeremonialstabe aus Zentral-und Ostafrika (Staffs of Office from Central and Eastern Africa).* Munich: Galerie Fred Jahn, 1989.

Pwono, Damien, and Jacques Katuala. "Arts and Humanities Capacity Building in Africa: Problems and Prospects." In *The Muse of Modernity: Essays on Culture as Development in Africa,* ed. P.G. Altbach and S. Hassan, 19-36. Trenton, NJ: Africa World Press, 1996.

Reckling, Walter. "Handwerk und Kunst der Wazaramo." *Koloniale Rundschau* 33 (1942): 31-37.

Salim, Ahmed I. "The Elusive 'Mswahili'-Some Reflections on His Identity and Culture." In *Swahili Language and Society: Papers from the Workshop held at the School of Oriental and African Studies in April 1982,* ed. J. Maw and D. Parkin, 215-27. Wien: Beitrage zur Afrikanistick, Band 23, 1984.

Smith, William. *Nyerere of Tanzania.* London: Victor Gollancz, 1973.

Spear, Thomas. "The Shirazi in Swahili Traditions, Culture, and History." *History in Africa* 11 (1984): 291-305.

Speke, John Hanning. *Journal of the Discovery of the Source of the Nile.* London: William Blackwood and Sons, 1863.

Sutton, John E. "Dar es Salaam: A Sketch of a Hundred Years." *Tanzania Notes and Records* 71 (1970): 1-19.

Svendsen, Knud E., and Merete Teisen, eds. *Self-Reliant Tanzania*. Dar es Salaam: Tanzania Publishing House, 1969.

Swantz, Lloyd. "The Zaramo of Tanzania: An Ethnographic Study." M.A. Thesis, University of Syracuse, 1965.

_____. "The Zaramo of Dar es Salaam: A Study of Continuity and Change." *Tanzania Notes and Records* 71 (1970): 157-64.

_____. "The Role of the Medicine Man Among the Zaramo of Dar es Salaam." Ph. D. Thesis, University of Dar es Salaam, 1974.

_____. *The Medicine Man Among the Zaramo of Dar es Salaam*. Uppsala and Dar es Salaam: Scandinavian Institute of African Studies and Dar es Salaam University Press, 1990.

Swantz, Marja-Liisa. "The Religious and Magical Rites Connected with the Life-Cycle of the Woman in Some Bantu Ethnic Groups of Tanzania." M.A. Thesis, University of Helsinki, 1966.

_____. *Ritual and Symbol in Transitional Zaramo Society, with Special Reference to Women*. Uppsala: Almqvist & Wiksells, 1970.

_____. "Interaction of Islam and the African Society on the East African Coast." *Temenos: Studies in Comparative Religion* 12 (1976): 136-48.

_____. *Blood, Milk, and Death: Body Symbols and the Power of Regeneration Among the Zaramo of Tanzania*. Westport, CT: Bergin & Garvey, 1995.

Tanzania, Wizara ya Utamaduni wa Taifa na Vijana. *Introducing Wood carving and Art in Tanzania*. Dar es Salaam: Ministry of National Culture and Youth, 1976.

Trimingham, Spencer J. *Islam in East Africa*. Oxford: Clarendon Press, 1964.

Wembah-Rashid, John. "Current African Art: A Case Study of Makonde Sculpture in Tanzania," Paper presented at the 22nd Annual Meeting of the African Studies Association, Los Angeles, October 31-November 3, 1979.

_____. "Mwananyanhiti: Kwere Fertility." *Review of Ethnology* 3, no.1 (1970):1-4.

Westerlund, David. *Ujamaa na Dini: A Study of Some Aspects of Society and Religion in Tanzania, 1961-1977*. Stockholm: Almqvist & Wiksell International, 1980.

Yai, Olabiyi. "In Praise of Metonymy: The Concepts of 'Tradition' and 'Creativity' in the Transmission of Yoruba Artistry over Time and Space." In *The Yoruba Artist: New Theoretical Perspectives on African Arts*, ed. R.

Abiodun, H. Drewal, and J. Pemberton III, 107-15. Washington, D.C.: The Smithsonian Institution Press, 1994.

Yeager, Rodger. *Tanzania: An African Experiment.* Boulder, CO: Westview Press, 1982.

Young, Roland, and Henry Fosbrooke. *Smoke in the Hills: Political Tension in the Morogoro District of Tanganyika.* Evanston: Northwestern University Press, 1960.

NOTES

CHAPTER 1

1. The famous Arusha Declaration was Tanganyika African National Union's (TANU) policy document which ushered the country onto the socialist path for development based on the ideology of *ujamaa* (African Socialism). It is important to note that TANU was the national party which won independence. On February 5, 1977, TANU merged with Afro-Shirazi Party (ASP) of Zanzibar to form *Chama Cha Mapinduzi* (CCM – Party for Revolution), which is still the ruling party in Tanzania at this writing. For details on the Arusha Declaration see Julius K. Nyerere, *Ujamaa-Essays on Socialism* (Dar es Salaam: Oxford University Press, 1968).

2. *Mwana hiti: Life and Art of the Matrilineal Bantu of Tanzania* (Munich: Verlag Fred Jahn, 1990), 91.

3. A good example is Felix 1990.

4. See Diane Pelrine, "Zaramo Arts: A Study of Forms, Contexts and History" (Ph. D dissertation, Indiana University, 1991); Felix 1990, Felix, "Vinyago vya Kimila vya Tanzania" (Tanzania Traditional Sculpture), in *Tanzania: Meisterwerke Afrikanischer Skulptur/Sanaa za Mabingwa wa Kiafrika*, ed. J. Jahn (Munich: Verlag Fred Jahn, 1994); L. Swantz, "The Zaramo of Tanzania: An Ethnographic Study" (M.A. Thesis, University of Syracuse, 1965); Enrico Castelli, "Uchongaji wa Kimila kutoka Kati ya Tanzania Mashariki" (East- Central Tanzania's Traditional Carving), in Jahn 1994.

5. "Ekpo Eyo," in *Perspectives: Angles on African Art*, James Baldwin, et al. Interviews by M. J. Weber; Introduction by Susan Vogel (New York: Center for African Art and Harry N. Adams, 1987), 36. Eyo's use of the prescription "must" should not imply that his injunction is right.

6. Herbert Cole, *Icons: Ideals and Power in the Art of Africa* (Washington, D.C./London: The Smithsonian Institution Press, 1989), 16-18.

7. Rosalind Hackett, *Art and Religion in Africa* (New York: Cassell, 1996).

8. See Olabiyi Yai, "In Praise of Metonymy: The Concepts of 'Tradition' and 'Creativity' in the Transmission of Yoruba Artistry over Time and Space," in *The Yoruba Artist: New Theoretical Perspectives on African Art*, ed. R. Abiodun, H. Drewal, and J. Pemberton III (Washington, D.C./London: The Smithsonian Institution Press, 1994); Nkiru Nzegwu, "The Concept of Modernity in Contemporary African Art," in *The African Diaspora: African Origins in New World Self-Fashionings*, ed. I. Okpewho, C. B. Davis, and Ali Mazrui (Bloomington: Indiana University Press, 1999); Ngugi wa Thiong'o, *Moving the Centre: The Struggle for Cultural Freedoms* (London: James Currey, Nairobi: East African Educational Publishers, Portsmouth: Heinemann, 1993).

9. Ngugi wa Thiong'o 1993.

10. Nzegwu 1999.

11. "The Modernist Experience in African Art: Toward a Critical Understanding," in *The Muse of Modernity: Essays on Culture as Development in Africa*, ed. P. G. Altbach and S. Hassan (Trenton, NJ: Africa World Press, 1996), 46.

12. Valentin Y. Mudimbe, *The Invention of Africa: Gnosis, Philosophy, and the Order of Knowledge* (Bloomington/Indianapolis: Indiana University Press, 1988).

13. Hassan 1996, 46.

14. Nzegwu 1999.

15. Yai 1994, 113-114. In Yoruba culture *ori* is the principle of individuality.

16. Ibid., 114.

CHAPTER 2

1. Joe Lugalla, *Crisis, Urbanization, and Urban Poverty in Tanzania: A Study of Urban Poverty and Survival Politics* (Lanham, Maryland: University Press of America, 1995), xviii. He states that the economic and social development policies formulated on the basis of the Arusha Declaration were operating in Tanzania "at least until early 1991." At the time, through the Zanzibar Declaration, the Central Committee of *Chama Cha Mapinduzi* (CCM) "denounced most of the major policy directions inherent in the Arusha Declaration."

2. Cuthbert K. Omari, "The Management of Tribal & Religious Diversity," in *Mwalimu: The Influence of Nyerere*, ed. C. Legum and G. Mmari (London: Britain-Tanzania Society and James Currey, Dar es Salaam: Mkuki na Nyota, Trenton: Africa World Press, 1995), 23-24.

3. Julius K. Nyerere, *Freedon and Unity. Uhuru na Umoja: A Selection from Writings and Speeches, 1952-1965* (Dar es Salaam: Oxford University Press, 1966), 187.

4. Penina Mlama, "Tanzanian Traditional Theatre as a Pedagogical Institution: The Kaguru Theatre as a Case Study" (Ph. D Thesis, University of Dar es Salaam, 1983), 33.

5. Nyerere 1966, 170.

6. M-L. Swantz 1995, 23. For more on Villagization and the organization of *ujamaa* villages as a socialist strategy for rural development in Tanzania, see Raymond G. Abrahams, ed., *Villagers, Villages, and the State in Modern Tanzania* (Cambridge: The Center for African Studies, 1985); Dean E. McHenry Jr., *Tanzania's Ujamaa Villages: The Implementation of a Rural Development Strategy* (Berkeley: Institute of International Studies, University of California, 1979); Donatus Komba, "Contribution to Rural Development: *Ujamaa* & Villagization," in Legum and Mmari, 1995; Andrew Coulson, ed., *African Socialism in Practice: The Tanzanian Experience* (Nottingham: Spokesman, 1979); Michaela von Freyhold, *Ujamaa Villages in Tanzania: Analysis of a Social Experiment* (New York: Monthly Review Press, 1979), though Freyhold has been criticized for using data drawn entirely from villages in the Tanga Region to represent the whole country as her title suggests.

7. S. S. Sangweni, "*Ujamaa*–The Rural Development Strategy in Tanzania" as quoted in Komba 1995, 40.

8. For more information on Zaramo history as it relates to Dar es Salaam, see African American historian David Anthony's brilliant and extensive study of the city, "Culture and Society in a Town in Transition: A People's History of Dar es Salaam, 1865-1939" (Ph.D. dissertation, University of Wisconsin Madison, 1983). Useful summaries of the city's history include Morwenna Hartnoll, "A Story of the Origin of the name of Bandar-es-Salaam, which in the old days was called Mzizima." *Tanganyika Notes and Records* 3 (April 1937): 117-9; Sir John Gray, "Dar es Salaam under the Sultans of Zanzibar." *Tanganyika Notes and Records* 33 (July 1952): 1-21; John E. Sutton, "Dar es Salaam: A Sketch of a Hundred Years." *Tanzania Notes and Records* 71 (1970): 1-19. Stephen Martin's "Music in Urban East Africa: A Study of the Development of Urban Jazz in Dar es Salaam" (Ph.D. dissertation, University of Washington, 1980) is primarily a cultural study of music. It explains the development of the musical genre of urban jazz in a complex process of acculturation. James Leslie's A Survey of Dar es Salaam (London: Oxford University Press, 1963) is an excellent social survey of the city, conducted between 1956 and 1957 when the country was still under colonial rule. Though Leslie's work is more a treatment of urbanization than a historical study, this does not deny its value. This is certainly the case with Lugalla 1995 which nonetheless does not focus on Dar es Salaam. In 1970 *Tanzania Notes and Records* devoted a special issue (71) to explore various aspects of Dar es Salaam – see Anthony 1983, 243, n.47. I refer to some of these papers in this book.

9. Martin 1980, 10.

10. Leslie 1963, 40.

11. See L. Swantz 1965, although based on our historical sources the dates for these migrations are conjectural and speculative. See also Edward Alpers, "The Coast and the Development of the Caravan Trade," in A History of Tanzania, ed. I. N. Kimambo and A. Temu (Nairobi: East African Publishing House, 1969) who fails to put a definite time-frame of the Kamba invasion which oral tradition link it with these migrations (see the outline below). M-L. Swantz 1995 indicates that the Kamba were defeated in the eighteenth century, whereas Alpers suggests the late eighteenth century as "the most likely dating" of this Kamba invasion. Gray 1952 conjecturally puts it around the end of the eighteenth or at the beginning of the nineteenth century. So the matter is indeed controversial.

12. Roland Young and Henry Fosbrooke, *Smoke in the Hills: Political Tension in the Morogoro District of Tanganyika* (Evanston: Northwestern University Press, 1960), 21-22.

13. L. Swantz 1970; Ramadhani Mwaruka, *Masimulizi Juu ya Uzaramo* (London: McMillan, 1965). The late Mwaruka was a Zaramo; Salum Chuma, personal communication, Dar es Salaam, January 7, 1997. A Luguru field associate told L. Swantz 1965 that the Luguru refer to "people of the mountains." Their Kutu neighbors who live below the mountains mean "people of the plains." Beyond the Kutu, near the coast are the Zaramo meaning "to settle at the bottom, or settle down below-hence people who have settled at the bottom or settled the land below the mountain."

14. There are several versions on how the Zaramo moved to Uzaramo although basically all carry the same tale. See Mwaruka 1965; Thomas O. Beidelman, *The Matrilineal Peoples of Eastern Tanzania* (Zaramo, Luguru, Kaguru, Ngulu, etc.) (London: International African Institute, 1967); L. Swantz 1965; Alpers 1969; Anthony 1983. Aside from many myths which mention the Luguru Mountains as the Zaramo homeland, most Zaramo say their ancestors came from Uluguru.

15. John Iliffe, "The Age of Improvement and Differentiation (1907-45)," in Kimambo and Temu 1969, 146-147.

16. "The Elusive 'Mswahili'-Some Reflections on His Identity and Culture," in *Swahili Language and Society: Papers from the Workshop held at the School of Oriental and African Studies in April 1982*, ed. J. Maw and D. Parkin (Wien: Beitrage zur Afrikanistik, Band 23, 1984), 216.

17. Ibid., 220.

18. *The Swahili: Idiom and Identity of an African People* (Trenton, NJ: Africa World Press, 1994).

19. See for example, James de Vere Allen, *Swahili Origins: Swahili Culture and the Shungwaya Phenomenon* (London: James Currey, Nairobi: East African Educational Publishers, Athens, Ohio: Ohio University Press, 1993) who gives precedence to the African elements in Swahili civilization. For more information on the debate about the Swahili see Salim 1984; Mazrui and Shariff 1994; John Middleton, *The World of the Swahili: An African Mercantile Civilization* (New Haven: Yale University Press, 1992).

20. For a detailed discussion, see James Allen 1993; Middleton 1992.

21. M-L. Swantz, "Interaction of Islam and the African Society on the East African Coast." *Temenos: Studies in Comparative Religion* 12 (1976), 136-138.

22. Thomas Spear, "The Shirazi in Swahili Traditions, Culture, and History." *History in Africa* 11 (1984), 292.

23. Azim Nanji, "Beginnings & Encounters: Islam in East African Contexts," in *Religion in Africa: Experience & Expression*, ed. T. D. Blakely, et al (London: James Currey, 1994), 48.

24. Ibid. See also Spencer J. Trimingham, *Islam in East Africa* (Oxford: Clarendon Press, 1964) for more details on the factors behind the rapid spread of Islam in Tanzania.

25. M-L. Swantz 1976, 136.

26. L. Swantz 1970, 158. Leslie 1963 also found that the Zaramo embrace the social aspects of Islam and cling to their ancestral religion and other traditional practices. And Pelrine 1991, 15 observes that to a large extent Zaramo Muslim society "differs little from non-Muslim." Trimingham 1964, 66-73 discusses a synthesis of Bantu and Islamic culture.

27. M-L. Swantz 1995, 130-131.

28. "Mwananyanhiti: Kwere Fertility." *Review of Ethnology* 3, no.1 (1970), 3.

29. *African Islam* (Washington, D.C.: The Smithsonian Institution Press and Ethnographica, 1983), 104.

30. See Middleton 1992, "Power, Ritual and Knowledge," 161-183.

31. Data from interviews held between February and November, 1998. Mjema informed me that her mother Monica Kuga provided assistance toward answering my interview questions in the areas of Zaramo history, art, women's rites of maturity and identity, and also, Zaramo culture as it related to Islam, Swahili culture, European missionaries, and some aspects of the Tanzanian state.

32. Mazrui and Shariff 1994, 5.

33. Pelrine 1991, 22.

34. Ngugi wa Thiong'o, *Decolonizing the Mind: The Politics of Language in African Literature* (London: James Currey, Nairobi/Portsmouth: Heinemann, Harare: Zimbabwe Publishing House, 1986), 16.

CHAPTER 3

1. Information on which this discussion is based primarily derives from oral sources, written sources, and my own research. Parts of this chapter appeared in Fadhili S. Mshana, "Zaramo Sculptor Salum Chuma." *Baobab* 1 (1997): 47-58. Other than Walter Reckling, "Handwerk und Kunst der Wazaramo," *Koloniale Rundschau* 33 (1942): 31-37, Felix 1990, and Pelrine 1991, which at length deal with aspects of Zaramo visual arts, other works (listed below) have some bits and pieces of data on Zaramo art.

2. L. Swantz 1990, 13-14 indicates that the city had over 700 waganga. L. Swantz's book is based on his Ph. D Thesis "The Role of the Medicine Man among the Zaramo of Dar es Salaam" accepted at the University of Dar es Salaam in 1974 which I also consulted for this work.

3. Richard F. Burton, *The Lake Regions of Central Africa: A Picture of Exploration*, 2 Vols. (New York: Harper Brothers, 1860. Reprint, New York: Horizon Press, 1961), 1:110.

4. L. Swantz 1965, 132.

5. Bernard Kiyenze, *The Transformation of Tanzanian Handicrafts into Cooperatives and Rural Small-Scale Industrialisation* (Helsinki: Finnish Anthropological Society, 1985), 78.

6. As quoted in Kiyenze 1985, 78-79 based on Daily News of 11/12/1978.

7. Interviews with Chuma (January 7 and 19, 1997; July 10, 2004) and Sultani Mwinyimkuu (January 21, 1997) in Dar es Salaam. In these interviews we covered several areas of Zaramo art, culture, and history as seen below.

8. See Nassoro Nyumba, "A Comparative Study of Artistic Themes between Zaramo and Makonde Carvings" (Unpublished B.A. (Ed.) Degree dissertation, University of Dar es Salaam, 1979).

9. *Sanamu: Adventures in Search of African Art* (New York: Dutton, 1964), 43.

10. Tanzania, Wizara ya Utamaduni wa Taifa na Vijana, *Introducing Wood carving and Art in Tanzania* (Dar es Salaam: Ministry of National Culture and Youth, 1976).

11. M-L. Swantz 1970, 265.

12. Felix 1990, 296.

13. Pelrine 1991, 138

14. Ibid., 132.

15. Dick-Read 1964, 43.

16. Walter Elkan, "The East African Trade in Woodcarvings." *Africa* 28, no.4 (1958): 314-23.

17. Interview at Maneromango with Omari Abdallah (January 18, 1997); Mgumba, Bilali, and Zena Yusufu Mwinyihija (July 23, 2004). Mgumba, Bilali, and Mwinyihija offered me pertinent information on the Zaramo carving tradition, including the interaction between Zaramo carvers and Lutheran missionaries at Maneromango.

18. *African Art: The Years Since 1920* (Bloomington: Indiana University Press, 1973), 22-38.

19. Ibid., 22.

20. "Yoruba Craft Work at Oye-Ekiti, Ondo Province." *Nigeria Magazine* 35 (1950), 347.

21. Ibid.

22. John Wembah-Rashid, "Current African Art: A Case Study of Makonde Sculpture in Tanzania." Paper presented at the 22nd Annual Meeting of the African Studies Association, Los Angeles, October 31-November 3, 1979.

23. Ibid.

24. See Nyumba 1979; L. Swantz 1965; interview with Zaramo carvers in Dar es Salaam.

25. *Art in East Africa: A Guide to Contemporary Art* (London: Frederick Muller, 1975).

26. Ibid., 321-322.

27. Dele Jegede, "Patronage and Change in Nigerian Art." *Nigeria Magazine* 150 (1984), 33 identifies three broad categories in art patronage in Nigeria. First, the adviser-participant-consumer; second, the disseminators; and third, the consumers. In the second group are the cultural units of some foreign embassies in Nigeria, galleries, art councils, and some cultural organizations which promote artists within and outside the country through exhibitions. The last group comprises the consumers, that is, organizations, governments and individuals who make purchases and/or commissions to patronize the artists.

28. See Sidney Kasfir's work, "Patronage and Maconde Carvers." *African Arts* 13 no. 3 (1980): 67-70, 91-92, which looks at the relationship between artists and patrons in art production and trade, not least stylistic influences and shifts arising from patronage. Field research was undertaken in 1970.

29. John Korn, *Modern Makonde Art* (London: Hamlyn, 1974), 4.

30. Kasfir 1980, 68.

31. Miller 1975, 45.

32. I have paraphrased these from Fadhili Mshana, "Art Promotion in Tanzania: Problems and Perspectives" (Unpublished B.A. (Ed.) Degree dissertation, University of Dar es Salaam, 1987), having drawn as one of my sources on the National Arts of Tanzania's "Memorandum of Association" of 1976.

33. Kasfir 1980, 70.

CHAPTER 4

1. Data for this chapter derives from written sources and my own research. As well, I had an extended period of contact with the Zaramo; I lived, attended school, and worked in Uzaramo – in Dar es Salaam and the surrounding areas periodically between 1967 and 1994 also, in 2000-2002. There is no need to discuss other Zaramo rites here because they will not serve our purpose in this study. Furthermore, I will not repeat what scholars such as Felix, Pelrine, and the Swantzes have written with regard to the initiation ceremonies in which the *mwana hiti* sculpture is used. Instead, it is instructive to focus on relevant aspects of this object in order to understand its importance to Zaramo culture.

2. See Pelrine 1991, 120-121. The "*nya kiti/nhiti/hiti*" words should not be seen as variations of the concept given the common use of Kiswahili among the Zaramo. The core matter is to understand that the term designates "child of wood" – a wooden sculpture representing a child.

3. M-L. Swantz 1970, 273 n.39.

4. See Felix 1990, 27-31.

5. Ibid.

6. Quoted in M-L. Swantz 1995, 43.

7. Interview at Maneromango, January 19, 1997.

8. J. R. Harding, "'Mwali' Dolls of the Wazaramo." *Man* 61, no.83 (1961), 73. In this rather short article (two pages), Harding analyzes three *mwana hiti* objects: two are wooden while the remaining is a gourd.

9. M-L. Swantz, "The Religious and Magical Rites Connected with the Life-Cycle of the Woman in Some Bantu Ethnic Groups of Tanzania" (M.A. Thesis, University of Helsinki, 1966), 129.

10. Wembah-Rashid 1970, 3.

11. Omari Abdallah; Mode Kuga in interview at Maneromango, January of 1997. Though Kuga did not attend von Waldow's school, her elder sister did.

12. Alice Nkhoma-Wamunza, "My Life is a Life of Struggles: The Life History of a Young Barmaid," in *The Unsung Heroines: Women's Life Histories from Tanzania*, ed. M. K. Ngaiza and B. Koda (Dar es Salaam: Women's Research and Documentation Project, 1991), 37-38.

13. Quoted in M-l. Swantz 1995, 36.

14. Pelrine 1991, 8-9. Her impression during fieldwork was that Kizaramo appeared to be dying. See also M-L. Swantz 1995, who noted the same trend in the field, which is hardly surprising given the Zaramo's location on the Swahili coast and on the major trade routes. Zaramo women Manamkulu Lamba (a renowned *kungwi*), Zena Mwinyihija, and Cheusi Abdallah with whom I spoke about the *mwali* rites and *mwana hiti* at Maneromango (July 23, 2004) and Bunju 'A' in Kinondoni District (July 5, 2005) respectively, stated that both Kiswahili and Kizaramo are now used in the *mwali* instruction.

15. Interview with Salum Chuma in Dar es Salaam, January 7, 1997. Chuma made the translation from Kizaramo to Kiswahili. Translation from Kiswahili to English is mine.

16. Pelrine 1991, 125. The Zaramo who provided her with this information, and even Pelrine, do not attempt to explain why this is so and how it works.

17. Fenella Mukangara and Bertha Koda, *Beyond Inequalities: Women in Tanzania* (Dar es Salaam: Tanzania Gender Networking Programme and Southern African Research and Documentation Centre, 1997), 47.

18. Wembah-Rashid 1970, 2.

19. L. Swantz 1965, 71, following Anna von Waldow.

20. Felix 1990, 485. In view of this difficulty in the field, Felix alerts us about his own interpretations of the symbols of East-Central Tanzania. They "must also be approached with great caution."

21. M-L. Swantz 1995, 39.

22. Felix 1990, 487.

23. The Zaramo with whom I spoke and whose names are entered in previous notes, are not repeated here. Interview with Ramadhani Mwinyimkuu at Kisarawe on July 5, 2005; Selemani Mungi at Chang'ombe village (June 29, 2005).

24. Felix 1990, 488.

25. Felix 1990, 488.

26. Harding 1961, 72.

27. Felix 1990, 28. These are Felix's words not the elders'.

28. Pelrine 1991, 26.

29. Felix 1990, 20.

CHAPTER 5

1. Interview with Salome Mjema, March 1999.

2. Since traditionally the immediate Zaramo family members were not allowed to touch the body of a deceased kin, the *watani* were obligated to attend the funeral, contribute to the expenses involved, and organize the wake and the burial. The *watani's* duties include digging the grave, preparing the body for burial, organizing funeral rites, and sometimes acting as jesters to cheer the mourners during the wake.

3. M-L. Swantz 1995, 97; See also L. Swantz 1974.

4. Interview with Mjema, March 1999.

5. Ibid.

6. *Taifa Letu* (Dar es Salaam) of April 18, 1999; Binghamton (New York) *Press & Sun-Bulletin* of April 20, 1999.

7. Felix 1990, 193-194.

8. See examples of these in ibid., figs. 55-57. Mjema informed me that she has seen erected markers with the *mwana hiti* figure together with the cross on some graves in Uzaramo.

9. Interview at Maneromango, July 23, 2004.

10. See Felix 1990; Pelrine 1991. Felix describes these Zaramo funerary ceremonies but he does not indicate when the sculptures are put up on graves. Pelrine was told that the markers are erected seven days after the deceased has been buried.

11. Mwaruka 1965, 66-74.

12. I did not manage to take a photograph of this Zaramo grave figure, but it is listed in the collections' records of the Museum and House of Culture in Dar es Salaam. I shall describe the object further below.

13. Felix 1990, 79, 193.

14. Burton 1961: 1, 57-58.

15. *A Walk Across Africa or Domestic Scenes from My Nile Journal* (London: William Blackwood, 1864), 39.

16. Pelrine 1991. Ida Pipping-van Hulten, *An Episode of Colonial History: The German Press in Tanzania1901-1914* (Uppsala: The Scandinavian Institute of African Studies, 1974) exposes aspects of German oppression during their colonial epoch in Tanzania, stating that Dr. Stuhlmann was a renowned scholar and that he served as an officer in the colony.

17. See Pelrine 1991.

18. Quoted in McHenry 1979, 148.

19. Damien Pwono and Jacques Katuala, "Arts and Humanities Capacity Building in Africa: Problems and Prospects," in Altbach and Hassan 1996, 24.

20. Ibid.

21. Mlama 1983, 36. I might mention that Mlama is one those who consistently argued that there has been no defined cultural policy in Tanzania.

22. David Westerlund, *Ujamaa na Dini: A Study of Some Aspects of Society and Religion in Tanzania*, 1961-1977 (Stockholm: Almqvist & Wiksell International, 1980), 138.

23. Ibid.

24. As quoted in Donatella Lorch, "Bagamoyo Journal: An Art School in Search of a Soul." *New York Times*, November 22, 1995.

25. Komba 1995, 42-43.

26. Ibid., 44.

27. Irene and Roland Brown, "Approach to Rural Mass Poverty," in C. Legum and G. Mmari, 1995, 16.

28. Komba 1995, 34.

29. As quoted in ibid.

30. Nyerere 1966, 186-187.

31. See Westerlund 1980, 138-144. The title of the feature was, "Old Habits Must Go – Nyerere," *Nationalist*, July 29, 1969.

32. *Freedom and Socialism. Uhuru na Ujamaa: A Selection from Speeches and Writings, 1965-1967* (Dar es Salaam: Oxford University Press, 1968).

33. Westerlund 1980, 138-144.

34. Ibid.

CHAPTER 6

1. Nelson Graburn, ed., "Introduction." in *Ethnic and Tourist Arts: Cultural Expressions from the Fourth World* (Berkeley: University of California Press, 1976), 10-11.

2. *Kifimbo: Zeremonialstabe aus Zentral- und Ostafrika* (Munich: Galerie Fred Jahn, 1989).

3. See John Hatch, *Tanzania: A Profile* (New York: Praeger, 1973); James Graham, "Indirect Rule: The Establishment of 'Chiefs' and 'Tribes' in Cameron's Tanganyika." *Tanzania Notes and Records* 77 and 78 (1976): 1-9.

4. Felix 1990, 82-83.

5. Patrick Dikirr (Kenyan Maasai), personal communication, January 12, 1999.

6. M-L. Swantz 1995, 98-99. She uses the Kiswahili word, *mteja* here to mean patient. This word also means customer in English. Ramadhani Mwinyimkuu, Selemani Mungi, and Cheusi Abdallah were helpful in answering my questions on a number of Zaramo spirits and exorcism rites.

7. L. Swantz 1990, 147.

8. See Felix 1994; Castelli 1994.

9. Felix 1990, 302.

10. Patrick Dikkir, "Decentralized Government, Cultural Identity, and a Pastoral Mode of Subsistence: A Case Study of the Maasai of East Africa," (Unpublished Seminar Paper, Department of Art History, Binghamton University, May 1997).

11. William Smith, *Nyerere of Tanzania* (London: Victor Gollancz Ltd, 1973).

12. Janet Hess, "An 'Irrational Eschatology': Nkrumahism, Post-Nkrumahism, and the Discourse of Modernity," in Nzegwu 1998, 177.

13. Ibid.

14. Smith 1973, 14.

15. Hess 1998, 177.

16. Ibid.

17. *African Orature and Human Rights* (Roma, Lesotho: Institute of Southern African Studies, National University of Lesotho, 1991), 20.

18. See M-L. Swantz 1970. See also Swantz 1995 for more details. She states that, "Now waganga often wear red khangas on top and khanga cloths of red, white, and black wrapped around them as skirts."

19. Bismarck Mwansasu, *Nyerere, 1961-1985: Passing on the Tongs*, 1986 as quoted in Geoffrey Mmari, "The Legacy of Nyerere," in Legum and Mmari, 1995, 177.

INDEX

CPSIA information can be obtained
at www.ICGtesting.com
Printed in the USA
BVOW07s0607121116

467652BV00002B/2/P